THE ART OF

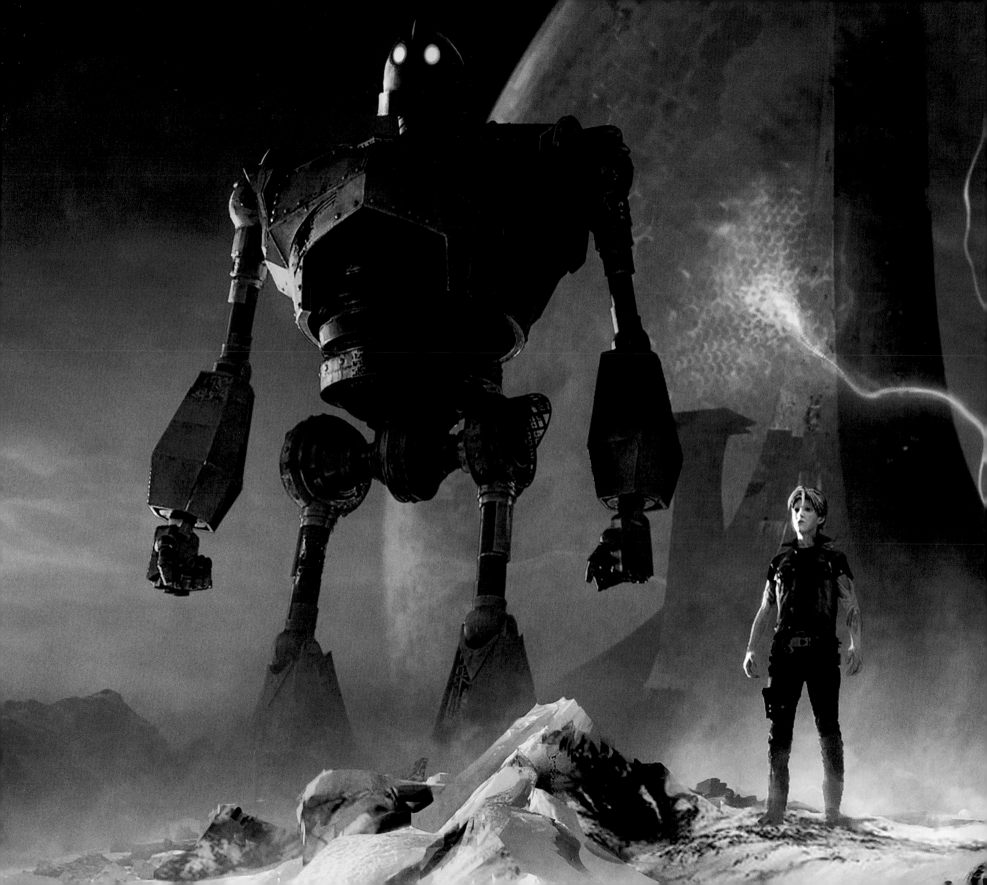

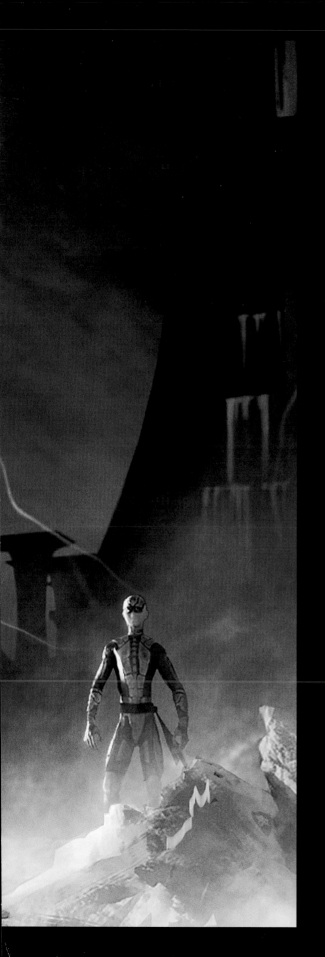

THE ART OF
READY PLAYER ONE

FOREWORD BY **STEVEN SPIELBERG**
INTRODUCTION BY **ERNEST CLINE**
WRITTEN BY **GINA MCINTYRE**

INSIGHT 👁 EDITIONS

San Rafael, California

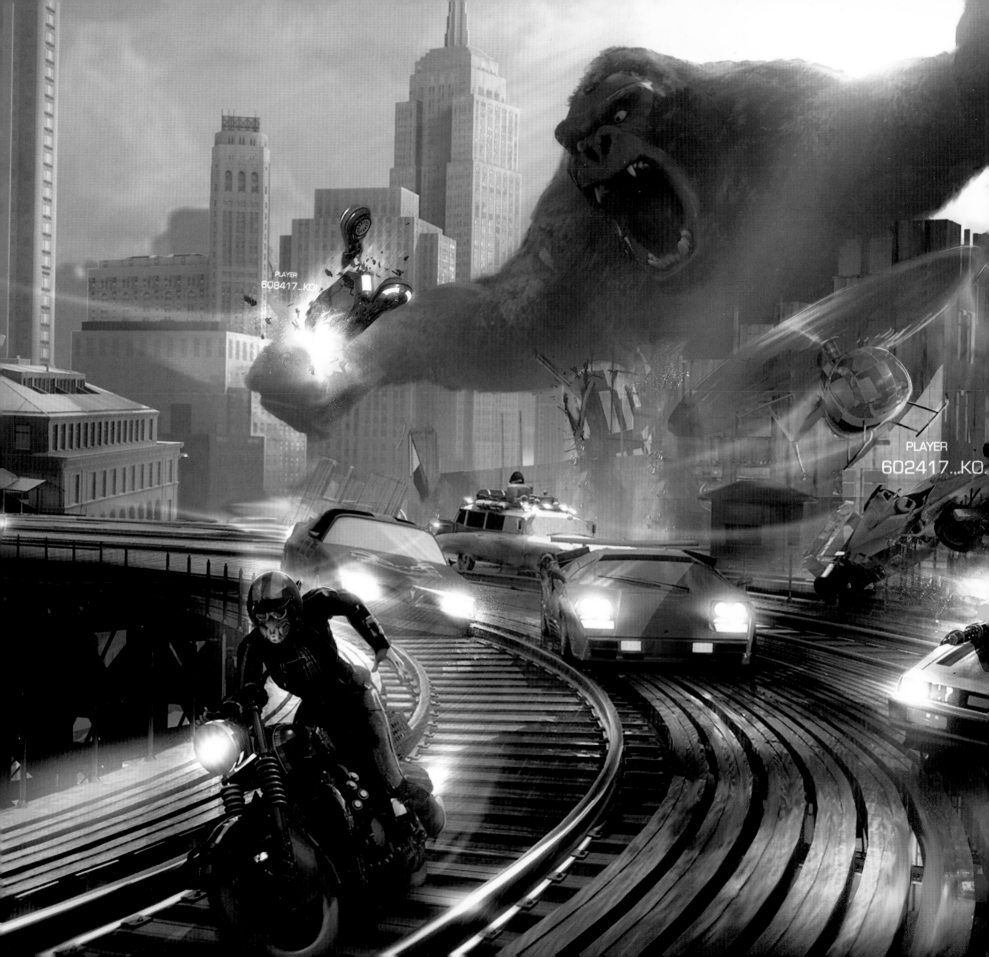

CONTENTS

ALTHOUGH ERNEST CLINE'S VISIONARY BOOK *Ready Player One* is a worldwide best seller, I hadn't read it until Warner Bros. sent it to me along with the screenplay adaptation. I recognized immediately that this was a movie I wanted to make. Frankly, they had me at OASIS, the virtual reality world at the center of the story, even though I knew this could be one of the most challenging films I would ever direct. And it was, taking almost three years to bring to life.

Ernie's imagination laid out a future that was exciting, original, and not too far away from where we are today as technology continues to advance. Using his book as a blueprint, Ernie and co-screenwriter Zak Penn crafted a screenplay that envisioned a dystopian society in 2045 where people can escape as avatars into the world of the OASIS. There they can do anything that they can imagine, subject to reasonable laws, without revealing their true identities—only those of their avatars. Many players spend more time in the immersive virtual world than in the reality of their downtrodden environments. When the billionaire designer of the OASIS dies, he posthumously launches a global contest within the virtual world, with the winner inheriting his fortune and the OASIS. Using clever rhyming clues, hidden Easter eggs, and encyclopedic knowledge of all things 1980s, the contest leads its players into deeper and deeper challenges.

The story is a nostalgic flashback to the 1980s with its many pop-culture references. I was involved as a director or producer on several movies from that decade, which is why I was so drawn to a story that incorporated not just my own work, but also so many more things I loved from that decade. As a fan, I wanted to include many surprises from the other iconic films, video games, and TV shows from those years.

But before we could get the cameras rolling, our remarkable art department, led by Adam Stockhausen, had to design both the real and the virtual worlds of *Ready Player One*. The movie also required real and virtual sets because about half the film takes place in the OASIS and the other half in the real future world of 2045. The production process was akin to making two films simultaneously.

The scope of the film also required us to take a whole new approach to motion capture that incorporated real-time virtual reality techniques. Each department had to create designs for not only our intrepid virtual heroes, the High Five, but also the armies of background characters that populate the OASIS—from gangs of Batmans to packs of ThunderCats, classic movie monsters, dinosaur-riding dictators, and much more. None of that would have been possible without the cooperation of a large number of film studios and entertainment companies that granted us permission to use many of the iconic references you'll see in the film. I thank them for lending these classic properties to the film.

This book is a tribute to Ernie's initial vision and the work it inspired from all those many talents—in front of and behind the cameras.

PAGES 2-3 **On Planet Doom, the Iron Giant stands side by side with heroes Parzival and Sho in this concept piece by Gaelle Seguillon.**

PAGE 4 **King Kong attacks during *Ready Player One*'s unforgettable race sequence in this preproduction art by Alex Jaeger.**

PAGE 5, RIGHT **Art3mis, Sho, Parzival, Aech, and Daito work together in this final frame from *Ready Player One*.**

ABOVE *(Left to right)* **Steven Spielberg, Clay Lerner, (Steven Spielberg's assistant), producers Donald De Line and Kristie Macosko Krieger, and co-screenwriter Zak Penn.**

OPPOSITE **Director Spielberg behind the camera on location in Manchester, England.**

WHEN WARNER BROS. ASKED ME TO GIVE THEM MY WISH LIST of potential directors for *Ready Player One*, I didn't even consider putting Steven Spielberg's name on it. Doing so would have felt like an act of hubris. Everyone who dreams of making movies dreams of working with Steven Spielberg someday. I know I always have. In fact, it's doubtful I ever even would have written *Ready Player One* if I hadn't grown up watching Steven's films. *Ready Player One* is my homage to the pop-culture landscape of my youth, and Steven Spielberg played a key role in creating that landscape. That's why he's mentioned by name several times in the book. That's why my protagonist, Wade Watts, carries a Grail Diary like the one in *Indiana Jones and the Last Crusade*, and it's why his avatar drives a DeLorean like the one in *Back to the Future*. (It's why I own a DeLorean, too!) The films that Steven Spielberg wrote, produced, and directed were major inspirations for my novel, so the notion that he might be interested in directing its film adaptation seemed like an impossible dream.

But it wasn't.

Roald Dahl's *Charlie and the Chocolate Factory* was another big inspiration for *Ready Player One*, and when I first went to meet Steven in his office at Amblin I remember feeling like Charlie Bucket, clutching his golden ticket as he prepared to meet his hero, Willy Wonka, and pass through the gates of his mysterious factory . . . into a world of pure imagination.

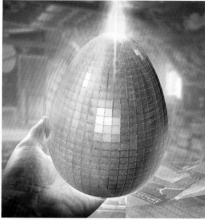

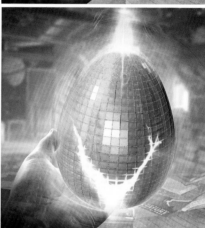

Throughout the entire process of making this film, that magical feeling never went away. For the past few years, I've felt as though I were living out every film fanatic's fantasy—and not just because I was working with Mr. Spielberg. I was given the opportunity to make a movie with many of the people who inspired me to become a writer and film-maker in the first place.

Among them is my friend and fellow screenwriter, Zak Penn, who also wrote *Last Action Hero*, one of the films that inspired the concept of Flicksyncs in my novel. Our shared passion for movies and video games made him the perfect collaborator, and I am eternally grateful to him for all of the care, consideration, and attention to detail he showed while adapting my novel.

The same goes for our brilliant production designer, Adam Stockhausen, who also worked on several of my favorite Wes Anderson films. He and his team brought the future depicted in my book to life, creating both the real world and the virtual world of the OASIS with a level of accuracy and vivid detail I never dreamed possible. When I first visited the set and saw his re-creation of the Stacks, I couldn't believe my eyes. The giant ramshackle towers of stacked mobile homes I'd envisioned in my novel now existed here in reality, and they were visible from miles away. Walking through them felt like stepping into the paperback cover of my novel. And when I put on a headset to visit the virtual reality sets he'd created inside the OASIS, I was just as awestruck.

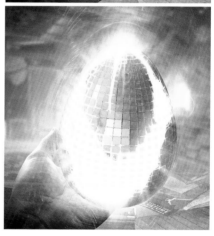

Everywhere I went on the set at Leavesden Studios, I saw countless little details from my novel that had now been rendered in reality. The set dressing, costumes, vehicles—they were all so perfect. Even better than what I'd imagined. After we finished shooting each scene, I wanted to steal every single prop and smuggle them all home in my suitcase as mementos. (It's possible that a few of those props are currently on display here in my office as I write this.)

Being a lifelong film geek, it was a constant struggle to contain my excitement over the epic things occurring all around me at any given moment—like watching Steven Spielberg collaborate with his legendary cinematographer, Janusz Kaminski. They're two of the most knowledgeable and passionate cinephiles I've ever met, and their adoration for the work of Stanley Kubrick is evident in the loving homage to *The Shining* that they crafted for this film. Watching two of my cinematic heroes pay tribute to one of their own filmmaking idols was incredibly inspiring. It also made me feel a lot less self-conscious about all the geeking out I was doing on the set. Because my heroes were geeking out, too.

But the greatest joy of all for me remains the experience of watching over Steven Spielberg's shoulder as he directed the incredible cast he assembled and helped them bring the characters I'd created to life, one scene at a time. I'm not sure anything will ever top that.

The movie is different from the book, of course. All great film adaptations deviate from their source material, because they must. Books and films are two completely different storytelling mediums, each with its limitations. A lot of tweaks were made to my original story, but Steven, Zak, and I always collaborated on these changes to ensure that the film stayed true to the spirit of my novel. And it has. Every writer should be so lucky.

The book you now hold in your hands is like my own personal Grail Diary—a document of one of the most thrilling adventures I've ever been on. And it's a testament to the boundless creativity, enthusiasm, and hard work of all the incredibly gifted artists, actors, producers, and crew members involved in making this film. We all worked together to create a new world for you to explore—a world where the limits of reality are your own imagination.

ARE YOU READY?

ABOVE Early three-stage concept for James Halliday's golden Easter egg by Alex Jaeger.

CENTER LEFT Steven Spielberg with *Ready Player One* author and co-screenwriter Ernest Cline.

OPPOSITE Parzival nears the end of his quest in this concept by Alex Jaeger.

WELCOME TO THE OASIS

THROUGHOUT HIS UNPARALLELED CAREER, cinematic visionary Steven Spielberg has created a huge number of jaw-dropping, immersive worlds—some depicting sleek, dystopian futures, others magical incarnations of our own reality. For his thirtieth feature film, he's unveiling yet another wildly imaginative, visually astonishing tale with *Ready Player One*, based on the international best seller by novelist Ernest Cline.

"I read the script first, and I was completely wowed by it," Spielberg says. "It was a crazy, conceptually nutty idea, but an idea that was not too far away from a future reality. Having made *Minority Report* and having spent so much time trying to imagine what the future could be for all of us in that circumstance, I suddenly saw a future that Ernest Cline envisioned. And it wasn't that far away from what I think is going to happen someday."

When the film opens, the year is 2045. The place is Columbus, Ohio. The fabric of the economy is crumbling, unemployment has skyrocketed, and the environment is in ruins. To escape the drudgery, people around the world log in to the OASIS (Ontologically Anthropocentric Sensory Immersive Simulation), a dynamic virtual reality where anyone can be anything he or she might want to be. There they create avatars of any shape, size, race, gender, or species and experience everything life has to offer through that invented identity—attend school, fall in love, work, play, and grow old on a nearly limitless array of planets. All it takes to be completely immersed in this vibrant, expansive universe is a set of haptic gloves paired with a virtual reality visor.

"The point of entry is you have to accept the fact that twenty-five to thirty years from now virtual reality will be a super-drug in the sense that it's going to addict so many people from every walk of life in every country on the face of the planet," Spielberg says. "But when you escape from reality, you're also, in a way, divesting yourself of any real human contact. And cyber contact is an entirely different area that we explore in the story. So, the story is a huge adventure; it's extremely compelling and thrilling. And it's also a little bit of a social commentary."

For those plugging into the OASIS, this virtual world holds far greater promise than simple escape. Before his death, the reclusive Gen X genius James Halliday (Mark Rylance, *Bridge of Spies*), the mastermind who invented the OASIS, planted an Easter egg within the simulation. To reach the egg, a player must solve three challenges and collect three special, color-coded keys (copper, jade, and crystal). The first person to collect all the keys and solve the puzzles inherits Halliday's vast fortune and the greatest prize of all: total control of the OASIS.

"It's almost like if Bill Gates decided to have a contest and whoever wins the contest, they get Microsoft," Spielberg says. "They become Bill Gates. And they get everything. And so, everybody in the world gets into this contest and into this huge, sprawling adventure."

Wade Owen Watts (Tye Sheridan, *X-Men: Apocalypse*) is desperate to find a way out of the Stacks—the towering Ohio slum where he lives with his aunt Alice and her louse of a boyfriend, Rick. He is determined to win Halliday's contest not only to better his own situation but also to protect the OASIS from falling under the control of Innovative Online Industries (IOI), the powerful corporation that designs and manufactures the gear necessary to access the OASIS. An avid Easter egg hunter (or "gunter," a term derived from a combination of the words "egg" and "hunter") known inside the OASIS as Parzival, Wade obsessively studies the rhyming clues Halliday left behind that hint at the location of each challenge. He also has a formidable knowledge of the music, movies, and video

games of the 1980s that loomed so large in Halliday's formative years and lived on through his memories and imagination. Consequently, he becomes the de facto leader of the celebrated group known as the High Five. The quintet hold the coveted top spots on Halliday's virtual scoreboard (which tracks the avatars who are closest to obtaining the egg), and they might as well be rock stars in the OASIS. The group includes Parzival's crush, Art3mis (Olivia Cooke, *Me and Earl and the Dying Girl*), his best friend, Aech (Lena Waithe, *Master of None*), and adventurer pals Daito and Sho (newcomers Win Morisaki and Philip Zhao, respectively). The High Five form a strong bond, working together to support one another in their shared goal of keeping the OASIS free and open to every user.

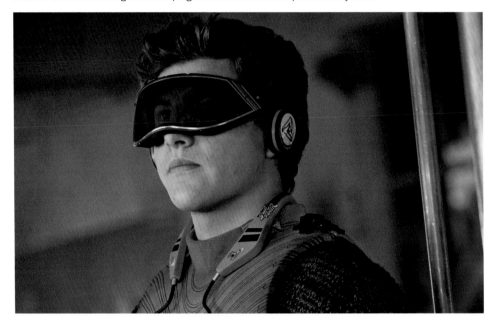

Although they are friendly competitors in the OASIS, in real life they have never met. "There is a kind of unspoken, unwritten law that people in the OASIS do not reveal who they are in the 'RW,' or the real world," Spielberg says.

Their elite status in the contest puts them in the sights of the ruthless Nolan Sorrento, played by Ben Mendelsohn (*Rogue One: A Star Wars Story*). The head of IOI, Sorrento wants to wrest control of the all-encompassing virtual world to establish a powerful monopoly. "The idea of the OASIS getting taken over by a corporation that would monetize it and keep it from being free is really horrifying to Wade, the other gunters, and a huge part of the population," Cline explains.

Once Wade solves the first puzzle left behind by Halliday, Sorrento begins to relentlessly pursue the High Five to stop them from winning Halliday's challenge. "It's really a story about this huge corporation against all these Main Street players from all around the world," Spielberg says.

TOP LEFT **Scroll design by Luis Carrasco showing the Copper Key, the first prize Wade Watts must win on his quest to gain control of the OASIS.**

ABOVE **Actor Tye Sheridan as Wade Watts.**

OPPOSITE LEFT **OASIS logo designs by Neil Floyd.**

OPPOSITE RIGHT **Logo design and an advertisement for the OASIS featuring concept art of the Distracted Globe location by Alex Jaeger.**

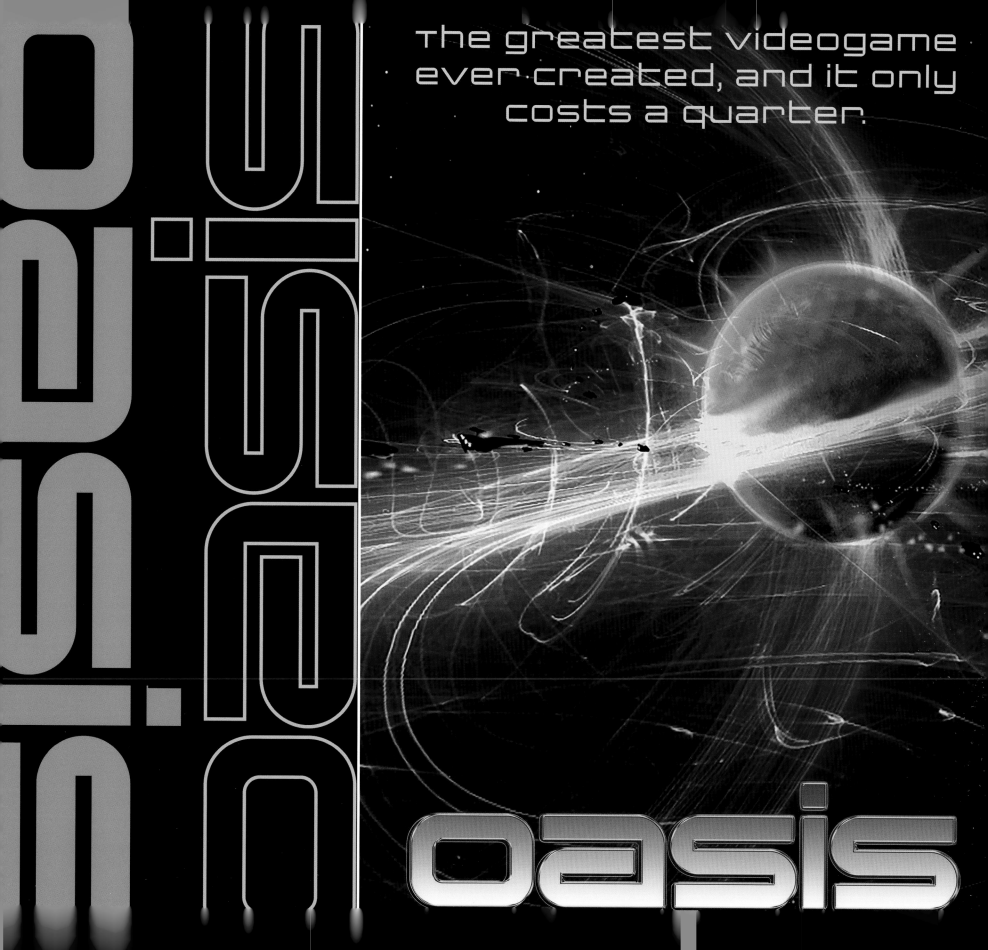

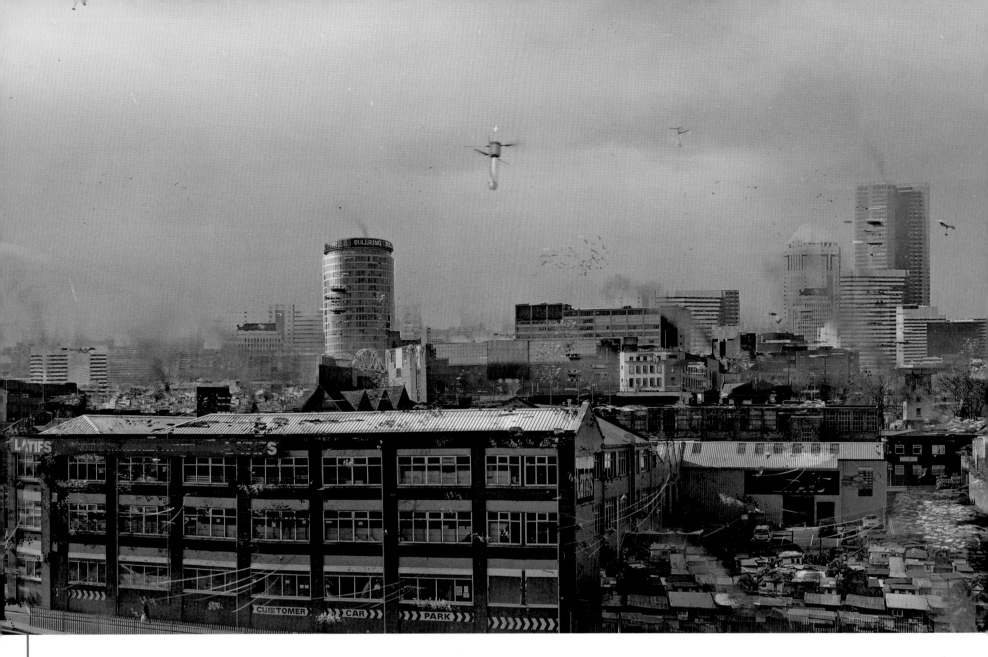

Through his experiences, Wade comes to embrace the possibilities that exist outside the OASIS. "Wade is not only on this fun treasure hunt trying to win a contest," explains producer Dan Farah. "He's also a young guy who, along the course of this journey, finds a reason to see hope in the real world. There's a very modern coming-of-age story at the heart of this."

Even before the book was released, Cline's story captured the imagination of Hollywood, sparking a bidding war for the movie rights, which ultimately went to Warner Bros. The project spent several years in development, but once Spielberg signed on to direct in March 2015, it quickly began to take shape. For Cline, Spielberg's involvement was a dream come true. "I couldn't have written *Ready Player One* if I hadn't grown up on a steady diet of Steven Spielberg movies," Cline says. "Steven's work directly informed

ABOVE **Concept art by Ulrich Zeidler of the Columbus, Ohio, skyline with IOI's headquarters looming large.**
PAGES 14-15 **The High Five assemble in this early concept by Dan Baker.**

the story. The fact that he's bringing the story that I wrote to life after helping inspire it is just the most meta and cool thing that's ever happened."

The veteran filmmaker embarked on an intensive period of preproduction during which he worked extensively with Cline and co-screenwriter Zak Penn (*X-Men: The Last Stand*) to carefully hone the script with an eye toward preserving the rich, colorful spirit that animated Cline's novel. Together, they also carefully mapped out some major changes to the original storyline to help better translate the story from the page to the screen—not only were the specific challenges updated but the timeline for when various characters meet was also altered. The overriding idea was to give audiences another window into the world of Cline's imagination and the limitless pathways of the OASIS.

Additionally, even though the novel does contain many mentions of the director's classic films, Spielberg sought to limit self-referential material. "It's a real throwback to an era when I was very involved in making movies," he says. "When I read the book, I saw a lot of references to my movies, and I kind of said to myself, well, if I direct this

movie, I'm not going to be able to include all those references. Maybe just a couple. This is not going to be me holding a mirror up to myself from the 1980s. It's going to be a story about the culture then, but also the culture of the future."

The culture of the future, however, is still bound up with passion for the pop culture of the past. *Ready Player One* is stuffed with blink-and-you'll-miss-them homages and fun allusions to beloved lore from yesteryear weaved in among the groundbreaking imagery of Parzival's all-important quest to save himself—and the rest of the world. The film simultaneously functions as a flashback and a flash-forward glimpse of the future.

In terms of the actual production, Spielberg sat down with his expert behind-the-scenes team—including two of his *Bridge of Spies* collaborators, production designer Adam Stockhausen and costume designer Kasia Walicka-Maimone, as well as the director's longtime cinematographer, Janusz Kaminski—to determine the best way to depict two distinct settings: the hardscrabble existence of the Stacks and the virtual majesty of the OASIS.

Ultimately, they adopted a wildly ambitious approach. The Stacks, its surrounding area, and other key sets were constructed on sprawling soundstages at Warner Bros. Studios Leavesden, just outside London, England, where filming was headquartered from June through September 2016. All the real-world action was shot on 35mm film to give it a distinctly cinematic look. For the scenes inside the OASIS, Spielberg used the latest in performance-capture technology and state-of-the-art CG imagery; the master technicians at the visual effects houses Industrial Light & Magic, Digital Domain, and London-based Framestore then laboriously constructed the world of Halliday's invention.

There's no question that Spielberg's breathtaking vision for *Ready Player One* promises to raise the bar for Hollywood spectacle for decades to come. "The movie really intercuts between a virtual world and a real world," Spielberg says. "The special effects are, we think, going to be groundbreaking. They're going to be unlike anything anyone has ever seen before."

GAME ON.

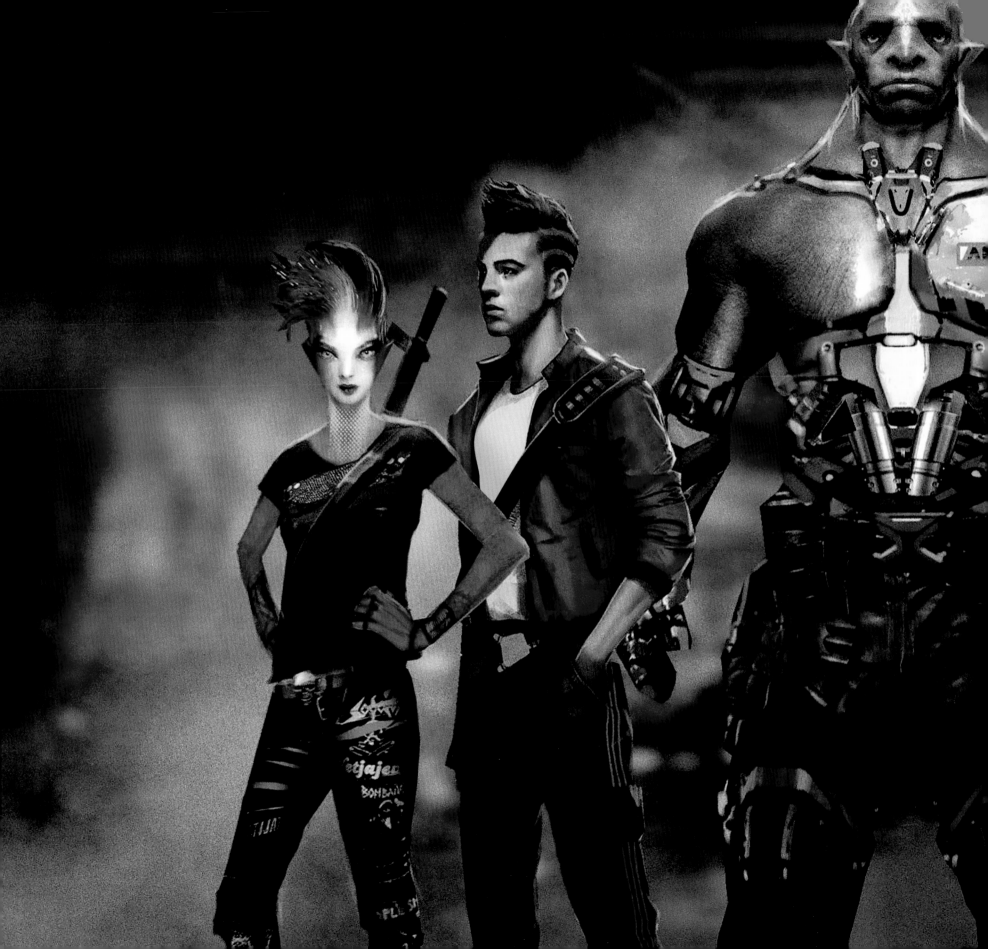

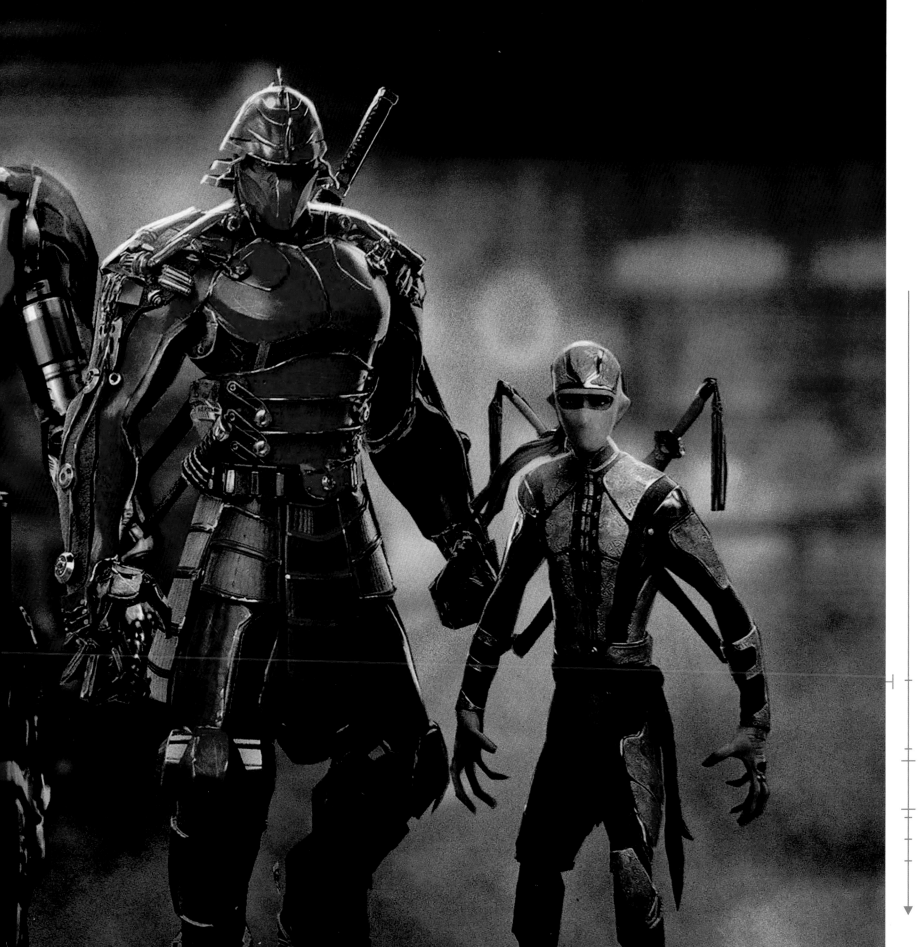

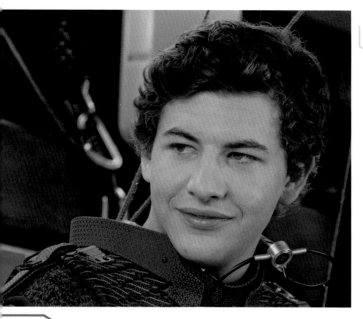

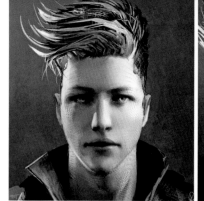

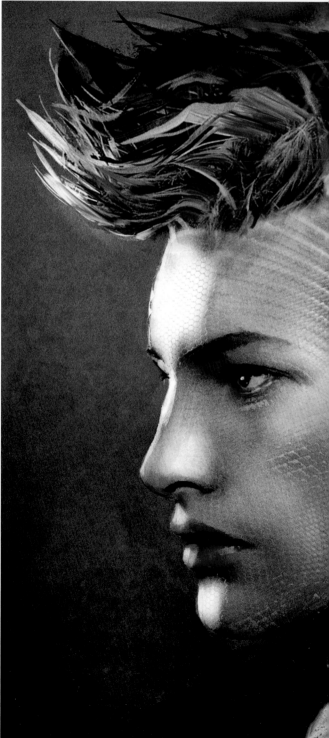

"What it came down to," says Stockhausen, "was he needed a level of humanity to relate to Art3mis in a human way, and yet [we didn't simply want him to be] human because he's in the OASIS—why would he just be a human? On the flip side, if you go too animalistic or too robotic, then, as you decrease the humanity, it makes it harder and harder to relate to him as a person. So, the real trick with him was how to pull in influences that gave him the sense that this was an avatar that he chose because he thought these qualities were cool or interesting—how do you get enough of that and enough relatability and enough coolness and toughness? It's a complicated puzzle."

The final look drew heavily from Wade's obsession with every facet of 1980s pop culture, with a nod to the myth that inspired the avatar's name. "It has roots in anime heroes, it has roots in '80s rock stars," Stockhausen says. "When you look at the hairstyle, and you look back at '80s rock 'n' roll hairstyles, you see where that comes from. He's got this sword on his back, which was sort of the idea of how do you make an '80s pop-culture knight—does he wear a whole suit of armor all the time? Or does a jean jacket with a skull and sword become his suit of armor?"

For Parzival's footwear, the design team looked back to Ernest Cline's original text. "He wears these shoes that were inspired by the book, actually," Stockhausen says. "There's a pair of shoes that Art3mis has that are Converse Chuck Taylors with wings. Parzival uses them at the end of the book. We liked that image and [made] those his shoes."

TAKING THE NAME of his avatar from a variant spelling of Percival, the Arthurian knight who discovers the Holy Grail, Wade Watts (whose initials spell WOW) creates a slender, strong, and clever hero with finely wrought features and a chicly styled mop of ice-blond hair. "Wade and Parzival are two very different people," says actor Tye Sheridan. "Parzival is everything that Wade is not in the real world, and so, when we meet Wade, he's kind of this skittish guy who's quite introverted and closed off. The OASIS is where he expresses himself."

Arriving at exactly the right look for the *Ready Player One* hero was very nearly as difficult as discovering where James Halliday hid his Easter eggs. During the intensive design process, the character went through dozens of iterations as production designer Adam Stockhausen worked closely with Steven Spielberg and the visual effects experts at Industrial Light & Magic (ILM). Parzival not only had to serve as the audience's principal guide through the OASIS but also had to exist as a wholly believable, sympathetic, three-dimensional character who experiences love and loss, overwhelming joy, and real sorrow on his incredible journey.

TOP LEFT **Tye Sheridan as Wade.**

RIGHT **Early Parzival concepts by Stephen Tappin and Alex Jaeger.**

OPPOSITE RIGHT **A render created by Industrial Light & Magic captures the final design for Parzival.**

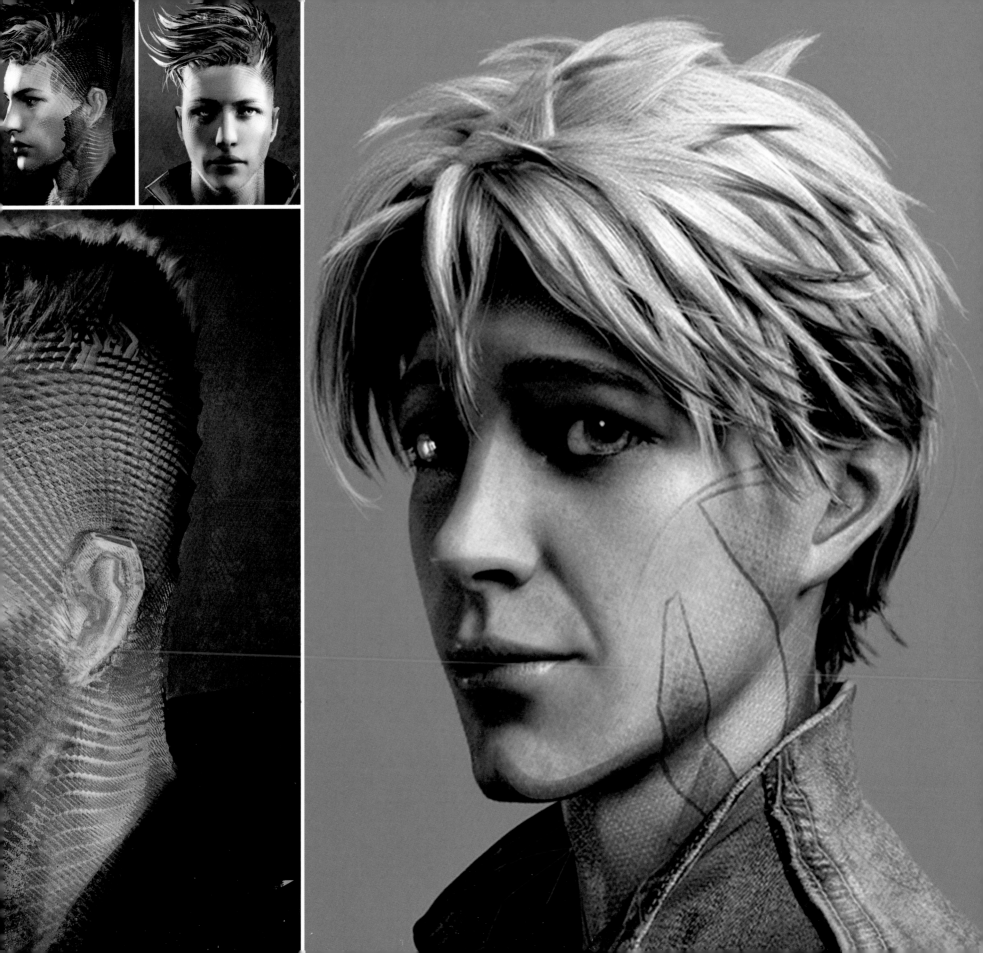

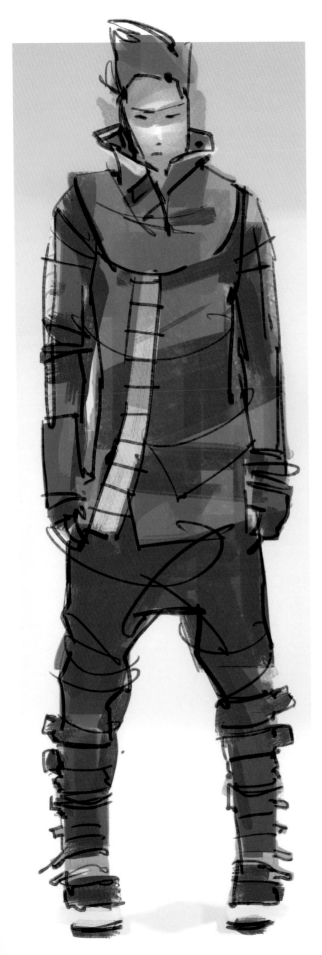

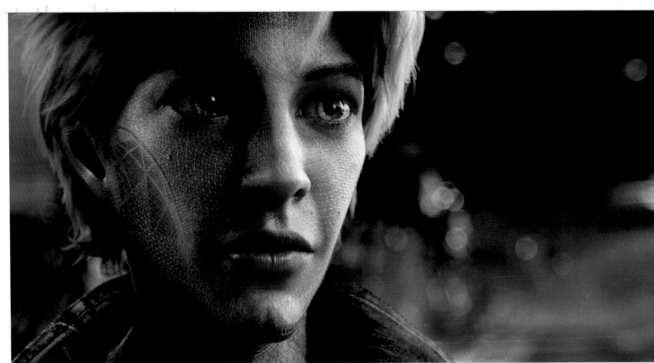

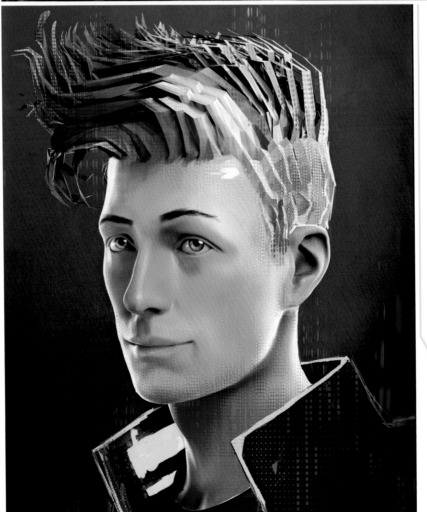

FAR LEFT AND OPPOSITE Early Parzival clothing designs by Stephen Tappin.

TOP A final frame from *Ready Player One* shows the remarkable lifelike detail that went into the final rendering of Parzival.

LEFT Early Parzival concept by Tyler Scarlet.

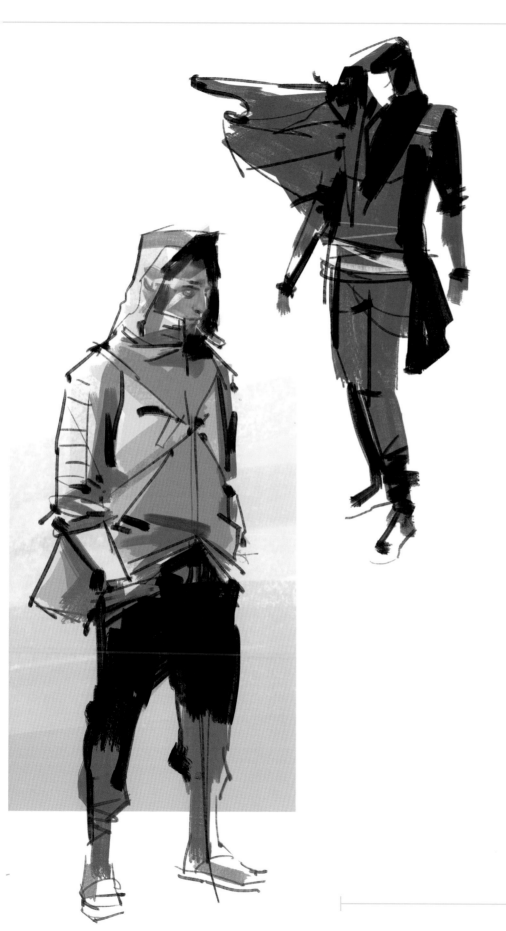
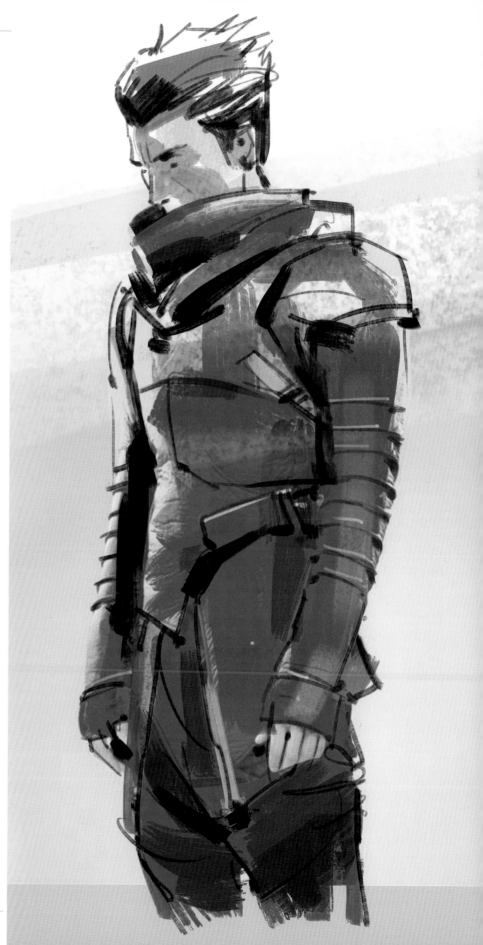

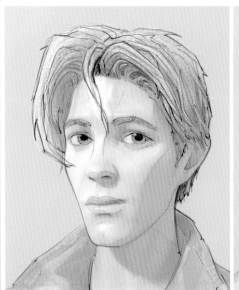
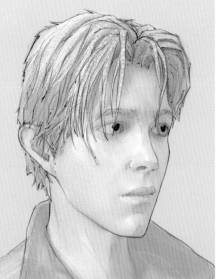
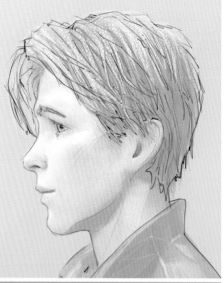

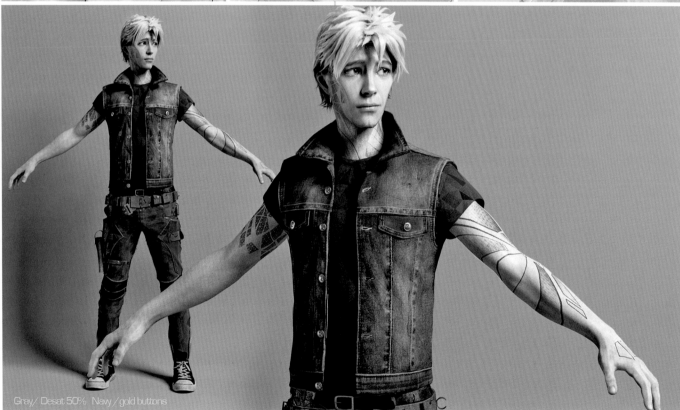

Gray/ Desat 50% Navy/ gold buttons

TOP Final Parzival hairstyling sketches by Alex Jaeger.

ABOVE Final ILM Parzival design and hero clothing model with adjustments by Alex Jaeger.

RIGHT Final ILM Parzival design detail model (including winged sneakers based on the pair worn by Art3mis in the book) with adjustments by Alex Jaeger.

OPPOSITE RIGHT Final Parzival design and costume by Stephen Tappin, head and arms by Alex Jaeger.

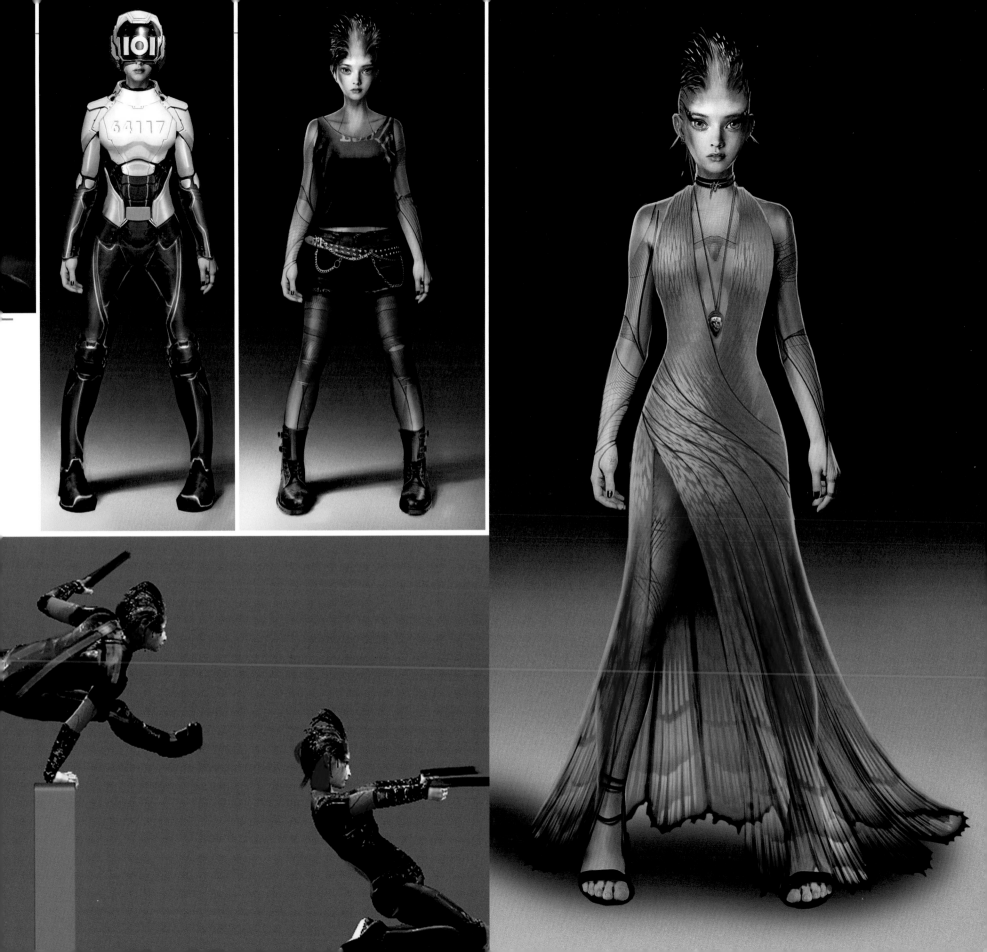

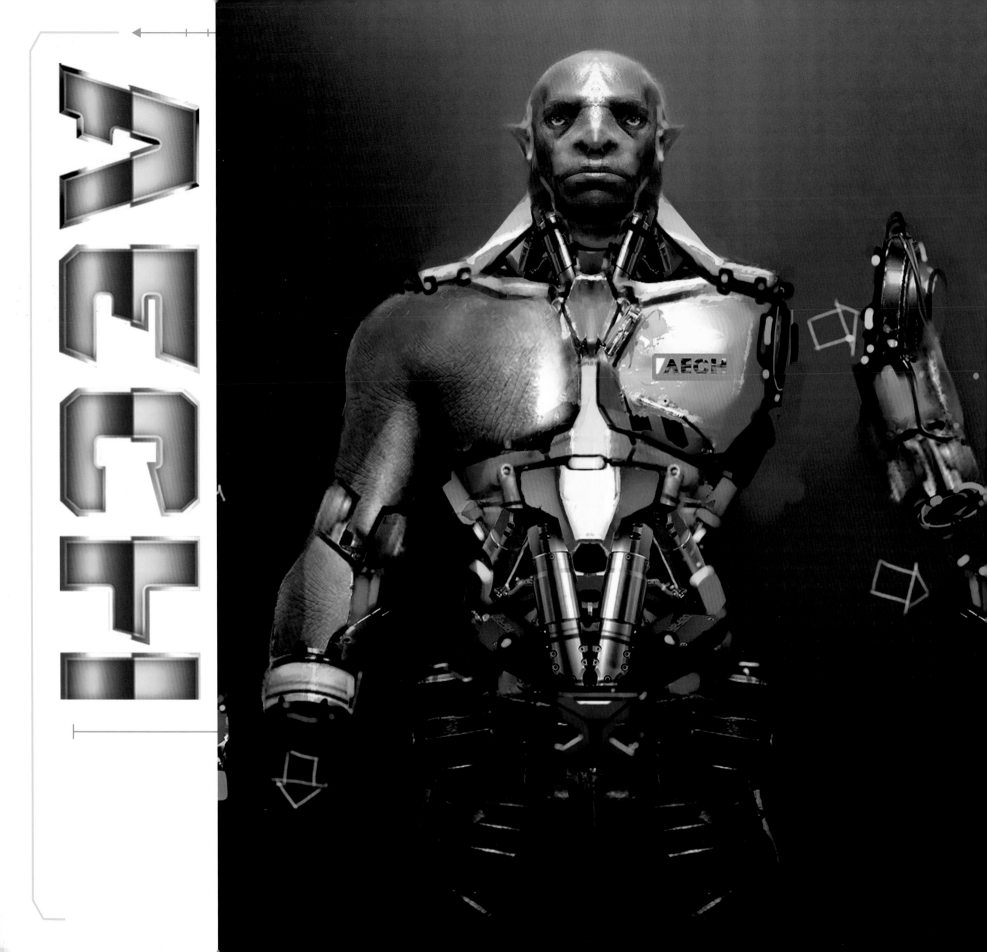

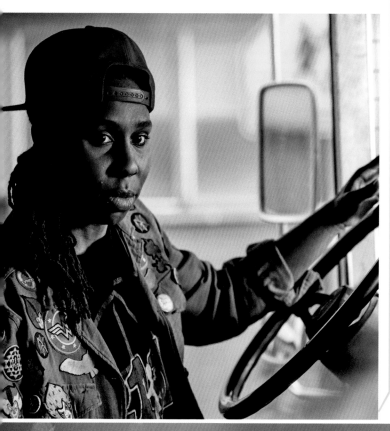

AECH / HELEN

PART HUMAN AND PART MACHINE, Aech has a bald head, an impossibly chiseled jaw, and enormous, bulging muscles—everything about the avatar screams physical power and technical prowess. The character is an avid mechanic who can repair almost anything inside the tricked-out garage filled with interesting inventions where he spends time when not hanging out in his basement retreat. "The images for Aech started with this mechanical body," says Adam Stockhausen, "this set of three pistons that make up his midsection that he can expand and contract and poke around corners. It has a kind of mechanic quality. It has this incredibly useful look—everything about that avatar is useful and purposeful."

The avatar's aggressively masculine exterior traits help disguise "H's"—short for Helen—real-world female identity. "In the OASIS, Aech is maybe six foot eight," Lena Waithe says. "He's got these huge muscles—he's part human, part machine. Just super tough, strong. [He can], like, swing a dumbbell with one hand. It's like Rambo meets Mr. T meets Rocky, Ice Cube, LeBron James. Every big tall black dude you can think of is

poured into one drink and stirred up and is this guy. But he's also just super cool, really chill." (Chris Munro, who handled production sound, lowered the pitch of Waithe's voice by three semitones to keep Aech's secret.)

Just as Olivia Cooke's traits show up in Art3mis, Aech's facial design and physicality was influenced by Waithe's mannerisms and gestures. "Once we did get Lena in there [during performance capture], we had to do some minor adjustments to make her expressions come through on Aech's face," says Alex Jaeger. "The early model was very smooth and very rigid, but [Lena] does a lot of face scrunching, so we knew we needed to have a lot more ability to move the eyebrows and scrunch the nose, things like that. While the actual design of Aech came from artwork early on, it basically just slightly morphed as we got the actress's performance."

OPPOSITE This Aech design by Jama Jurabaev includes a midsection inspired by pistons.

TOP LEFT Actress Lena Waithe as Helen.

BELOW Early Aech face concept by Aaron Sims Creative.

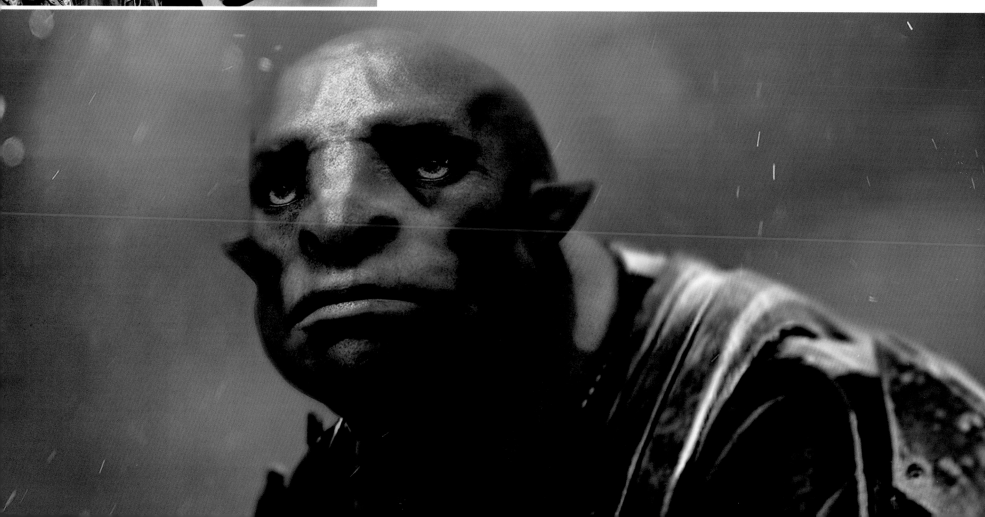

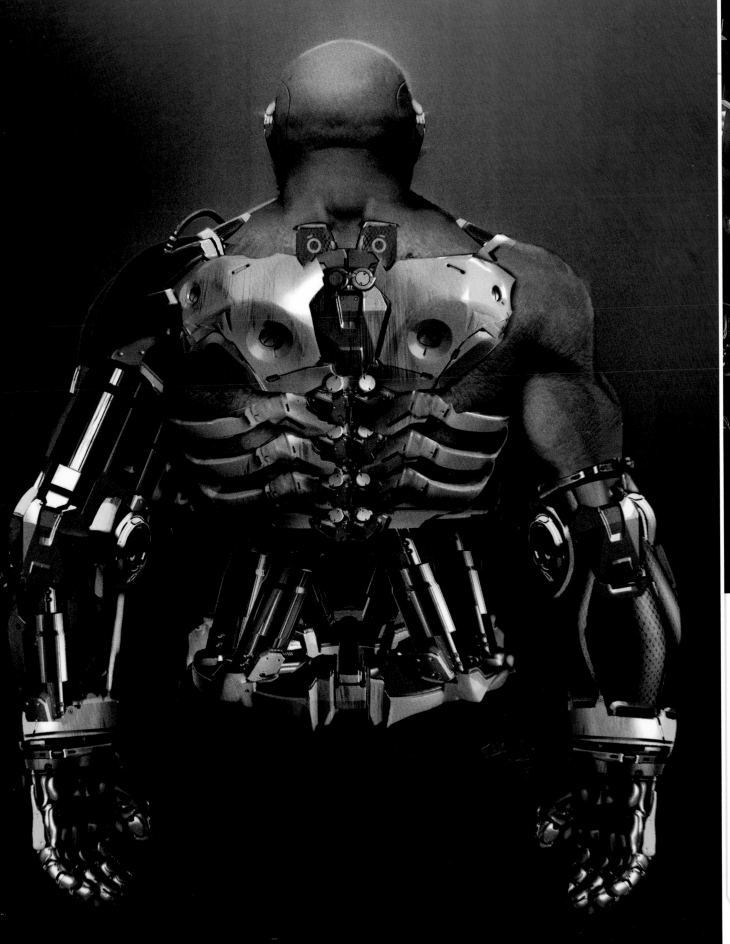

LEFT The vibrant mustard yellow accents of Aech's design contrast with the avatar's overall gunmetal-colored scheme, as seen in this concept for the back of the character by Adam Baines.

ABOVE When not in battle, Aech spends his time in his massive mechanic's hangar where, among other projects, he designs and builds a replica Iron Giant. Concept by Alex Jaeger.

OPPOSITE BOTTOM Final frames from *Ready Player One* show Aech in action.

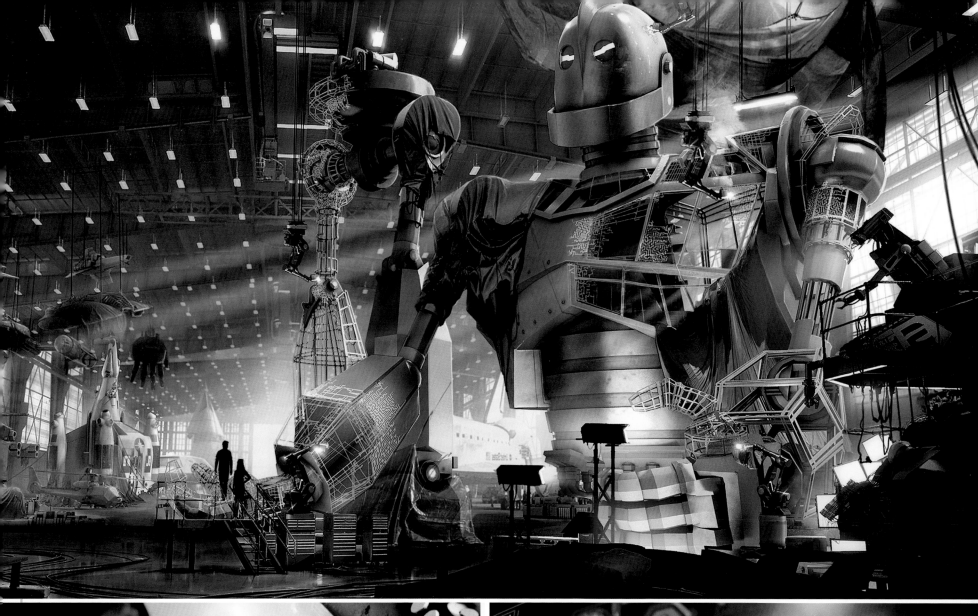

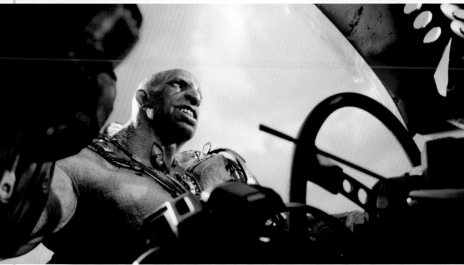

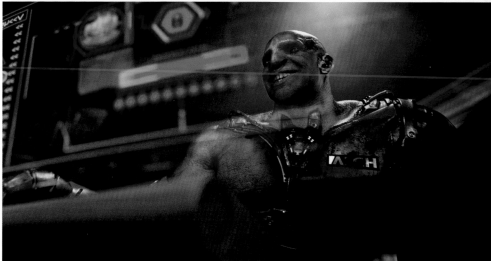

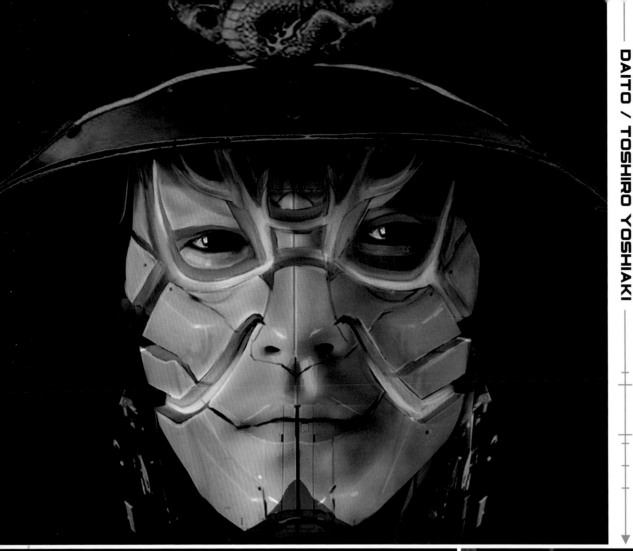

A KEY ALLY TO PARZIVAL, Daito has exceptional skills that prove incredibly valuable in the quest for Halliday's egg. Daito translates to "big sword," and the avatar is rarely seen without his katana—but his overall look also serves as a nod to one of Japan's greatest actors. "We had this idea of Daito being . . . a mechanical armored samurai," says Adam Stockhausen. "Then Steven had this idea that underneath his armored samurai helmet he would have a facial mask based on Toshiro Mifune." (Actor Toshiro Mifune, of course, was the longtime collaborator of legendary Japanese director Akira Kurosawa and starred in such films as *Rashomon* and *Seven Samurai*.)

To prepare for the role, Win Morisaki studied swordplay in Japan for a month before arriving on set. "The OASIS is a dangerous place," says the performer, a member of the Japanese boy band PrizmaX who makes his English-language acting debut in *Ready Player One*.

Fortunately, the towering avatar has no trouble looking intimidating: He stands much taller than some of his counterparts. "That's another thing in the OASIS—size is chosen by the user," Stockhausen says. "Daito [and Aech are] significantly taller than general human height. Art3mis and Parzival are about standard human height. Sho is smaller. So when they're standing together as a group, there's a whole range. That range is just like you would have [in] a range of regular people; it's just stretched."

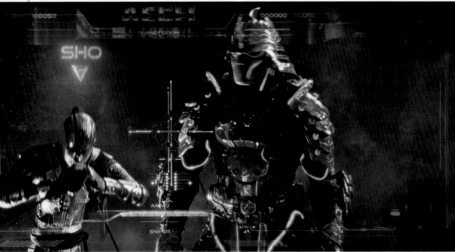

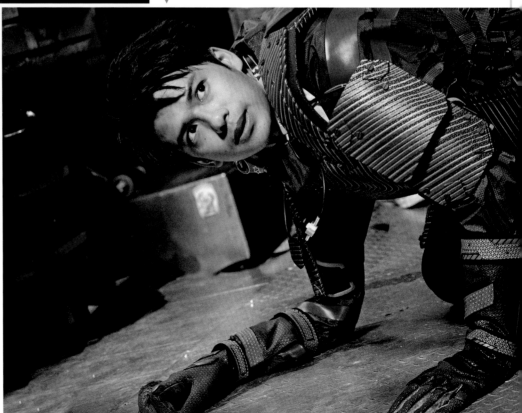

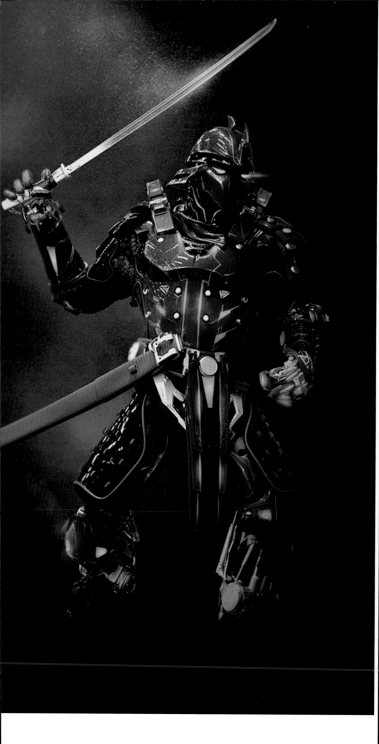

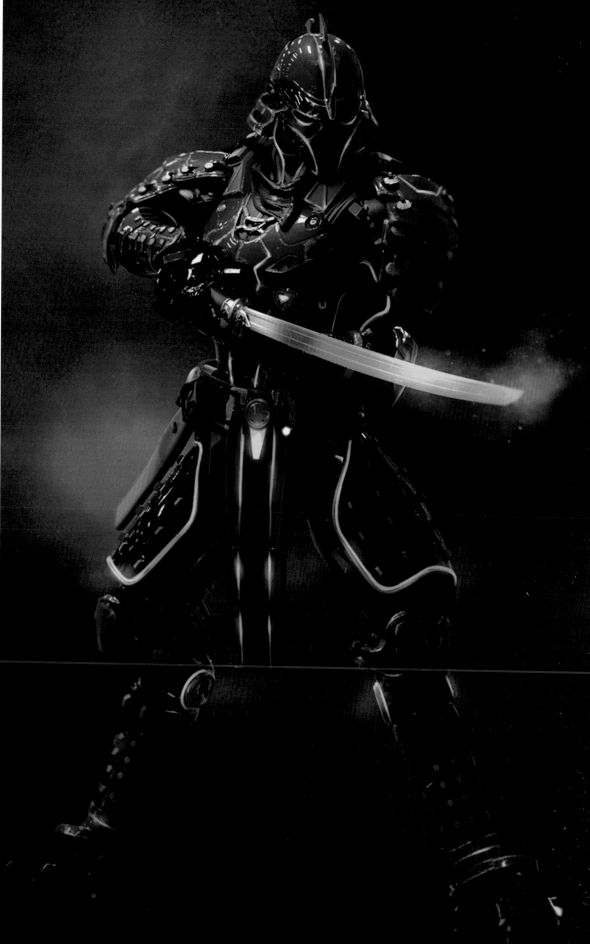

OPPOSITE TOP LEFT Daito inner face concept by Dan Baker.

OPPOSITE CENTER LEFT A final frame shows Daito and Sho in *Ready Player One*.

OPPOSITE BOTTOM RIGHT Win Morisaki plays Toshiro Yoshiaki.

ABOVE AND RIGHT Character design concepts by Aaron Sims Creative show Daito in his full red samurai regalia, complete with glowing katana.

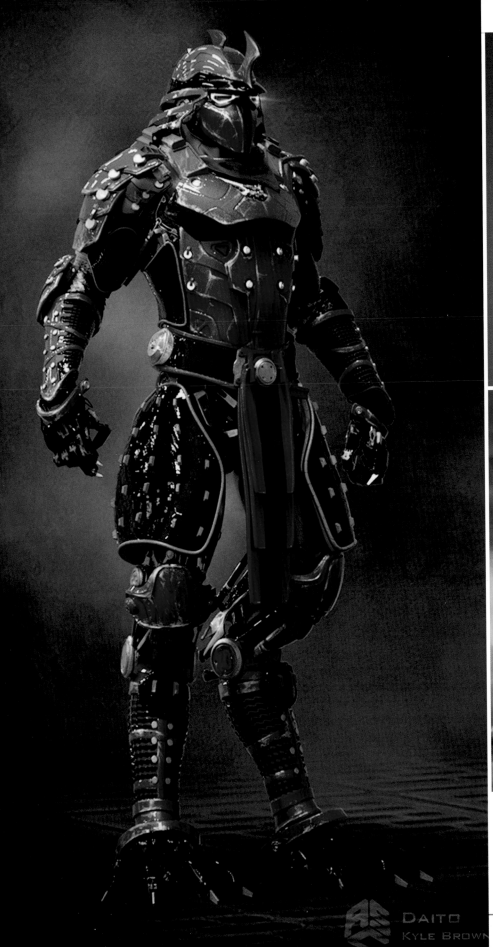

DAITO
KYLE BROWN

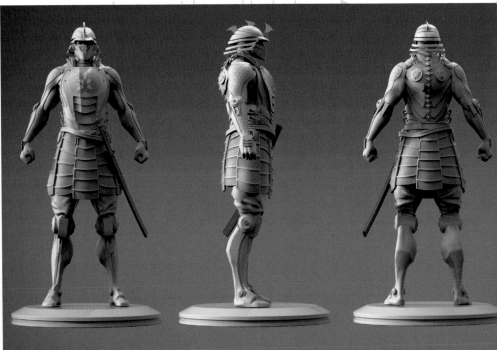

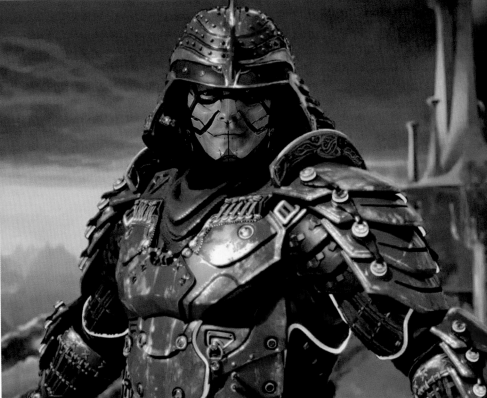

LEFT An early concept for the Daito character by Aaron Sims Creative.

TOP A turntable rendering by Kyle Brown shows the intricate detailing that went into Daito's armor.

ABOVE The final version of the character featured plated armor to accompany the distinctive helmet. Concept by Dan Baker.

OPPOSITE Daito's design was partially inspired by legendary Japanese actor Toshiro Mifune, as seen in this concept by Alex Jaeger.

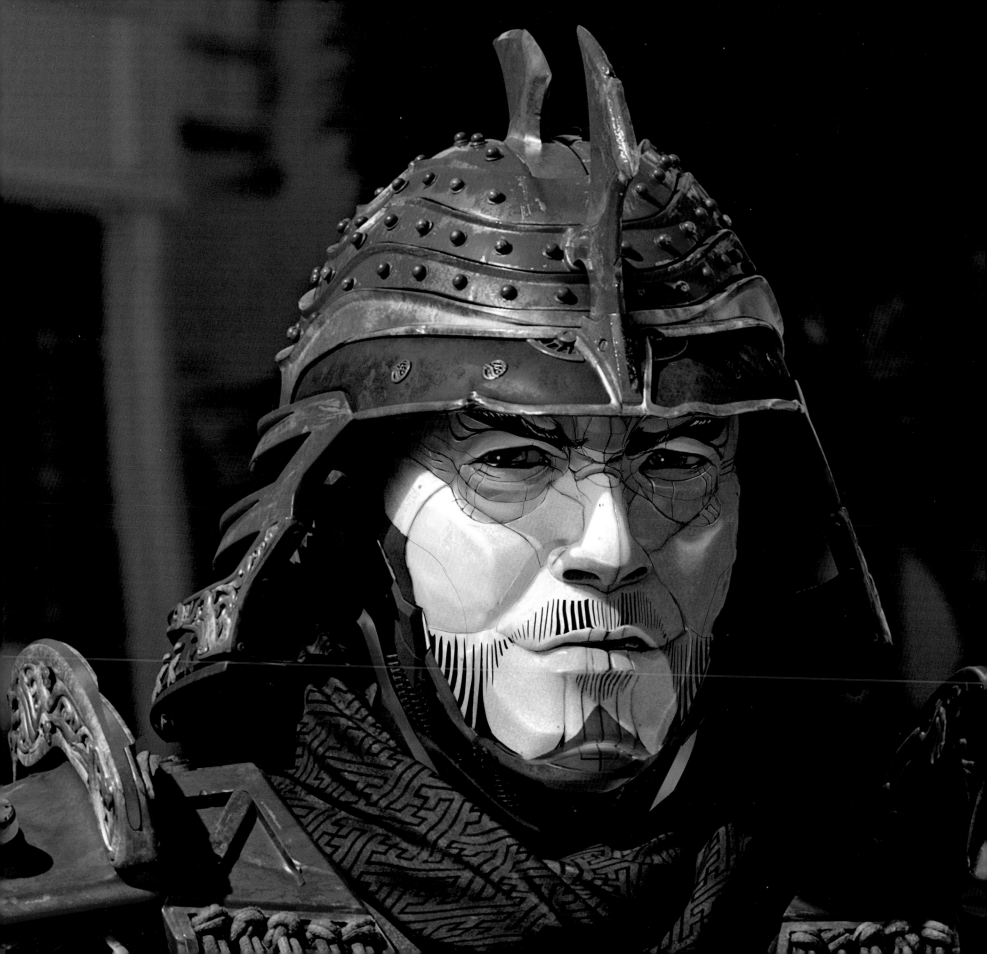

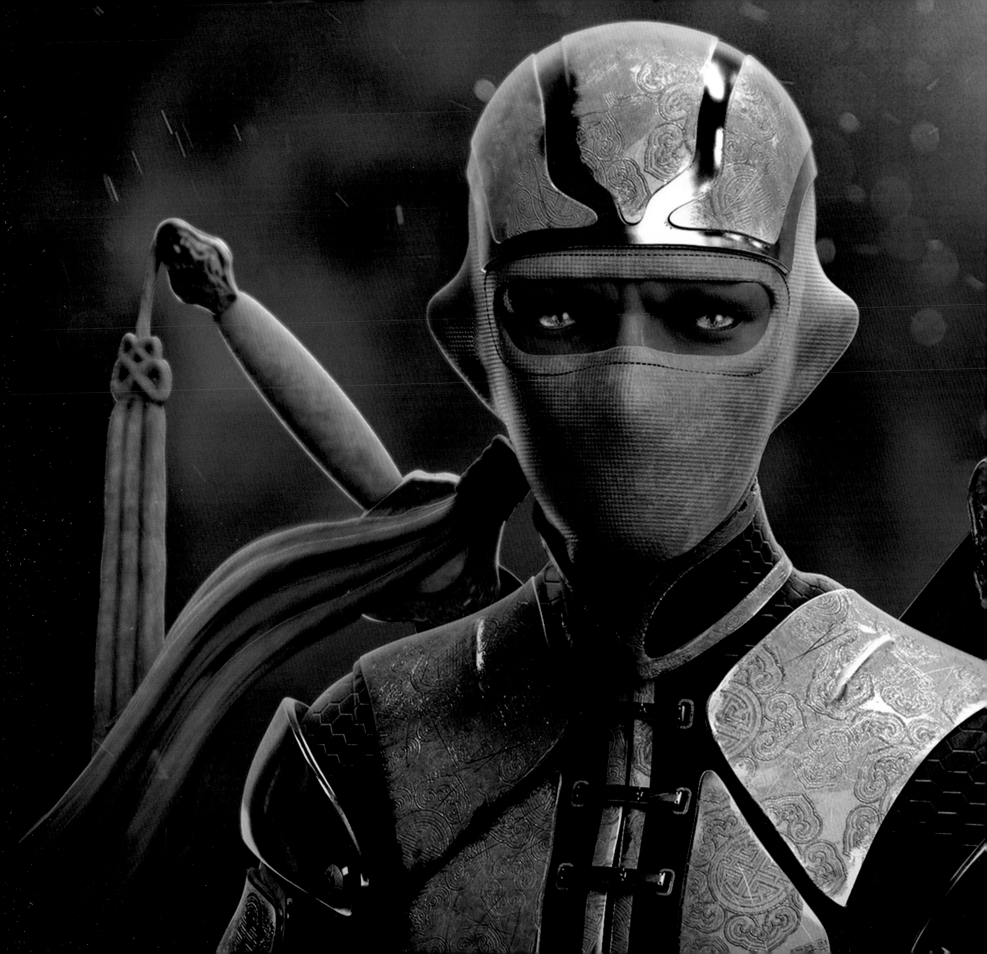

SHO

SHO / AKIHIDE KARATSU

SHOTO IS A LETHAL NINJA who fights side by side with Daito. "For Sho, we were looking at Chinese weaponry and Chinese armor," production designer Stockhausen says. "I liked the idea that he was quiet and stealthy, and so he's very slim and lithe. We were looking at intricate metalwork from shields and weaponry and pulled patterns from that and made a suit of armor for him."

Philip Zhao had never acted professionally when he decided to go after the role of Sho, the youngest member of the High Five (though just *how* young he is remains a closely guarded secret throughout the film). With the help of his father, he filmed an audition in his basement, and ultimately landed the part. Zhao says he had an easy time bonding with Daito actor Win Morisaki—a necessity for the role, given that Daito and Sho are as close as brothers. "I'm like a wannabe ninja in this virtual world," Zhao says. "I look up to Daito and try to copy him and try to act like an adult, because I'm hiding my identity that I'm actually a kid."

Stockhausen notes that in addition to crafting singular designs for each avatar, the creative team took into consideration how the High Five would look as a single unit. "Knowing that they were going to be a group together, it was really important to color-code them to the degree that we were able to," Stockhausen says. "Parzival has a blue [look], Sho has a yellow, Daito has a red. Art3mis has some red, too, but it's a much different red. Aech has a strong kind of gray graphite metal and a hot, hot yellow. There's some overlap. It's not as simple as red, yellow, green, blue, black. But the idea was that when they're standing as a group together they each have their own individuality."

OPPOSITE Sho's striking yellow ninja garb was embossed with intricate designs pulled from real-world metalwork and weaponry. Concept by Aaron Sims Creative.

CENTER Philip Zhao as Akihide Karatsu, aka Sho.

LEFT Sho in a final frame from *Ready Player One*.

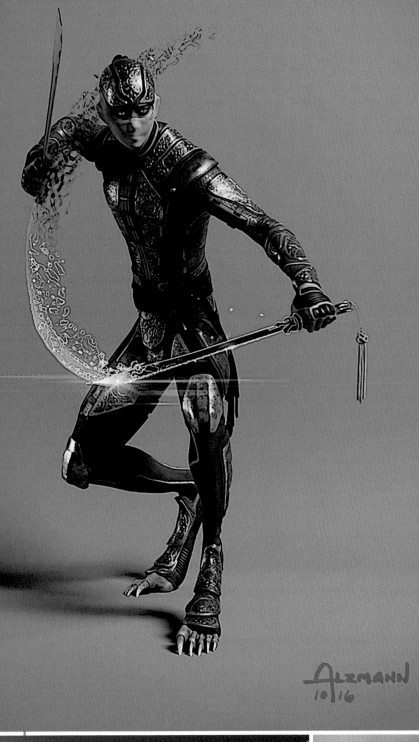

TOP LEFT Sho sword effect concept by Christian Alzmann.

ABOVE Sho shield concept by Christian Alzmann.

LEFT Sho throwing stars and custom crossbow concept by Alex Jaeger.

OPPOSITE Concept art by Alex Jaeger shows the activation of Sho's armor generator.

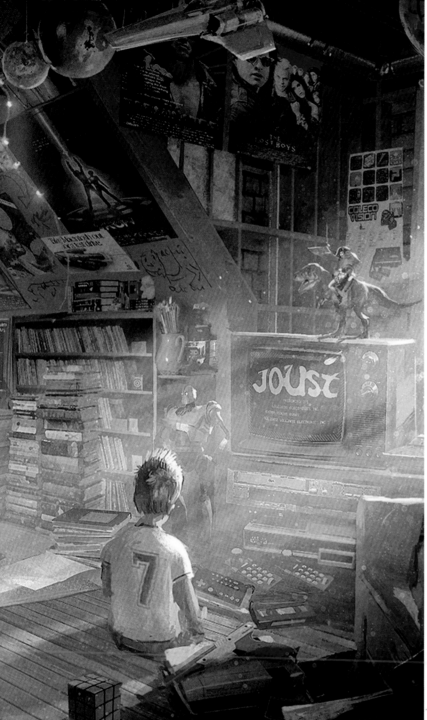

"OVERSIZED BLACK JACKET WITH A T-SHIRT, black jeans, and Adidas sneakers, that's Halliday," says costume designer Kasia Walicka-Maimone of the reclusive Gregarious Games cofounder who authored the OASIS. Although Halliday is a pivotal figure, he is seen primarily in flashbacks, or as his avatar, the wizard Anorak. "It's quite nice to have a role that appears only minimally," actor Mark Rylance says. "You only have a few chances to make an impression, and your character can have a lot of mystery." Rylance reveals that he drew on his own youthful observations of the pioneers of emerging computer technology in the '60s and '70s to help sketch Halliday: "I was a little bit early for the explosion of the computer and the Internet, but I remember seeing the seeds of it and seeing how isolated and shy and intense the early explorers were when I was a kid."

ILM's Grady Cofer, who served as visual effects supervisor on *Ready Player One*, says that as with some of the other avatars, Anorak's design was tweaked to more closely sync up to the performer's features. "What we found is that there are certain things, certain looks that a person has that are so tied to their personality and to their expressions," Cofer says. "For Mark, it was the eyes and the mouth. So, what we'd do is we'd take a look at Anorak, and we'd start bringing a little Mark Rylance into that character. You start with this great design based on these investigations into characters and the decisions that they might make, and it later becomes influenced by the actor or actress."

LEFT In this concept art by Stephen Tappin, Parzival encounters Halliday's avatar, Anorak, inside a re-creation of the reclusive genius's childhood home.

OPPOSITE BOTTOM Posters for the film *War Games* and the band Rush help give the environment the right 1980s touches in this concept art by Stephen Tappin.

ABOVE Gregarious Games logo designed by Neil Floyd.

BOTTOM LEFT Actor Mark Rylance as Halliday.

BELOW AND BOTTOM RIGHT In these final frames from *Ready Player One*, Parzival and Halliday come face-to-face.

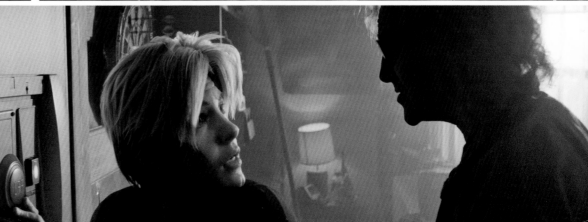

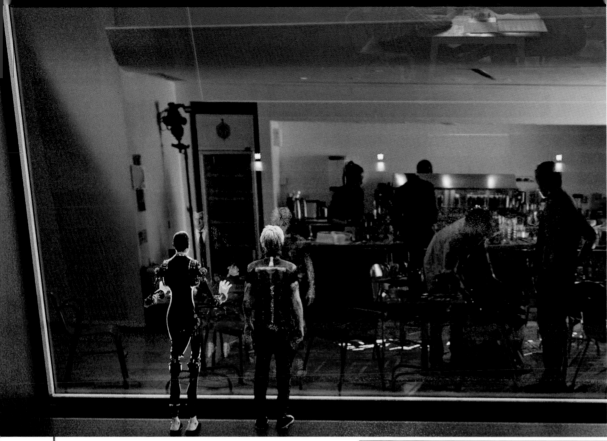

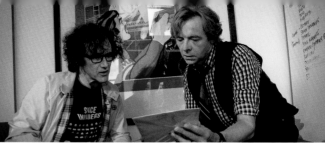

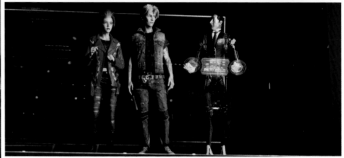

LEFT The Curator gives Parzival a tour of the archive devoted to Halliday's life in this concept by Bianca Draghici.

TOP Mark Rylance, left, as Halliday, and Simon Pegg as Ogden Morrow.

ABOVE A final frame from *Ready Player One* shows Art3mis and Parzival in conversation with the Curator.

BELOW Simon Pegg as Morrow.

OPPOSITE Morrow's avatar, the Curator, was based on famous movie butlers. Concepts by Dan Baker.

THE CURATOR / OGDEN MORROW

HALLIDAY'S FORMER PARTNER and once-close friend, Ogden Morrow—played by Simon Pegg (*Star Trek*, *Shaun of the Dead*)—helped introduce the OASIS to the world as Gregarious Games' more personable frontman. "Jim Halliday was the driving creative force behind the OASIS," Pegg says. "Ogden Morrow helped Halliday bring his idea to the masses and make it a reality. . . . He's kind of a cross between Steve Wozniak and Steve Jobs. He has this special sort of showmanship. He's the face of the OASIS, and he's the one who can actually talk to people and sell it."

Although Morrow, too, is mostly glimpsed in flashback, he plays a pivotal present-day role aiding the High Five, acting primarily through his secret identity as the Curator. The avatar serves as the custodian of Halliday Journals—the founding father's extensive video history archive inside the OASIS—and gifts to Parzival the all-important 1 Up coin that allows him to ultimately best Sorrento. Because the Curator's true identity needed to remain a secret in the story, none of Pegg's features were incorporated into the Curator's design. Instead, says Stockhausen, "The Curator is based on old film butler characters."

"It's interesting at this point in my career that I'm now playing sort of the Obi-Wan Kenobi figures," Pegg says. "I'm not Wade anymore—I don't know if I ever was, to be honest."

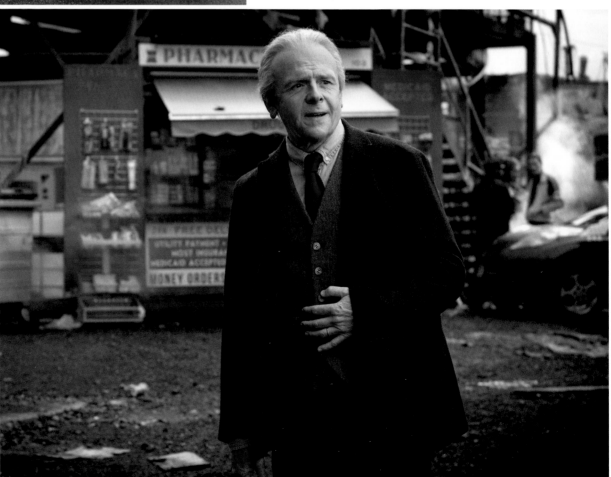

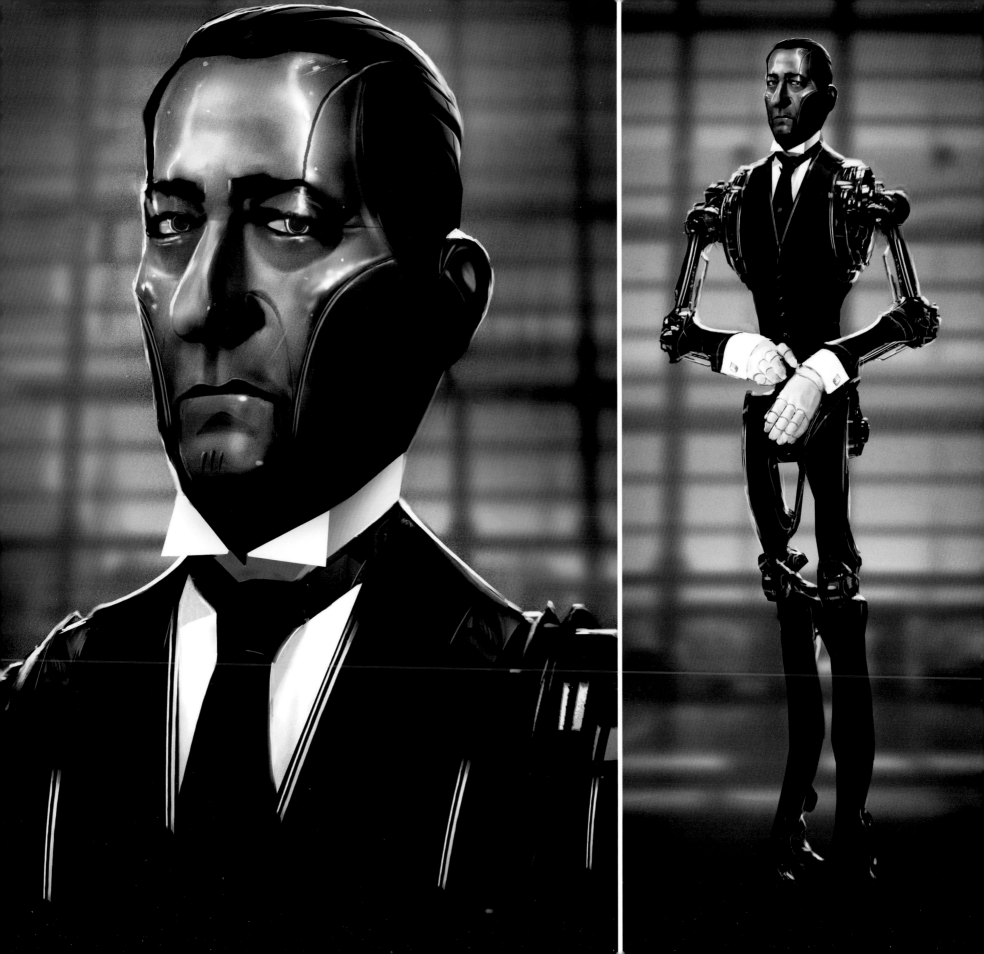

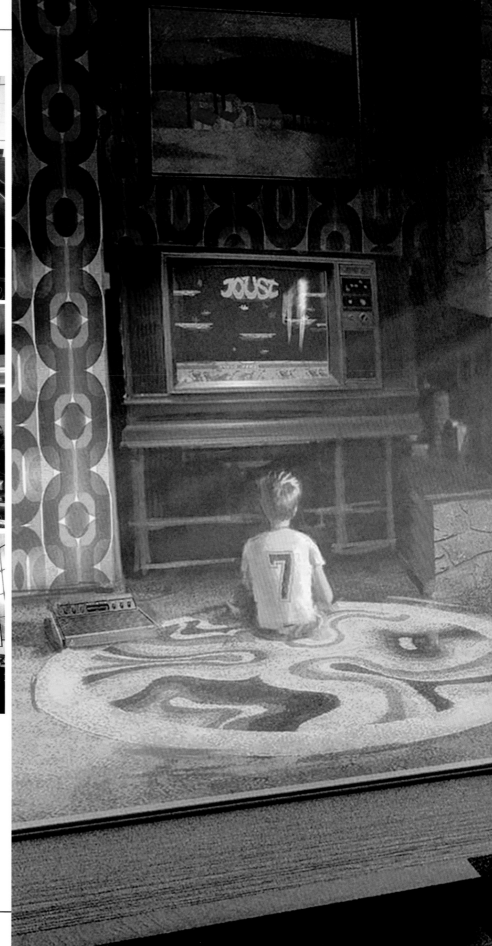

TOP LEFT AND CENTER LEFT Interior concepts of Halliday Journals by Stephen Tappin.

ABOVE An alternate view of Halliday Journals by Ulrich Zeidler.

RIGHT Parzival, Art3mis, and the Curator observe a young Halliday playing *Joust* inside Halliday Journals in this concept by Stephen Tappin.

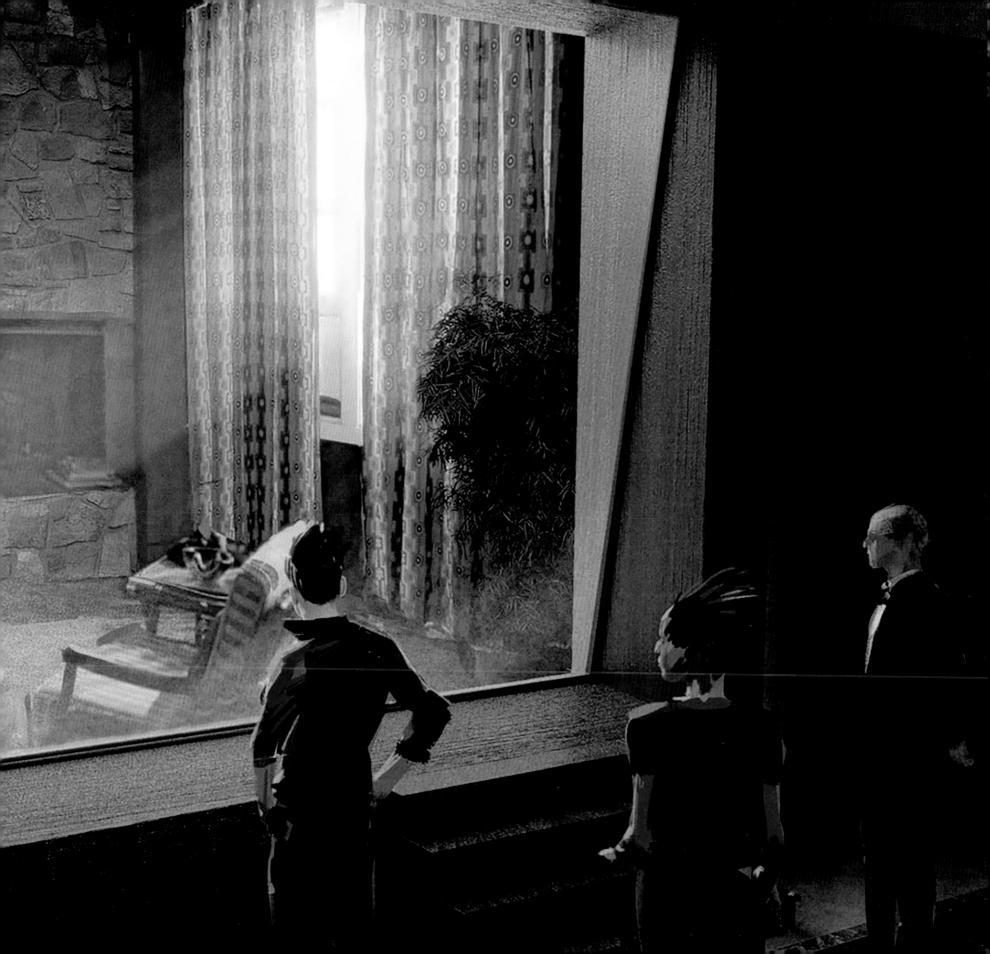

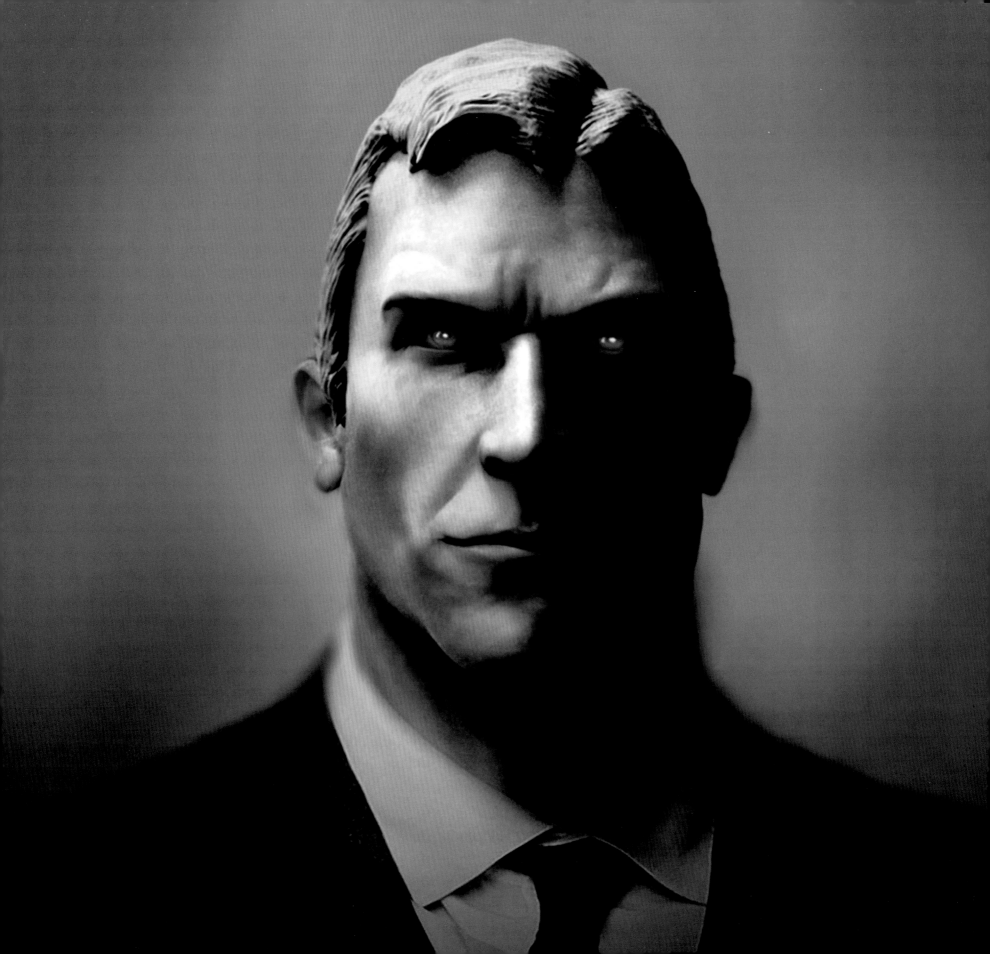

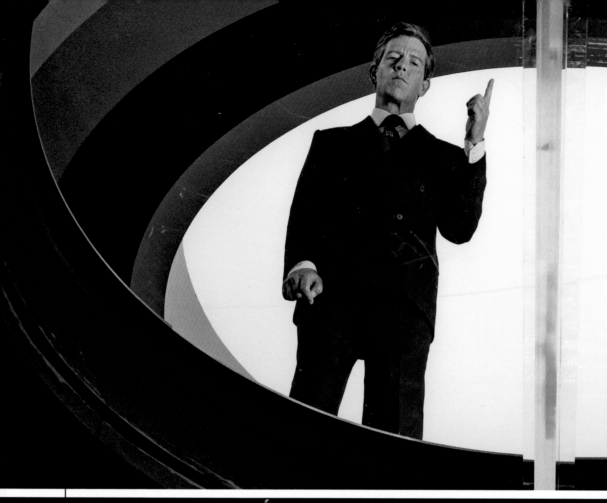

THE RUTHLESS head of Innovative Online Industries does not participate in Halliday's challenge for mere sport—his thirst for the prize-winning egg is motivated almost exclusively by greed. Stockhausen says the character's avatar design was based entirely on actor Ben Mendelsohn's features, thinking that he'd have little interest in disguising his identity in the virtual world. He would want other avatars to recognize him, and feel fear. "Sorrento's avatar has an unmistakable link to Ben Mendelsohn's likeness—he would have just gone for this super-tough version of himself in the OASIS, so we very much started with his face," Stockhausen says.

Sorrento's desire to always give off the impression of power extends to the real world, where he stalks the corridors of IOI in chic business attire, often accompanied by his head of security, F'Nale Zandor (Hannah John-Kamen, *Killjoys*). Says costume designer Walicka-Maimone: "For him, I wanted to fall back on an early-'80s Cerruti suit that is '80s yet extraordinarily classic. There was a touch of vanity in all his corporate looks."

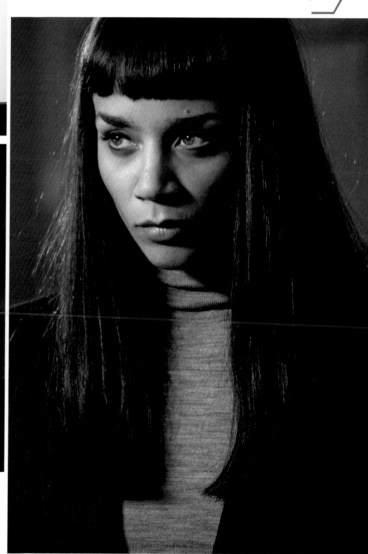

OPPOSITE Sorrento's avatar closely resembles the man himself in this concept by Aaron Sims Creative.

TOP Ben Mendelsohn as Nolan Sorrento inside IOI headquarters.

ABOVE Nolan Sorrento's avatar in a final frame from *Ready Player One*.

RIGHT Hannah John-Kamen as F'Nale Zandor.

I-ROK

I-ROK

INSIDE THE OASIS, Sorrento's right-hand man is a hulking bounty hunter avatar who goes by the moniker i-ROk (T.J. Miller, *Silicon Valley*). "i-ROk, he's pretty over-the-top," says Stockhausen. "He's another one who settled in very, very early. We had this sketch at the beginning of the process of this hooded figure in a long duster trench coat with the skull chest and being able to see right through him. It was a great sketch. Steven loved it, and that became i-ROk. Different elements of him were refined, and T.J.'s personality and face and likeness started to come in—we did different rounds on the face, but the basic idea happened very quickly."

Adds co-screenwriter Zak Penn of the character: "He's clearly some sort of overgrown man-child in the real world, but all we see of him is this enormous, frightening avatar that looks like someone overcompensating."

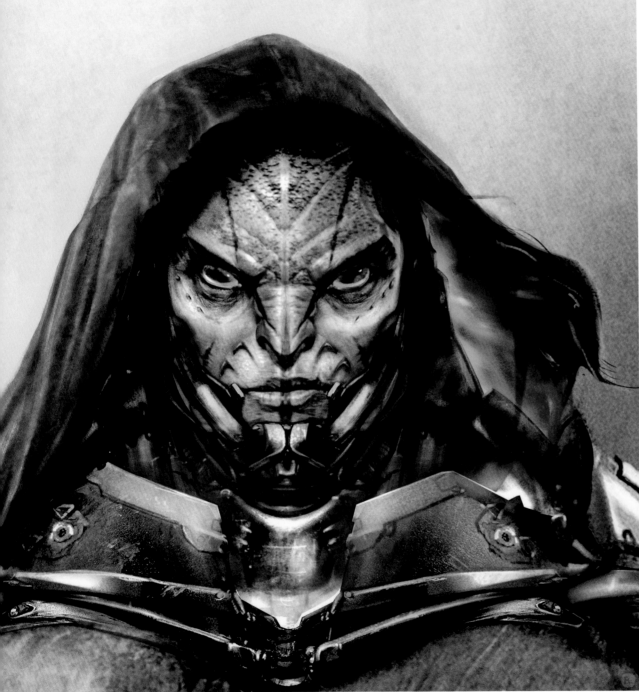

LEFT i-ROk head design by Sam Rowan.

ABOVE Concept for i-ROk's custom detonator by Alex Jaeger.

OPPOSITE i-ROk's iconography is designed to inspire fear, as seen in this concept by Jama Jurabaev.

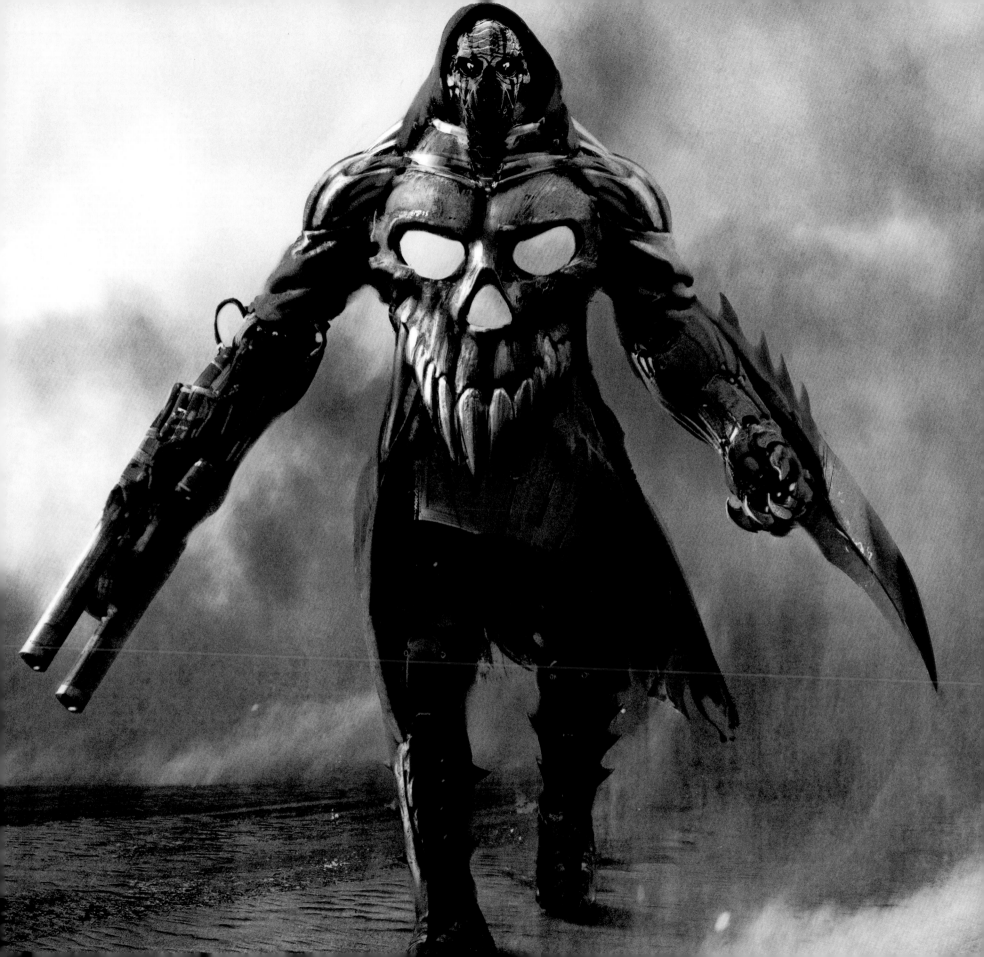

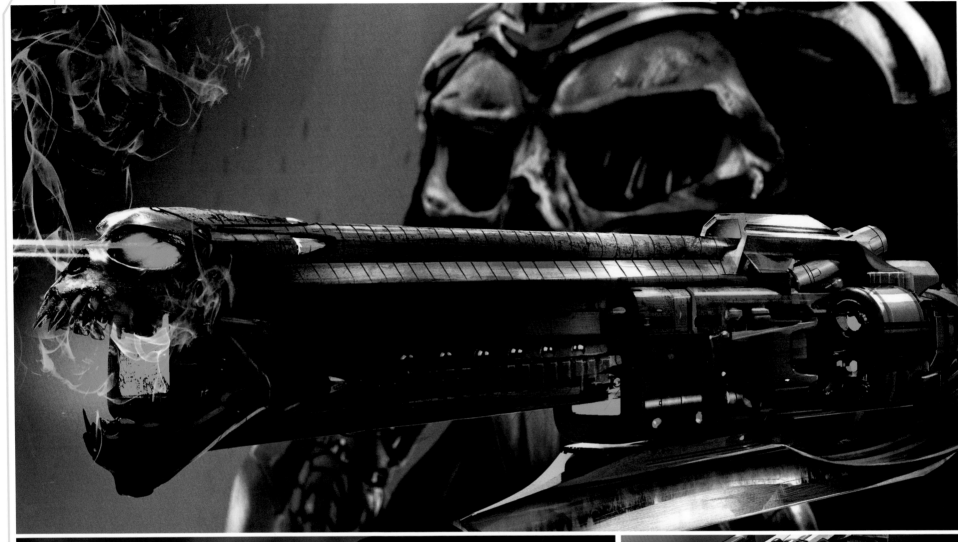

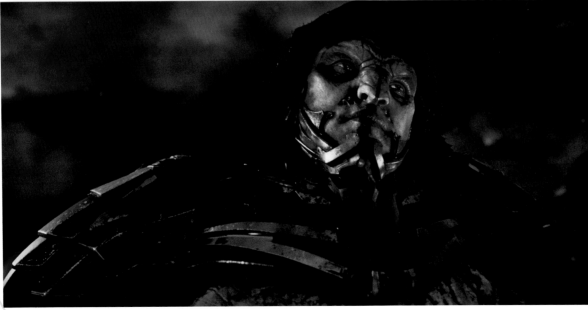

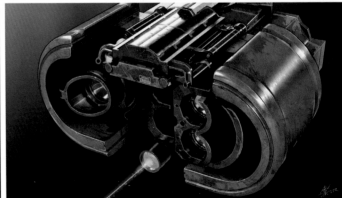

TOP i-R0k gun design by Sam Rowan.

ABOVE i-R0k's binocular/gunsight design by Alex Jaeger.

LEFT i-R0k in a final frame from *Ready Player One*.

OPPOSITE LEFT i-R0k's expanding energy shield concepts by Alex Jaeger.

OPPOSITE RIGHT The skull motif can be seen on the back of i-R0k's overcoat in this rendering by Sam Rowan.

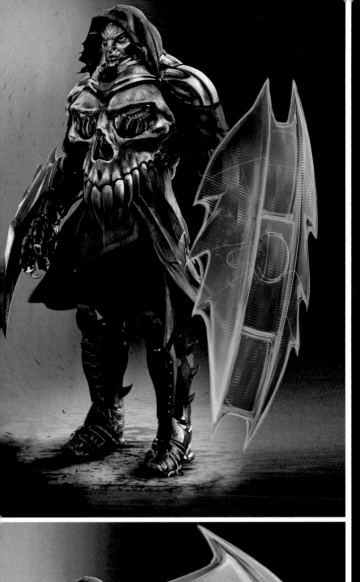
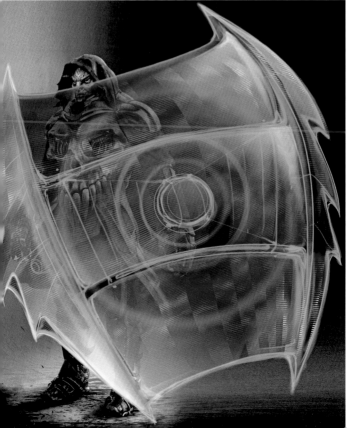
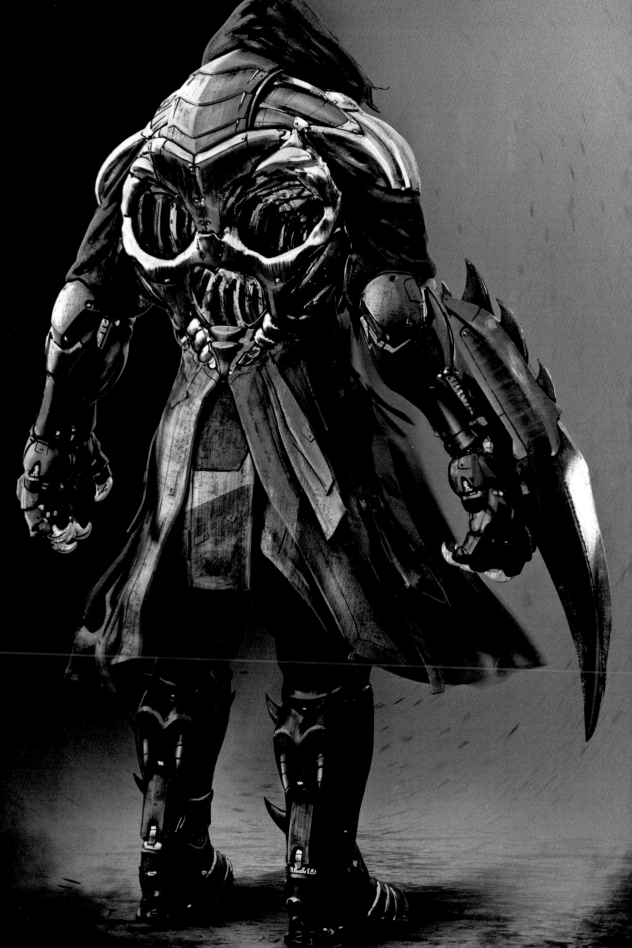

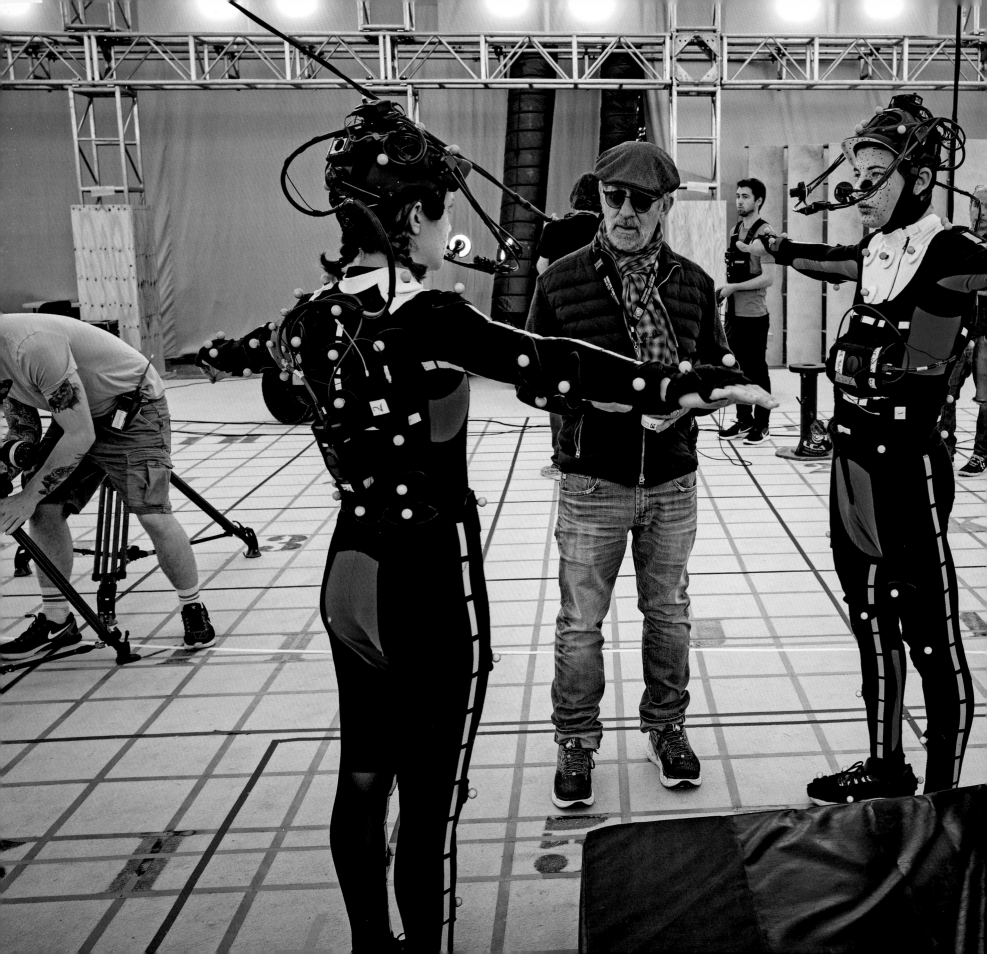

READY PLAYER ONE IS MANY THINGS: a high-stakes adventure, a science fiction thriller, a coming-of-age story, a romance, a love letter to 1980s culture, a sophisticated social commentary, a cautionary tale. But it all begins with Wade Watts leaving his home in the Stacks, the blighted community where he lives with his aunt, and heading for his secret hideout, where he can log in to the OASIS and continue his obsessive search for Halliday's Easter egg—the only object with enough power to change the circumstances of his ordinary life.

"He's living in a very unhappy place," says director Steven Spielberg. "His mother has died. His father is missing. And he's kind of alone in this world. He uses the OASIS, this amazing world, to escape from what he suffers in the real world."

Like its protagonist, *Ready Player One* occupies two opposing worlds, with roughly 80 percent of the story taking place in the virtual realm and the remainder in the stark reality of 2045 Ohio. Of course, on-screen, the real world and the OASIS needed to work in concert to create one brilliant, cohesive future. Pinning down the right way to tell that bifurcated narrative was the central challenge for the production.

"It very literally is making two movies at the same time," says production designer Adam Stockhausen. "We have a workflow and a process to making the real-world portion of this story that is very much a traditional film-making working process—when you design things, how you design them, how you get them executed and built, and how

you get them ready. Then you have this completely different process of how to make a digital film. And it has an entirely different set of needs and deadlines and way of working to fulfill the needs to execute all the digital designs."

The scenes inside the OASIS were shot first using cutting-edge performance-capture technology augmented by state-of-the-art virtual reality techniques. For the first six weeks of production, director Spielberg and the stars of the film gathered on a motion-capture stage, known as the "volume," where the actors would perform every scene wearing skintight suits covered with round markers that resemble ping-pong balls. The data collected by the markers was fed into computers for use by the visual effects team to create the most lifelike renderings possible of all the avatars.

Markers also were applied to the actors' faces to capture their expressions and facial movements, and the stars wore helmets fitted with four tiny cameras to capture the most minute detail of their performances. In all, between 100 and 150 cameras were placed at points all around the volume to capture the action in three dimensions.

"We were in a space that was a big white room with white carpeting with actors in spandex suits with little tracking markers," says producer Donald De Line. "And they had to emote as if everything was real. That in and of itself is a strange and very complicated way to make a film."

LEFT **Steven Spielberg (*center*) inside the volume with Olivia Cooke (*left*) and Tye Sheridan.**

TOP **Producer Dan Farah (*left*) with Ernest Cline.**

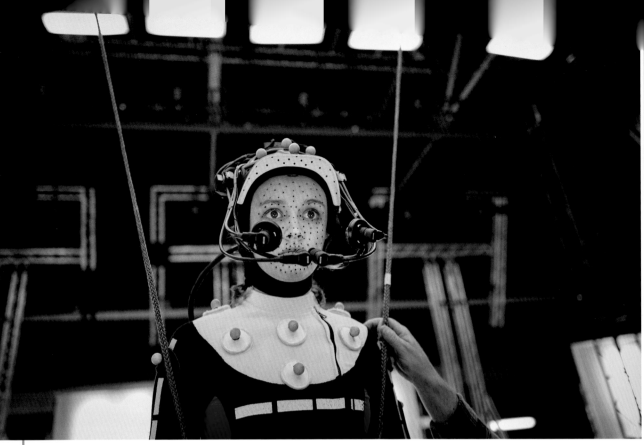

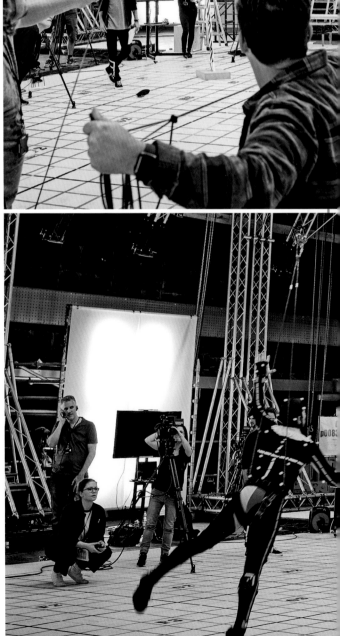

Olivia Cooke confirms that the process took some getting used to. "The first couple of weeks I was underwater a little bit because it was getting that balance of the subtlety and the kind of melodrama of it," she says. "You do have to be a bit broader to kind of transcend through your avatar—for your facial expressions and your movements to be expressed in the way that you want. You can't be as subtle as live action."

To physically represent any items the avatars might have been holding or interacting with, special gray mo-cap props were created. "It's just a proxy to represent the size, shape, weight of the object that the character's going to be holding," Stockhausen says. "It's a fairly straightforward process of making a gray thing with tracking dots all over it so that the computers can track it."

"It can be a fairly trying environment to work in because it's all monochrome," adds David Shirk, animation supervisor for ILM. "It's all white and gray, and it's very flatly illuminated. The illumination itself is actually fairly soothing, but it is a whole day under this very flat light. It can be a little difficult when you're doing that for weeks on end. Sometimes you just long for a visual break."

To direct the actors as they moved through the virtual landscapes, Spielberg himself wore VR (virtual reality) goggles that would allow him to see rough animation of the avatars in the digital environments. The final scenes

and effects were painstakingly completed during the film's extensive eighteen-month postproduction period. But there, on the set, with the OASIS before his eyes, Spielberg could select camera angles and compose shots just as he would on a set or a practical location.

"It was amazing to see," says ILM's Grady Cofer. "Steven is actually comfortable wearing a VR headset for quite a bit of time and reviewing a virtual set. He would put on the VR headset and walk around this virtual location, and immediately, because he's a filmmaker and a great storyteller, he'd start thinking about his camera angles. He would start finding angles and, based on those angles, he would make decisions about how that set was looking from that camera, and the artists were able to accommodate [changes] in real time."

"This is filmmaking that's really pushing the boundaries," adds producer Kristie Macosko Krieger. "With the goggles on, he could actually step in the sets and have a 360 view of the world."

TOP LEFT Olivia Cooke prepares to film a scene on the motion-capture stage.

TOP RIGHT Shooting an aerial scene in the volume.

OPPOSITE TOP RIGHT Steven Spielberg with Cooke.

RIGHT The crew captures a key scene within the volume.

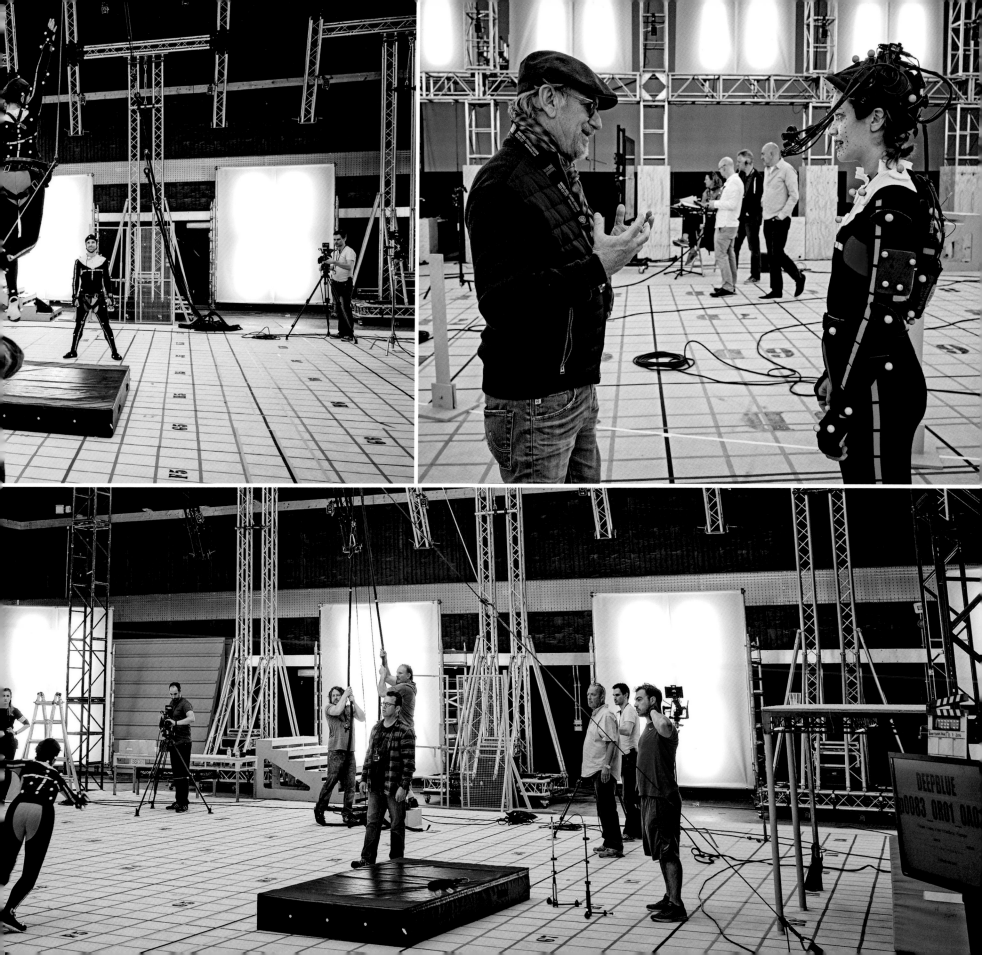

JUST AS ANYONE can be anything in the vast virtual reality of the OASIS, an avatar can visit almost any locale imaginable. "There's a few worlds we fly past in the intro," says *Ready Player One* concept design supervisor and ILM art director Alex Jaeger. "We see a *Minecraft* world. We get into more broad concepts like vacation world, sports planet, gambling world, things like that where it's not so much one particular game or concept."

Although some of the locations are more outlandish than others, nothing is mundane inside James Halliday's expansive universe. "You go to this world to play sports, and there's anything from golf to totally made-up weird things like unicorn polo," Jaeger says. "Vacation world is made up of planets [where] you can surf a 50-foot wave or you can ski down the pyramids. We put a couple of things in there that are like, oh, that's a vacation thing, but with an extra twist to it. Like climbing Mount Everest with Batman."

Production designer Adam Stockhausen sought to make the OASIS "*more* than the real and available world in just about every way you could imagine—more exciting, more colorful, more possibilities, more fun, more saturated . . . just *more*," he says. "This, I think, really comes quite literally from the name. It's an oasis from the real existence that people are living in reality. So, there are very different spaces that we go to that seemingly have no relationship to one another, but they are all the different facets of this escape from real life."

For every avatar, the entry point to the OASIS is a world called Incipio. "It's sort of the spawn point where everybody starts from," Jaeger explains. "We had to design Incipio to be around a central hub—it's almost like a tent where everybody zaps down into it and then heads out to all these different radial arms from the center. Along these arms are all these portals that lead you to all the different worlds in the OASIS. People start there, and you can travel pretty much anywhere using the portals."

One highlight on Incipio? Avatar Outfitters, a massive shopping area where avatars can choose from a myriad of items: armor, weapons, spells, costumes. Some items can be bought outright, while others (like rare artifacts) are auctioned.

The breezy aesthetic for Incipio came directly from Steven Spielberg. "Steven really likes the way sails look when they're blowing in the wind," Jaeger says. "Together with Adam, we came up with this idea of this world that's made of sails. It also made for a nice lighting environment—you have this diffuse light coming through all these levels of sails, which made for a nice clean background to put all these portals and wild characters walking around. [As a viewer,] you concentrate on the foreground and won't be distracted by some busy background with a million things flying around. You're forced to focus and look down at the Ninja Turtles walking next to Hello Kitty."

RIGHT **OASIS space concept by Alex Jaeger.**

BELOW **Ludus planet concept by Luis Carrasco.**

BOTTOM CENTER AND OPPOSITE BOTTOM RIGHT **Gunters congregate in the avenues of Incipio in these concept pieces by Stephen Tappin.**

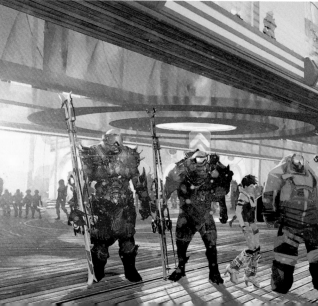

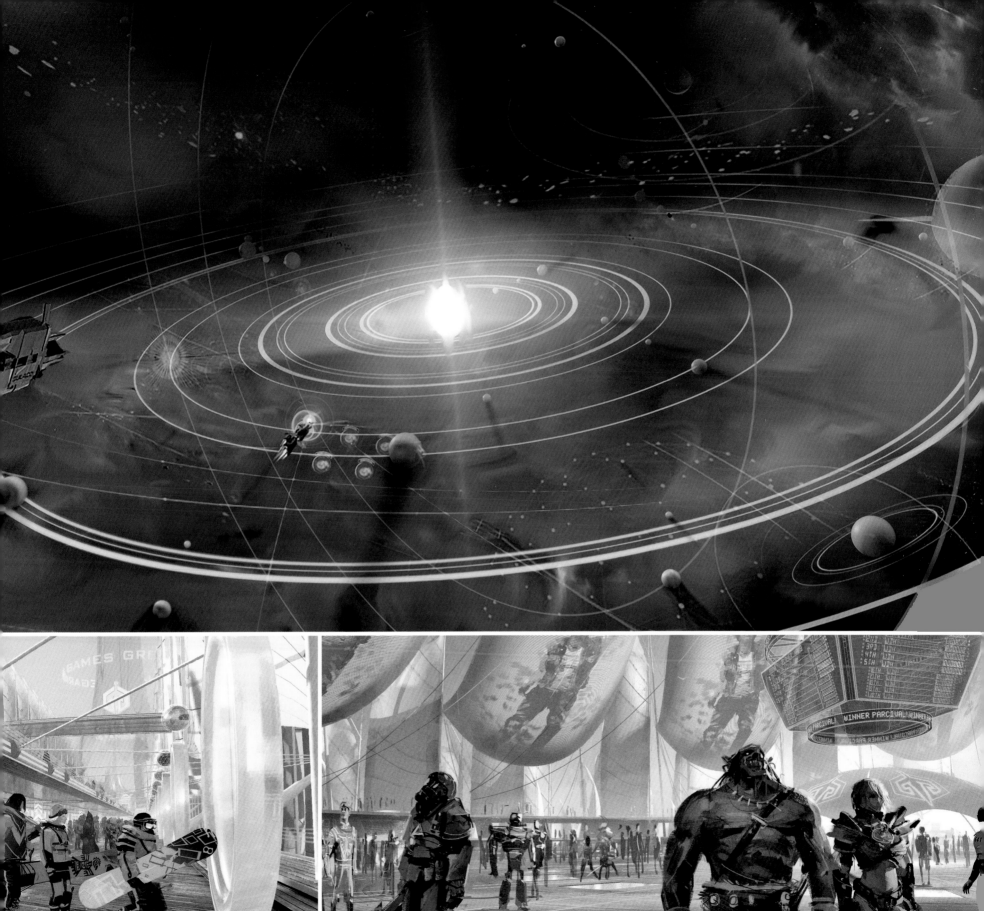

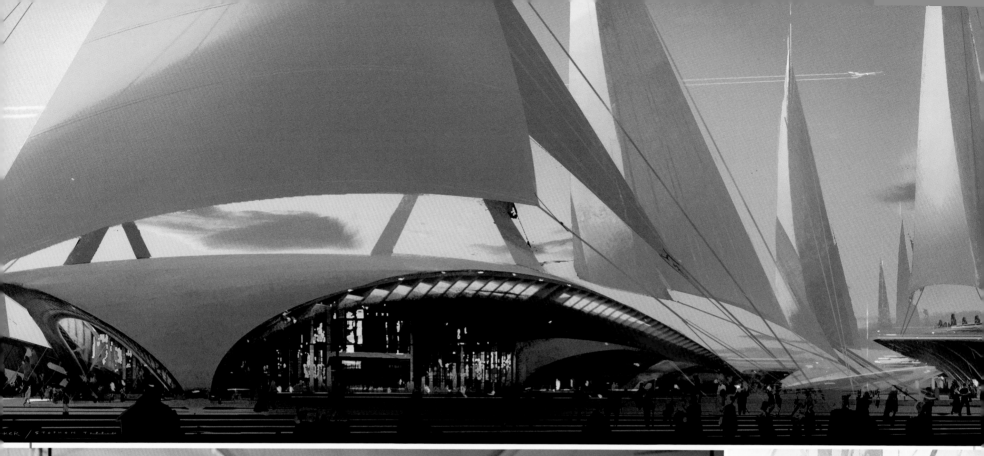

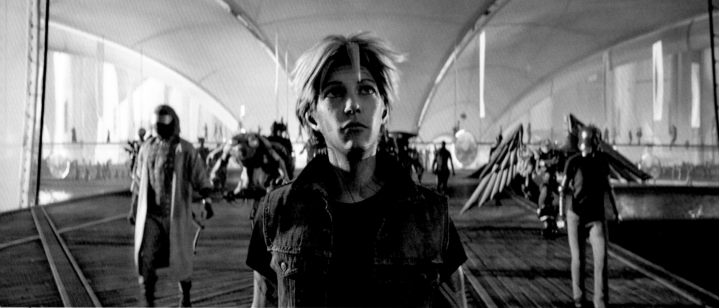

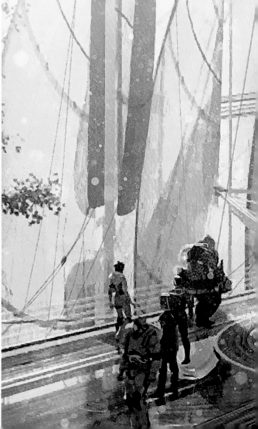

TOP Exterior of the Halliday archive on Incipio. Concept by Stephen Tappin.

ABOVE A final frame shows Parzival walking through the avenues of Incipio in *Ready Player One*.

OPPOSITE TOP Concept art by Dan Baker shows a spawn point on Incipio complete with an array of gunters eager to embark on their quests.

RIGHT A concept by Stephen Tappin shows avatars making their way through Incipio's streets.

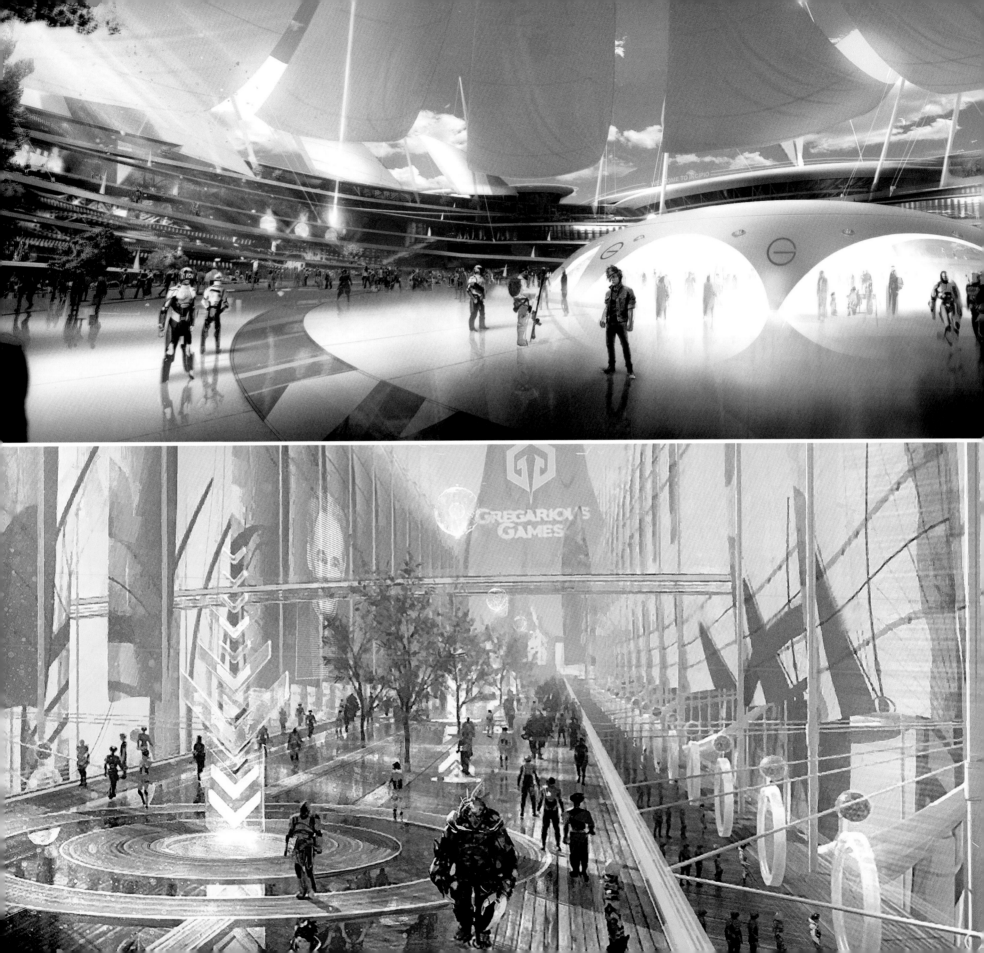

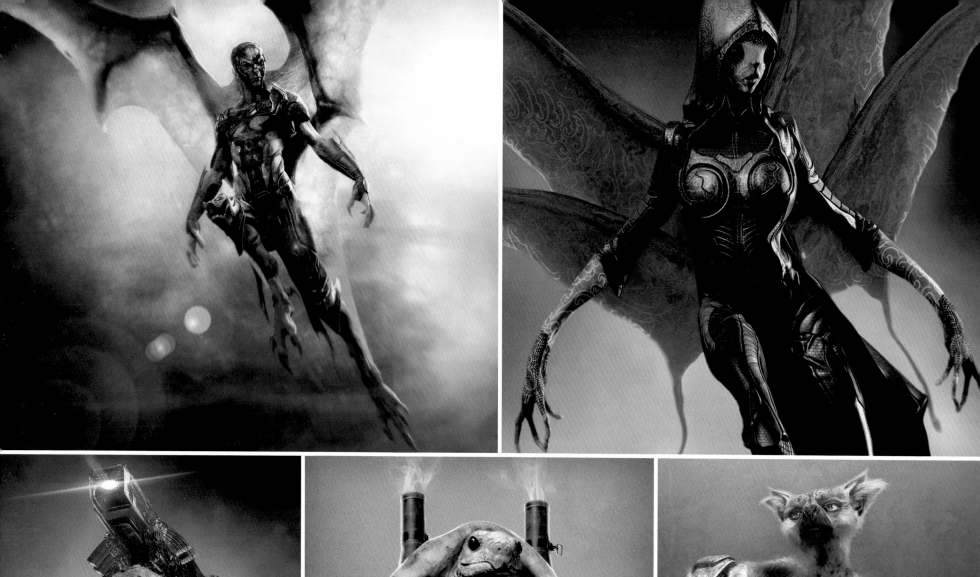
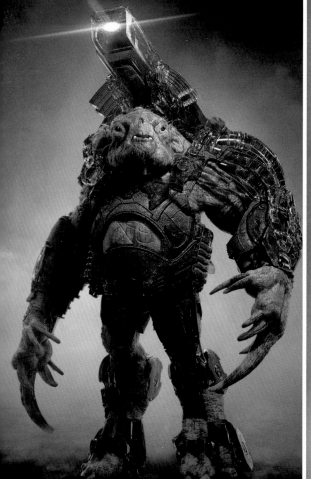

THESE PAGES A wide array of avatar designs created by Aaron Sims Creative.

PAGES 60-61 Avatar Outfitters concept by Stephen Tappin.

MUTHA LOAD
D ASS GUNS

KILL
STREAK

POWAH
GEMS

DOOM
GRENADE

FRAK

AMMUNITION
ASSORTED

SINGLE /MULTI USE

DOOM
GRENADE

FRAK

LIGHTNING BOLTS
EVER READY CHARGED

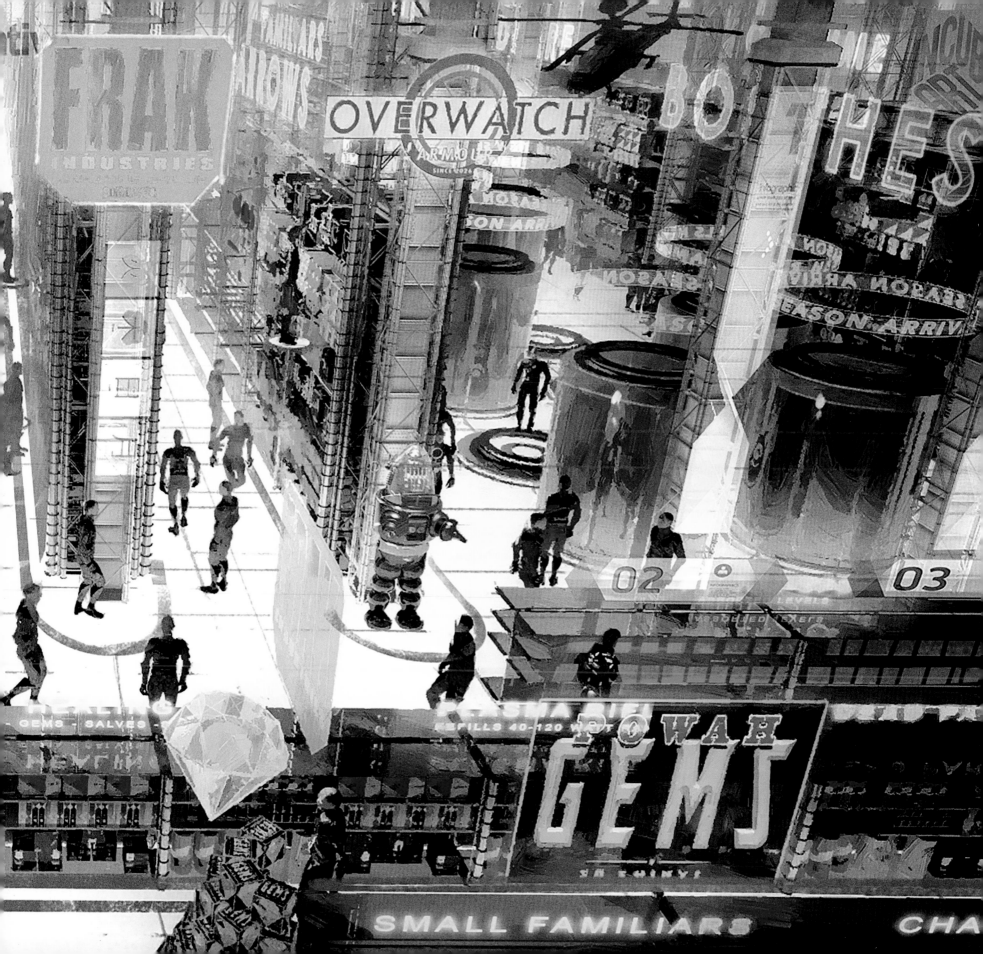

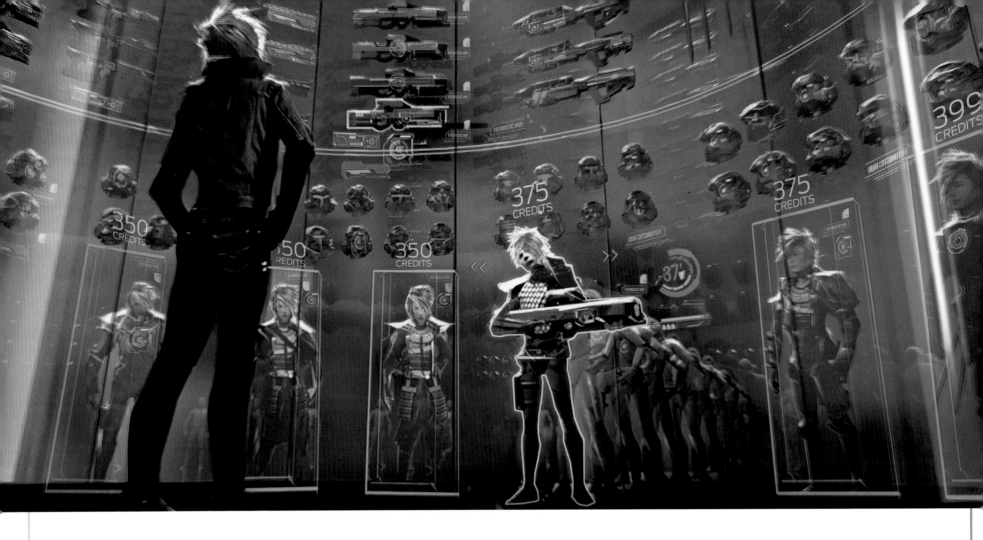

TOP Avatar Outfitters personal shopping booth concept by Dan Baker.

LEFT Avatar Outfitters auction podium sketch by Stephen Tappin.

OPPOSITE Avatar Outfitters concepts by Stephen Tappin.

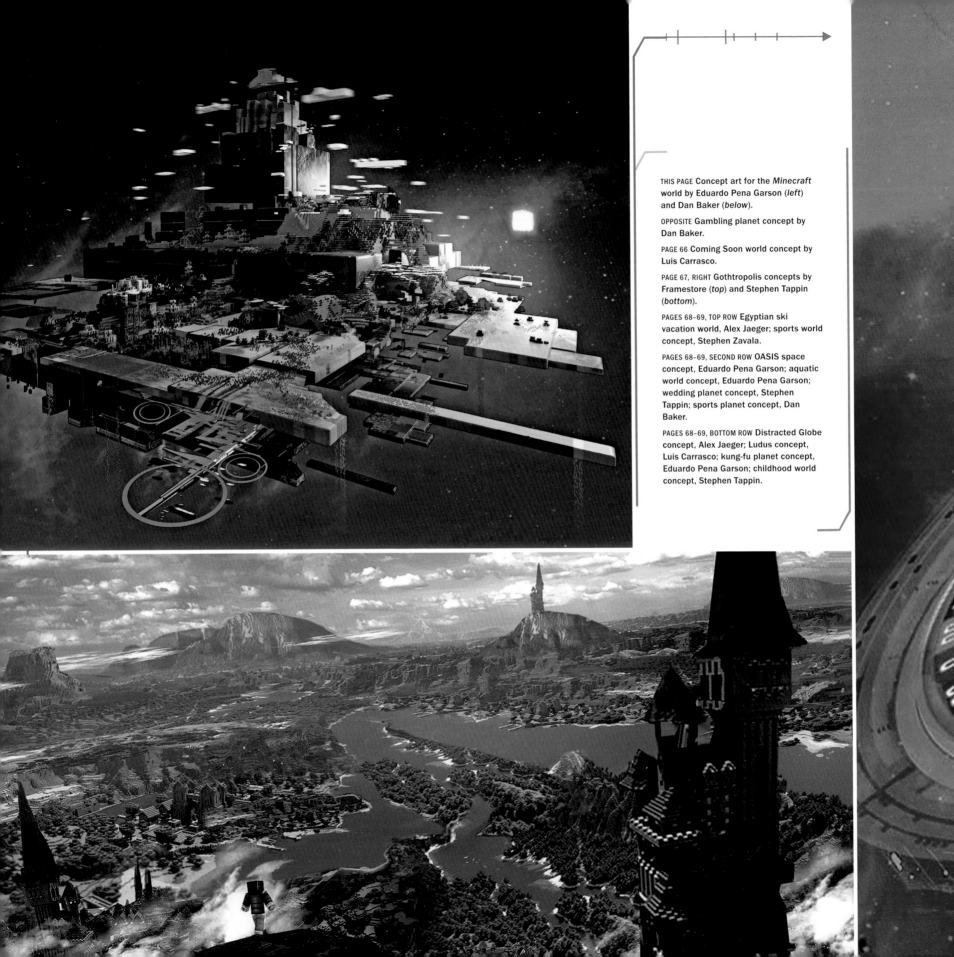

THIS PAGE Concept art for the *Minecraft* world by Eduardo Pena Garson (*left*) and Dan Baker (*below*).

OPPOSITE Gambling planet concept by Dan Baker.

PAGE 66 Coming Soon world concept by Luis Carrasco.

PAGE 67, RIGHT Gothtropolis concepts by Framestore (*top*) and Stephen Tappin (*bottom*).

PAGES 68–69, TOP ROW Egyptian ski vacation world, Alex Jaeger; sports world concept, Stephen Zavala.

PAGES 68–69, SECOND ROW OASIS space concept, Eduardo Pena Garson; aquatic world concept, Eduardo Pena Garson; wedding planet concept, Stephen Tappin; sports planet concept, Dan Baker.

PAGES 68–69, BOTTOM ROW Distracted Globe concept, Alex Jaeger; Ludus concept, Luis Carrasco; kung-fu planet concept, Eduardo Pena Garson; childhood world concept, Stephen Tappin.

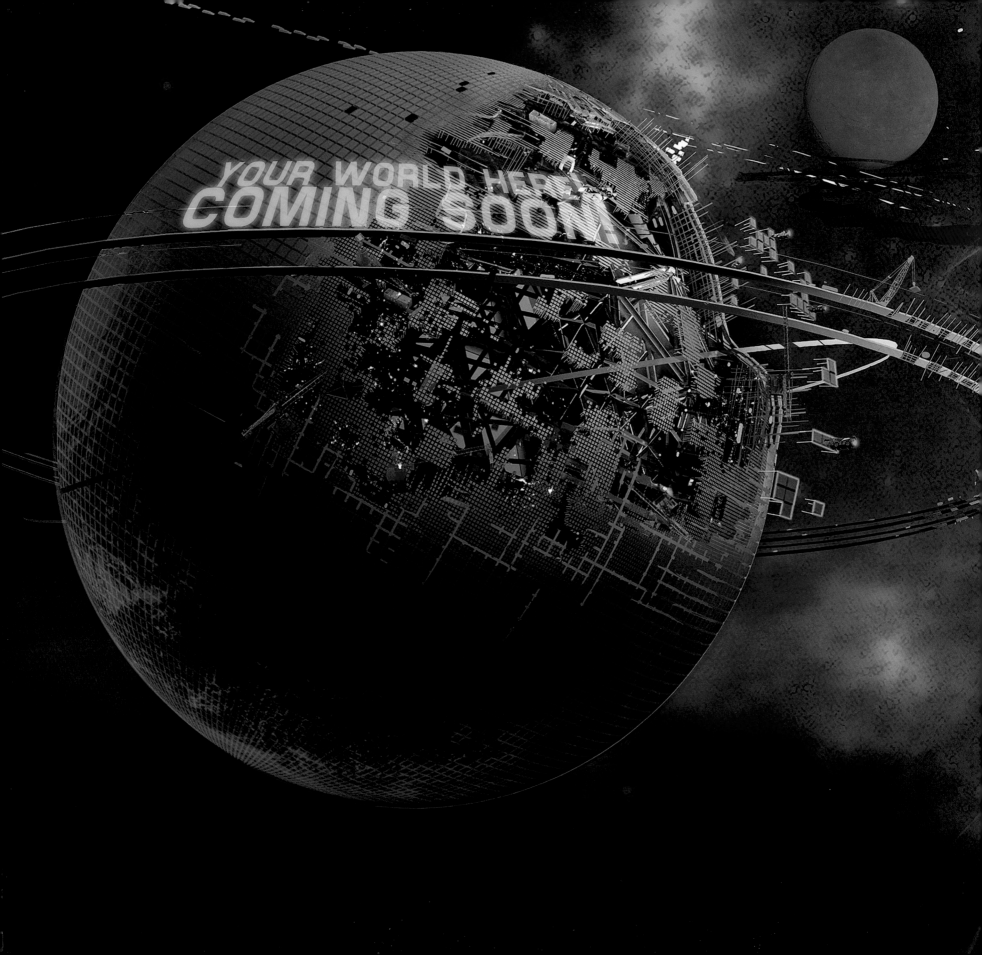

OFF TO THE RACES

THE FIRST OF HALLIDAY'S CHALLENGES inside the film version of the OASIS takes players through an eye-popping race that traverses the streets of a gleefully heightened version of New York City. The race is a daily ritual for the High Five and plenty of other gunters: The winner will receive the elusive Copper Key, the first of the three coveted artifacts that will unlock Halliday's fortune. Trouble is, the contestants have been trying to win for years, but no one has ever crossed the finish line. This is maybe not too surprising given that the streets constantly shift and erupt and racers must evade dangerous blows from adversaries like King Kong—who lurks behind buildings, waiting for the perfect moment to strike.

The sequence is one of many stunning set pieces invented for Spielberg's film that are designed to surprise fans of the novel and thrill newcomers to the world of Cline's story. "Right off the bat, I felt we need to make these challenges physical and visceral," says co-screenwriter Zak Penn.

That meant creating intense new contests that were not only in keeping with the spirit of the book but also inherently cinematic. Set in a radically reimagined futuristic metropolis, the race gave the filmmakers the chance to show the story's epic scale (and 1980s influence) at work—something that would have been slightly more difficult had they retained the book's first challenge, which sees Parzival complete a *Dungeons & Dragons* campaign before facing off against a "demilich" in a tournament based on the video game *Joust*.

"The entire thing is sort of a gigantic pinball machine version of New York City," says production designer Adam Stockhausen. "It's as if you combined New York City with the way the city looked in all the '80s films like *Ghostbusters*, plus *Pole Position* or any racing game. It has elements that are very much New York, and then it has these textures and looks from those '80s films layered upon it. We have the Manhattan Bridge connecting to Liberty Island and spinning on a corkscrew like a carnival ride. The streets are opening up and moving."

Adds ILM's Alex Jaeger, "The world itself is trying to kill you. We'd have these big brainstorm sessions where everybody came up with ideas: What if these things shoot up out of the ground? Or suddenly the bridge peels up and does a loop-the-loop or throws people into buildings? Or the floor drops out from under them?"

The High Five are front and center in the race: Aech piloting a behemoth monster truck, Art3mis astride the red motorcycle from anime classic *Akira*, and Parzival in perhaps the most immediately recognizable vehicle of all—the DeLorean from *Back to the Future*, a film that Spielberg produced. Although Cline's novel includes numerous nods to Spielberg's work, the director largely struck them from the script. But, Penn recalls, "He said right up front . . . we've got to have the DeLorean."

Fans will instantly recognize this iconic automobile, but Marty McFly might notice some key changes to the car that Wade drives—for starters, the license plate reads PARZIVAL instead of OUTATIME. "It's the *Back to the Future* DeLorean, but it's not 100 percent the *Back to the Future* DeLorean," says Jaeger. "It's Parzival's DeLorean, so it's been beat up and he doesn't have the money to fix it up. So, the first time we see it, it looks very dilapidated and headlights are missing. Parts are hanging off of it. It's got bullet holes all through it. He's done a few little modifications, too. On the grill, instead of the 'DMC DeLorean Motor Company,' it's got the light bar from KITT from *Knight Rider*. He's sort of mixing his pop culture in there."

Cline owns a *Back to the Future* model DeLorean, and he invited Parzival actor Tye Sheridan to his home in Austin to take it out for a test drive, an experience that would prove useful once the actor was on the motion-capture stage pretending to pilot the car. "If I hadn't been in the DeLorean before, I wouldn't have known that you can't see out of the rearview mirror because there's a blind spot," Sheridan says. "And it's got this interesting steering wheel that's not a wheel at all. It's just one bar with two handle grips. It was nice for me to get an understanding of what it feels like to actually be in the DeLorean."

Within the volume, Sheridan piloted a wire-frame version of the DeLorean made from steel rods. "They would just have the frame of the door and seats and steering wheel there, so there was enough there for the actors to act against," says Jaeger. "Because they're wearing the motion-capture suits and we didn't want to block the motion sensors, all the props had to be very airy and open. Anything bigger than a table had to have as many holes in it as possible so it wasn't blocking the signals."

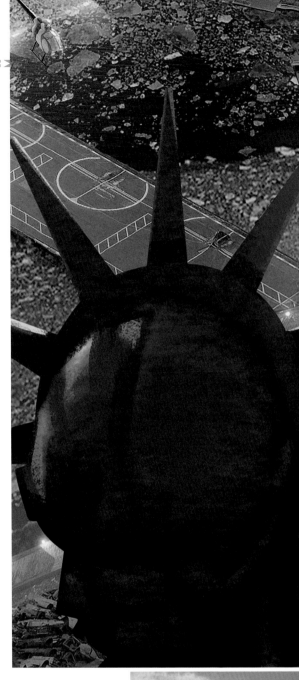

CENTER The coveted Copper Key. Concept by Dominic Lavery.

ABOVE The Statue of Liberty overlooks the racers lined up for the first challenge in this concept image by Stephen Tappin.

RIGHT (*from left*) Early race concept by Emmanuel Shiu; final frame of IOI racers in *Ready Player One*; Chinatown race concept by Emmanuel Shiu.

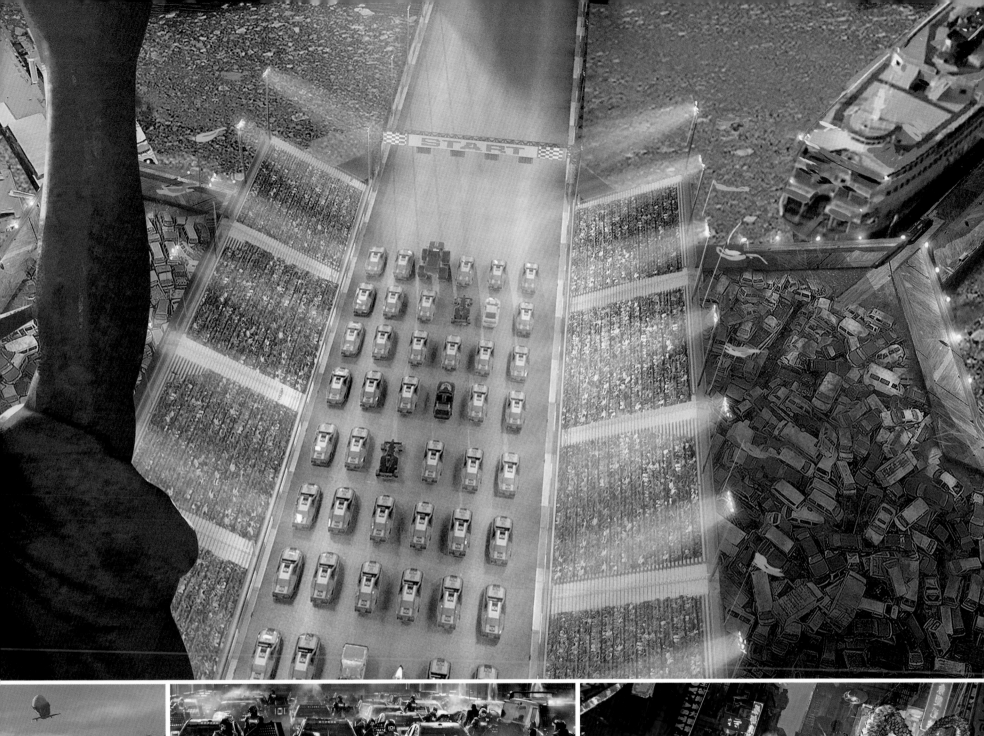

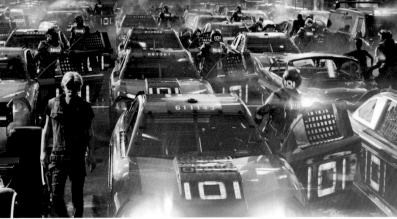
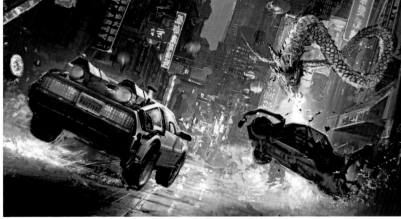

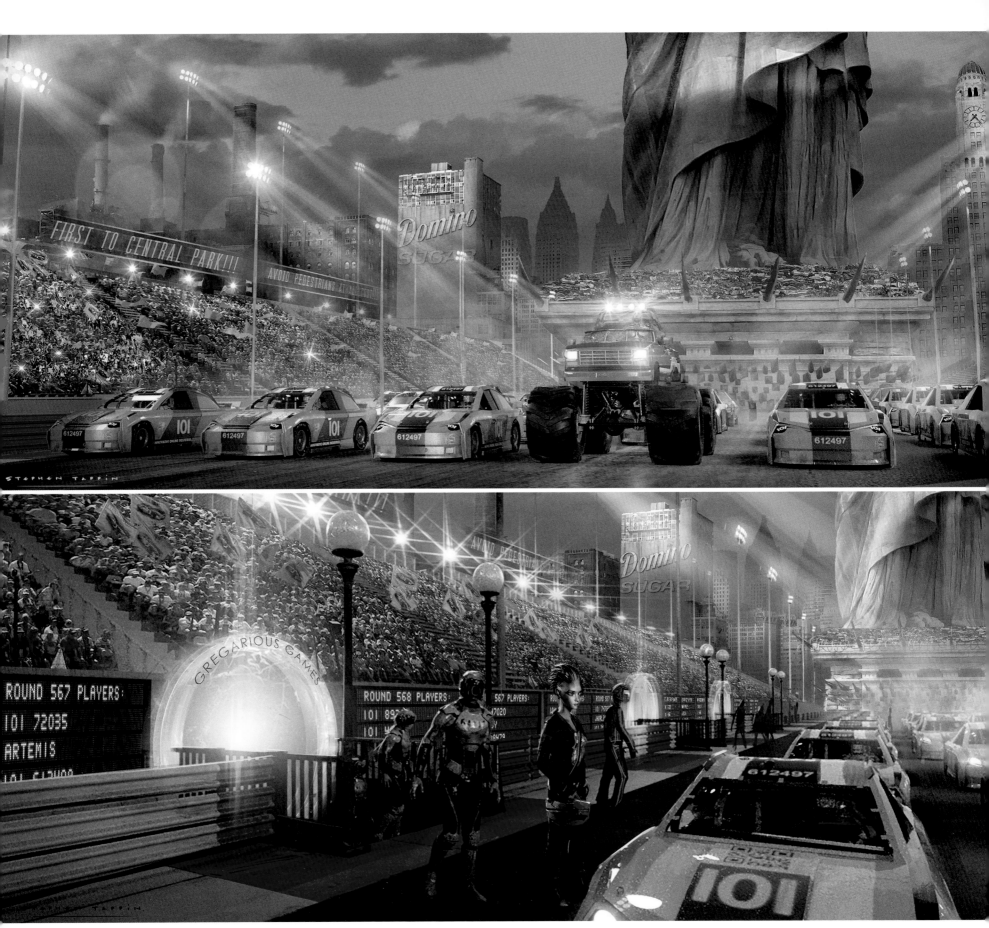

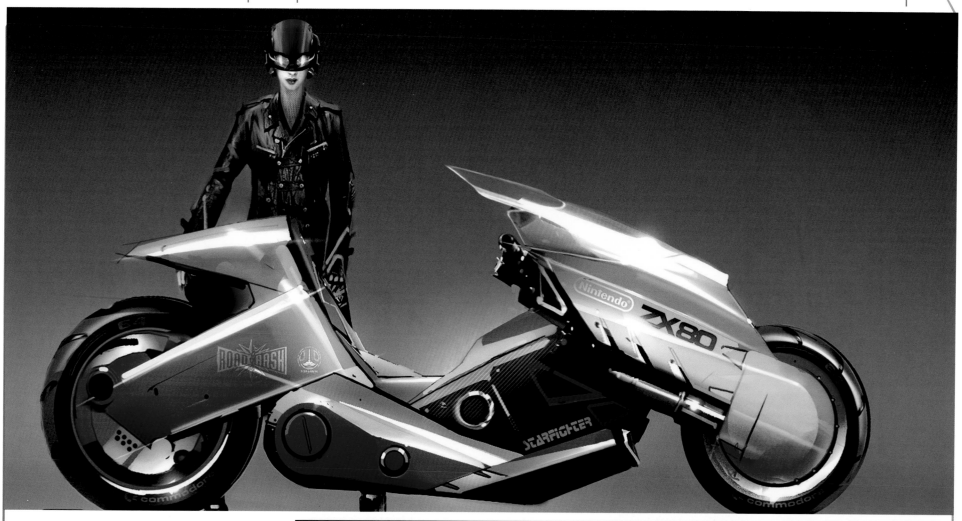

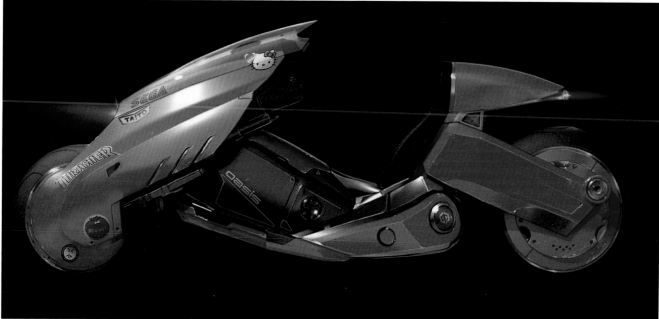

OPPOSITE IOI racers prepare to take on the High Five in these concepts by Stephen Tappin.

TOP Art3mis's motorcycle is modeled after the high-tech bike Shotaro Kaneda pilots in the landmark anime *Akira*. Concept by Jama Jurabaev.

RIGHT Alex Jaeger concept showing the decals Art3mis has used to decorate her bike.

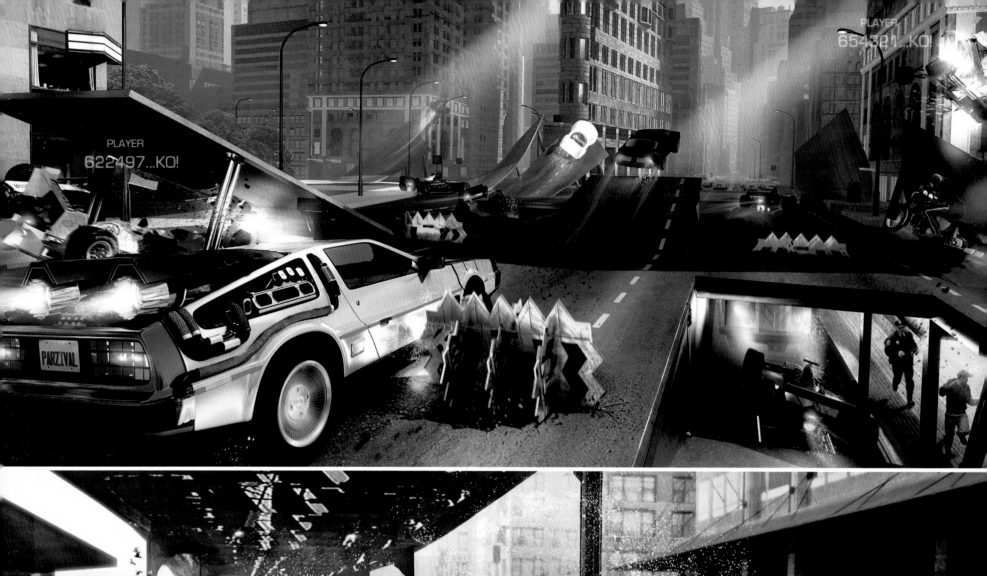

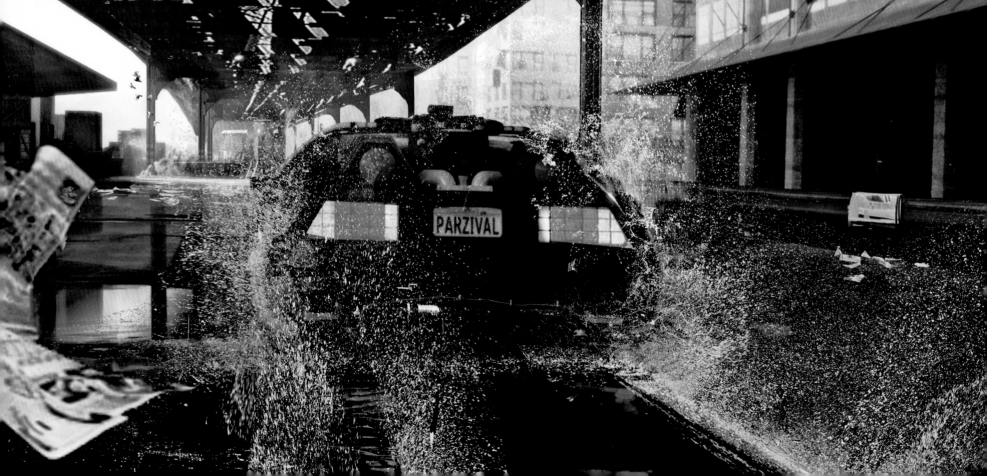

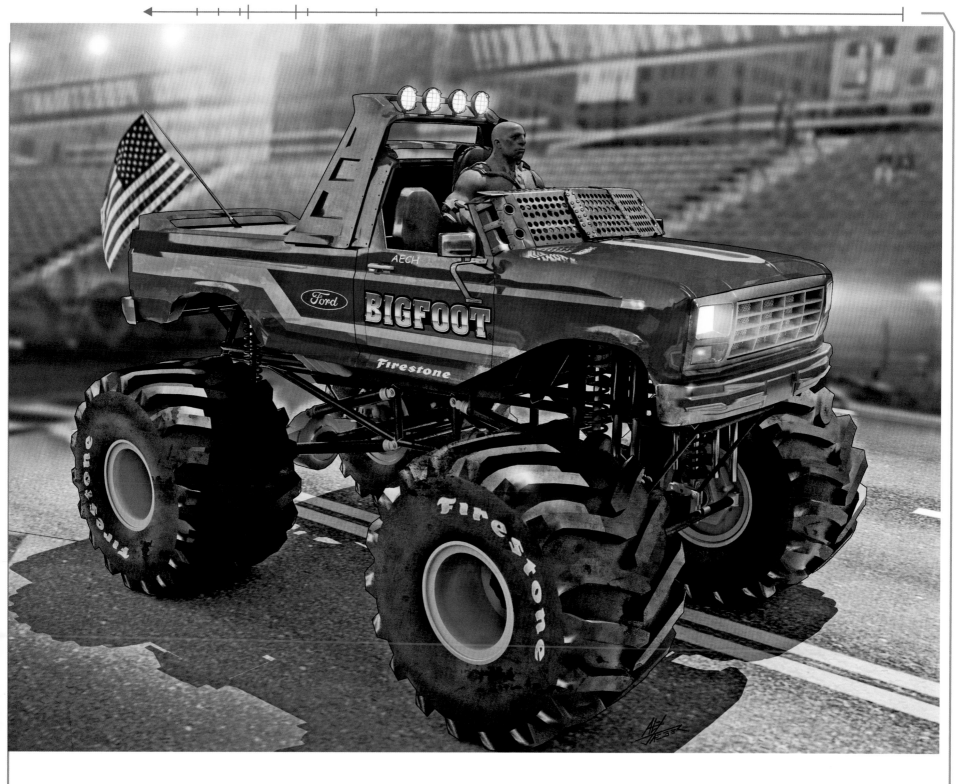

OPPOSITE TOP Parzival drives a replica of the famous time-traveling DeLorean from *Back to the Future* in this preproduction concept by Alex Jaeger.

OPPOSITE BOTTOM Parzival's DeLorean burns rubber through the streets of New York City in this concept by Christian Alzmann.

ABOVE Aech pilots a massive monster truck. Concept by Alex Jaeger.

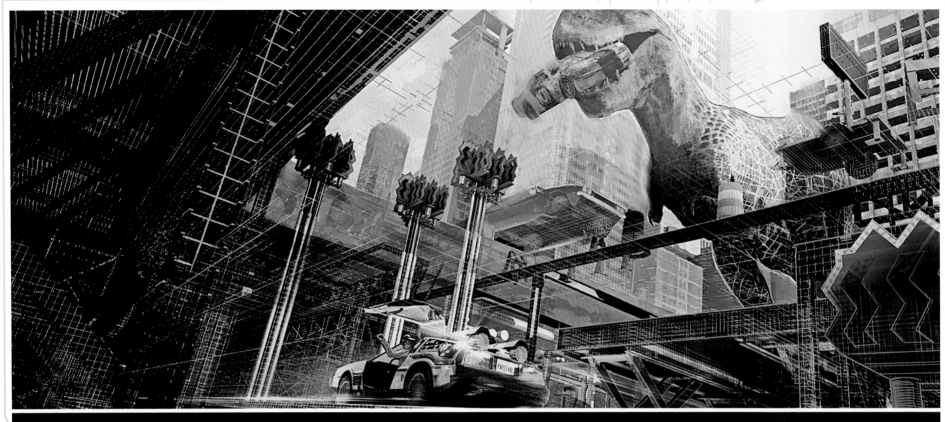

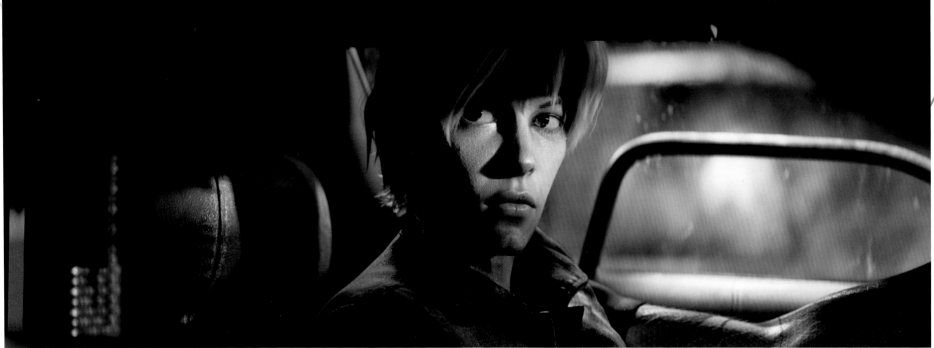

TOP Parzival hits reverse in this concept by Hugh Sicotte.

ABOVE A final frame of Parzival behind the wheel of his DeLorean in *Ready Player One*.

OPPOSITE Concept art for a damaged version of the DeLorean by Kirsten Franson. Note that it features the OUTATIME license plate from *Back to the Future*, which would ultimately be changed to read PARZIVAL.

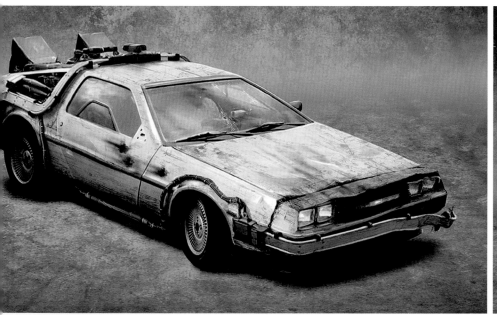

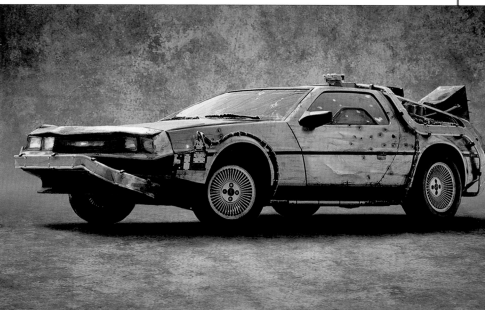

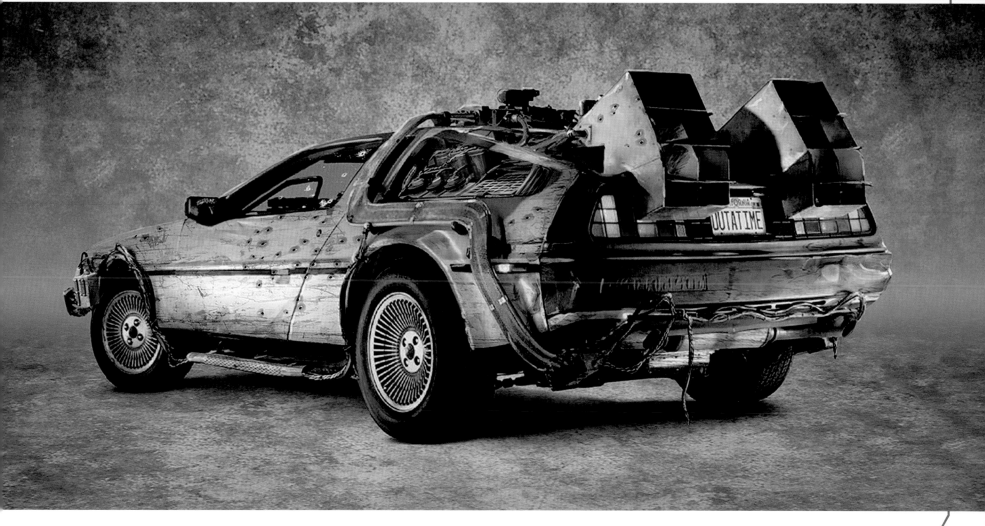

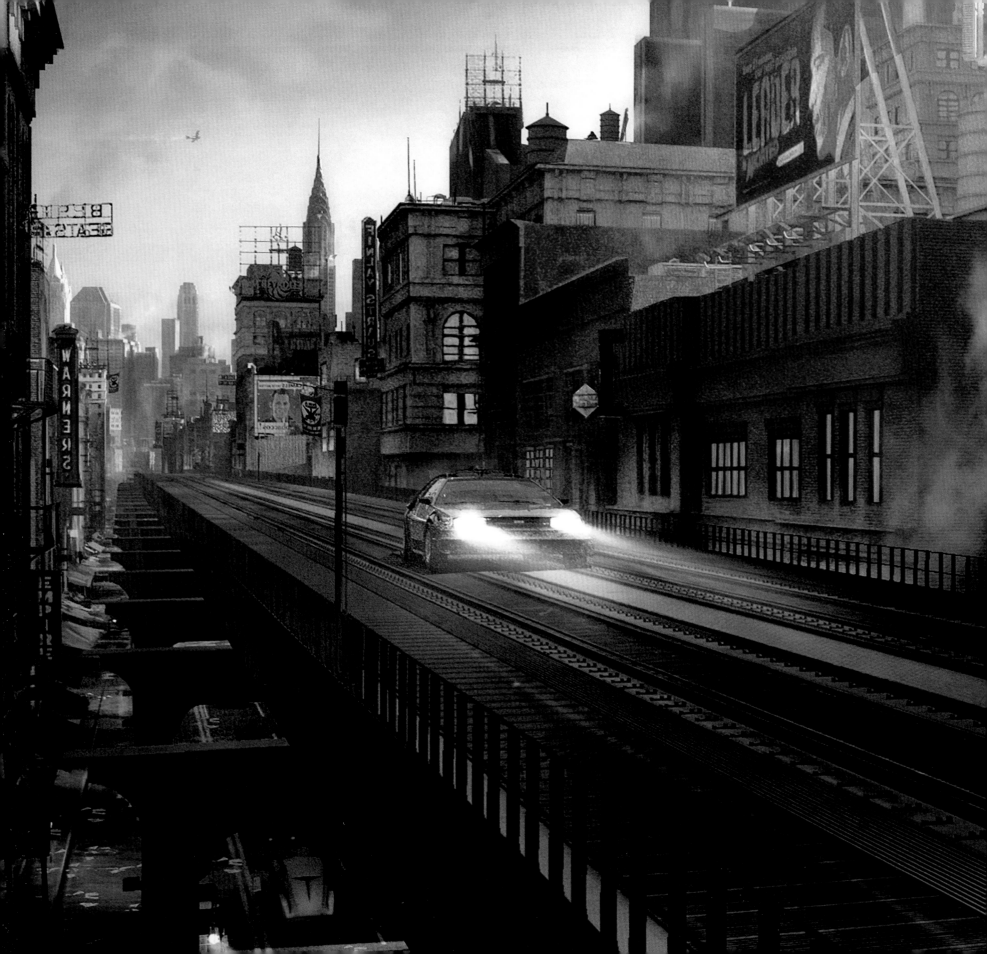

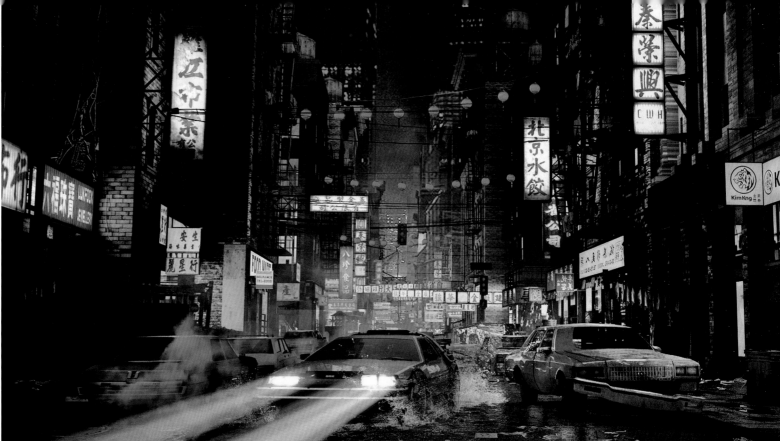

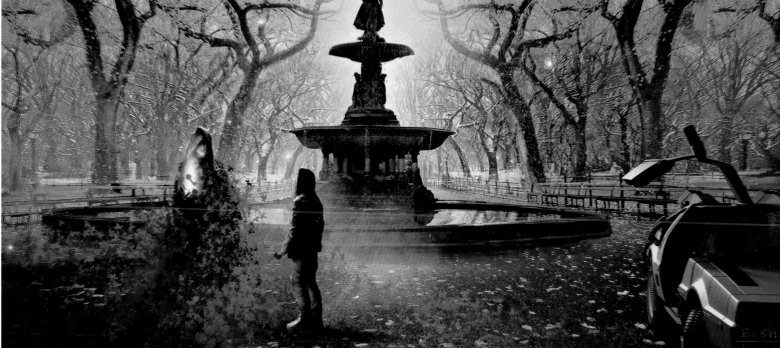

OPPOSITE Parzival drives through the deserted streets after winning the race in this concept piece Michael Sheffels created to help determine the lighting in the scene.

TOP Michael Sheffels lighting study for *Ready Player One*'s Chinatown.

ABOVE Parzival gets the Copper Key in this concept by Emmanuel Shiu.

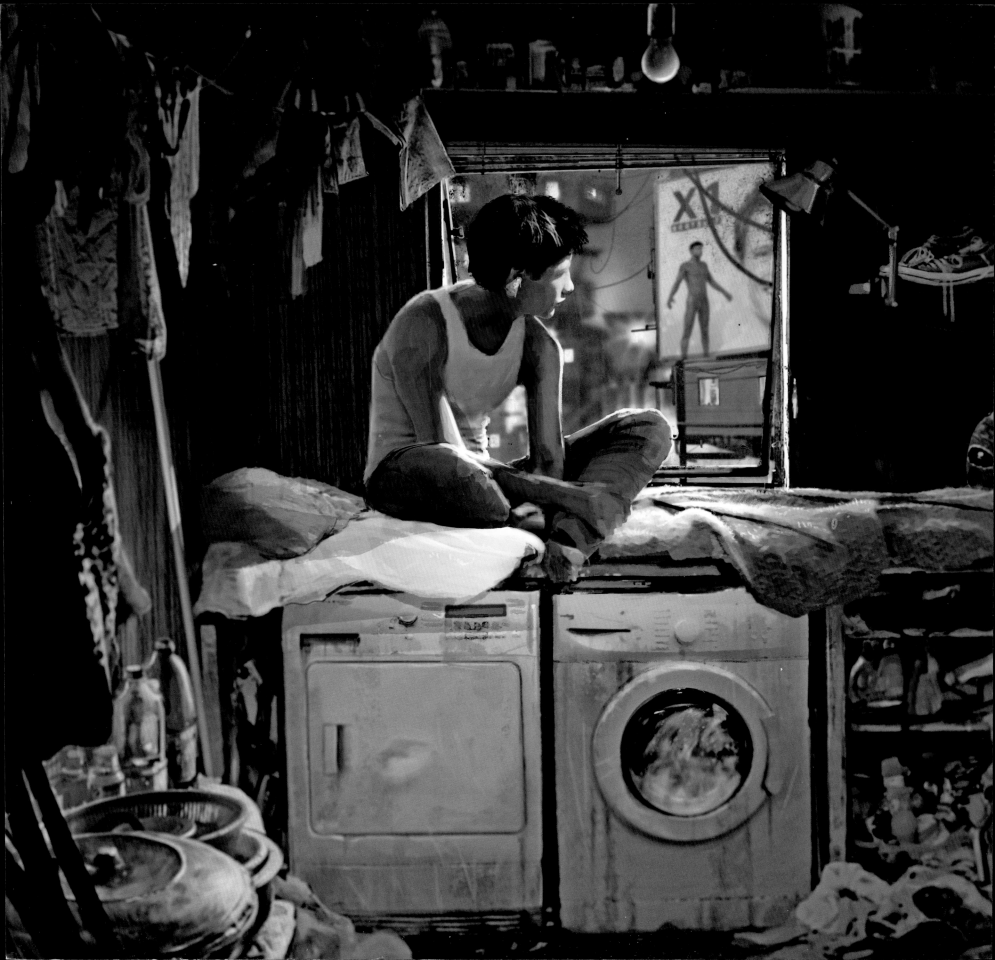

HIS AVATAR MIGHT HAVE the sweetest ride in the OASIS, but in the real world, there's little glamour in Wade Watts's life in the Stacks. "A lot of people live in these trailers where they're stacked one on top of the other, 60 to 70 feet into the air," says director Spielberg. "And there's little outdoor elevators and kind of like New York–style fire escapes to get up and down."

Over the course of several months, beginning in April 2016, Stockhausen and his team built the Stacks on the exterior backlot at Warner Bros. Studios Leavesden, a former Rolls-Royce aircraft engine factory. The first task was to construct the massive steel frame that would support the towering structures. "The spot where we built it is actually the end of a runway and gets some pretty significant winds, and we were building several stories up in the air, so there was a good deal of safety engineering involved," production designer Adam Stockhausen explains. "It couldn't look like a planned, reasonable development or structure. It had to look unreasonable. [We had to] make it look like it's teetering and random and unsafe."

The production designer sourced between fifty and sixty RVs and mobile homes from around the United Kingdom and began stacking them like giant Jenga towers. "On top of the basic steel structure, we dropped in real mobile home trailers and then started layering on loads and loads of bits and pieces," Stockhausen says. "The Stacks became a gigantic collage of satellite dishes, windmills, solar panels, salvaged stairs, fence parts, and drain pipes."

For the remarkable establishing shot that opens the film—in which Wade clambers out of the window of his aunt's trailer and down to ground level—Stockhausen made sure to reinforce various positions with handholds and footholds for safety. "As we were building the set, the exact path changed over time, so we were adding these pieces of steel for him to walk across and swing down," the production designer says.

From there, Wade heads to his sanctuary: a rusted-out cargo van tucked away inside an automobile graveyard on the outskirts of the Stacks, where he can safely remain logged in to the OASIS for hours at a time. "It was definitely an older style—I liked that it felt a bit more like part of Wade's pop-culture life than any futuristic van," Stockhausen says. "We made a fiberglass topper for it as well, which gave him room to stand up and further reminded me of vans from the '80s. We made it into his home—the center of his quest for Halliday's egg. It's his secure world. Really, it's his man cave."

One side of the van's interior is what Stockhausen describes as Parzival's "Halliday wall," which is filled with newspaper clippings, old magazine covers, and other memorabilia that might yield important clues in Wade's search for the egg. Plenty of 1980s collectibles are on display, too—from Garbage Pail Kids stickers to a Masters of the Universe lunchbox. But one of the most valuable assets Wade owns is his omnidirectional treadmill, a vital piece of equipment for any VR adventurer who doesn't want to inadvertently walk into a wall. The device that the production design team built into the floor of the van set was actually an early version of a piece of real-world tech: the newly developed Infinadeck, which was designed to allow users to walk and run in any direction while using a VR headset.

The other pieces of essential tech that Wade owns are his haptic gloves and visor. "The simplest way to get into the OASIS is with a headset that shows you the world around you, like an advanced version of a VR headset today combined with controllers and a face scanner to translate your emotions and expressions to your avatar," Stockhausen says. "Wade has a very old version of this at the beginning—held together with duct tape and partially homemade."

The exterior junkyard set that surrounds the van was built from the ground up, but unlike the Stacks themselves, there was no initial framework built for the old cars that create a kind of shield around Wade's van. They were all piled atop one another with cranes until they had the right sort of look, with steel supports added after the fact to ensure that they wouldn't topple over. "Again, we wanted them to look precarious, but not actually be precarious," Stockhausen says.

OPPOSITE Wade sits inside the laundry room of his aunt's trailer in the Stacks in this concept art image by Dominic Lavery.

LEFT A preproduction storyboard by Alex Jaeger shows Wade wearing his VR gear.

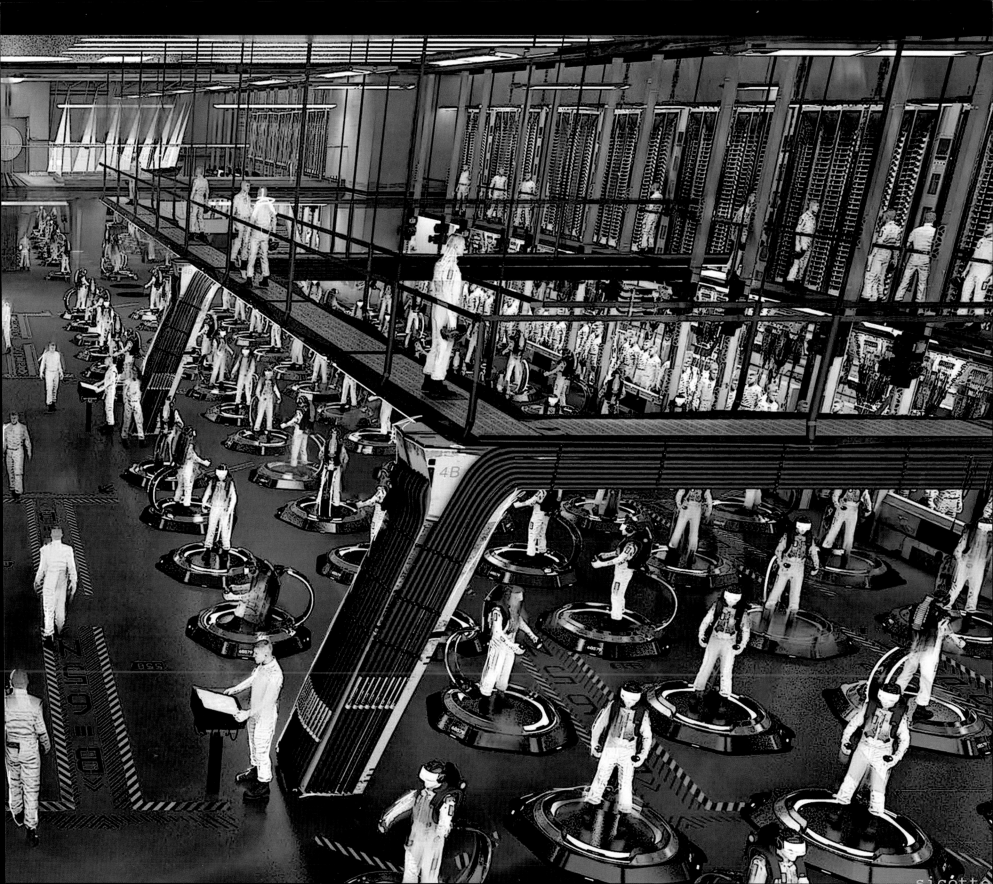

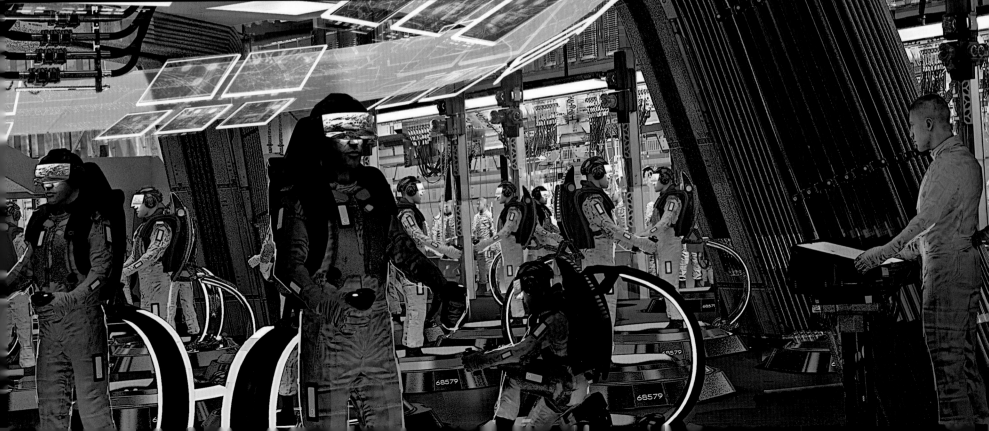

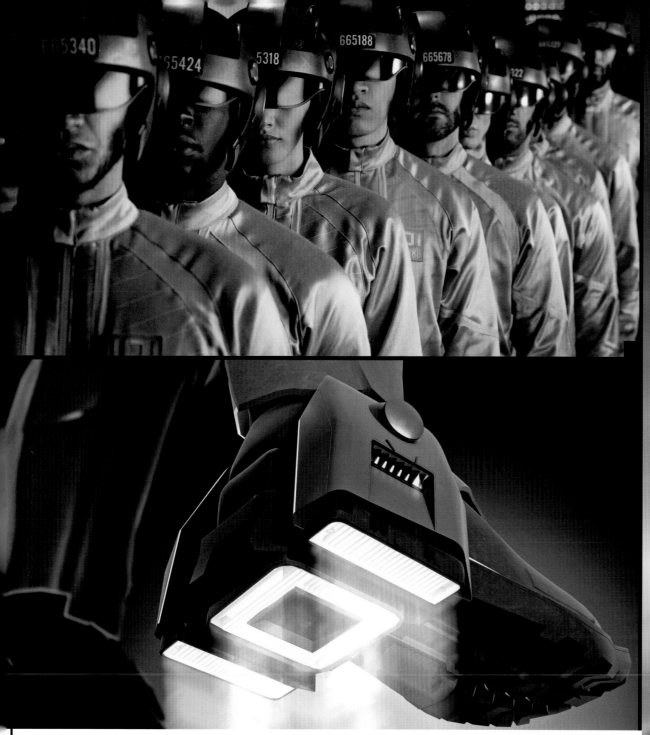

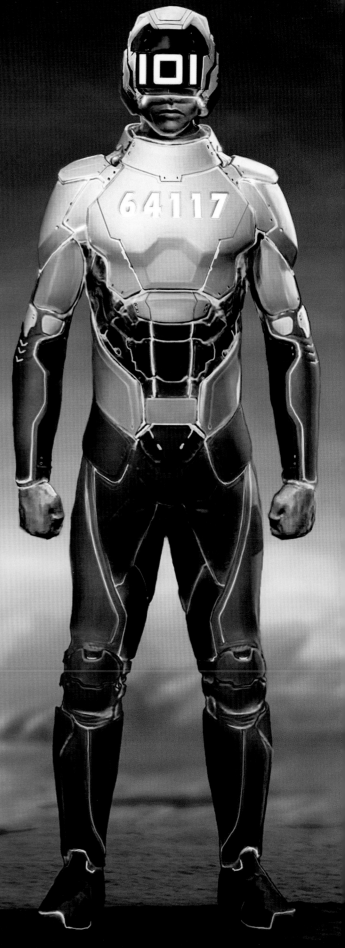

OPPOSITE TOP LEFT Sixer concept by Dominic Lavery.

OPPOSITE TOP RIGHT Early Sixer design by Ulrich Zeidler.

OPPOSITE BOTTOM Sixers prepare to do battle in the OASIS.
Concept by Hugh Sicotte.

TOP LEFT Drone-like Sixers ready for duty.

ABOVE Sixer jet boots concept by Alex Jaeger.

RIGHT Sixer armor illustration by Alex Jaeger and Ulrich Zeidler.
The uniforms for the Sixer army included helmets with VR goggles
and specially designed jumpsuits that, like the film's more elaborate
boot suits, were wired for connectivity.

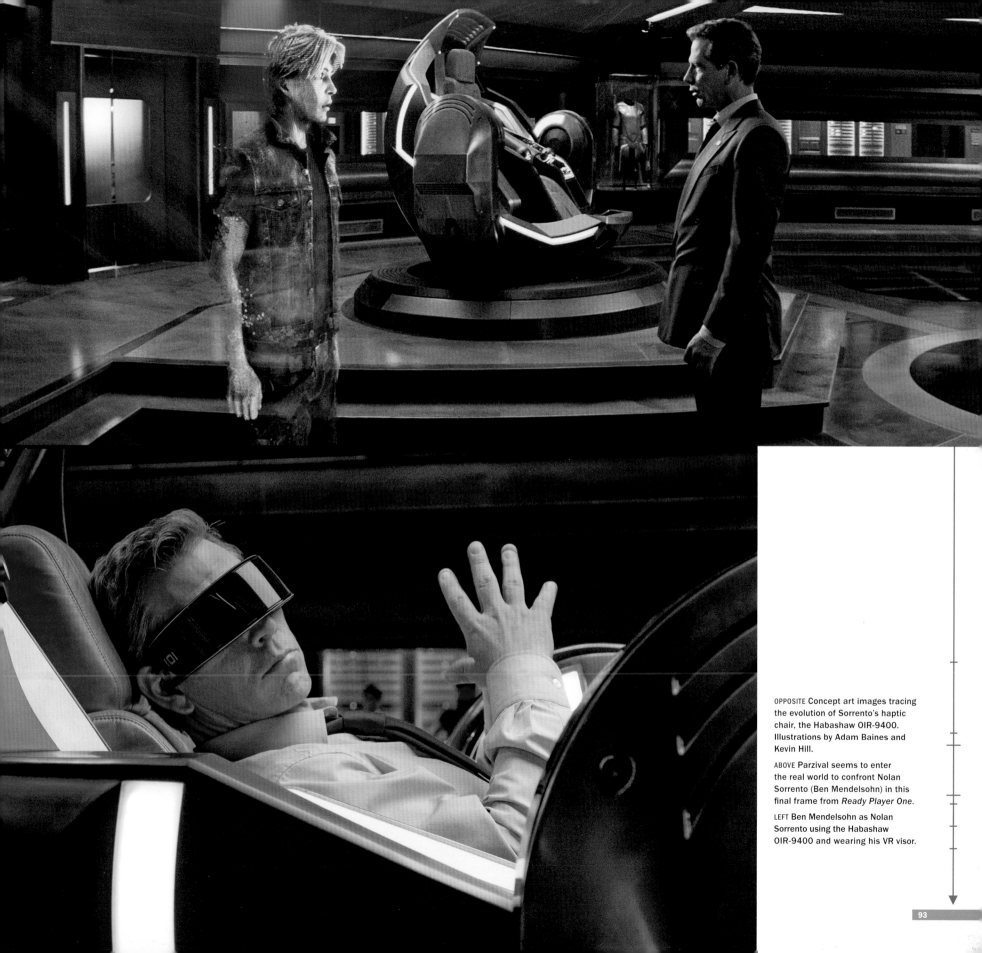

OPPOSITE Concept art images tracing the evolution of Sorrento's haptic chair, the Habashaw OIR-9400. Illustrations by Adam Baines and Kevin Hill.

ABOVE Parzival seems to enter the real world to confront Nolan Sorrento (Ben Mendelsohn) in this final frame from *Ready Player One*.

LEFT Ben Mendelsohn as Nolan Sorrento using the Habashaw OIR-9400 and wearing his VR visor.

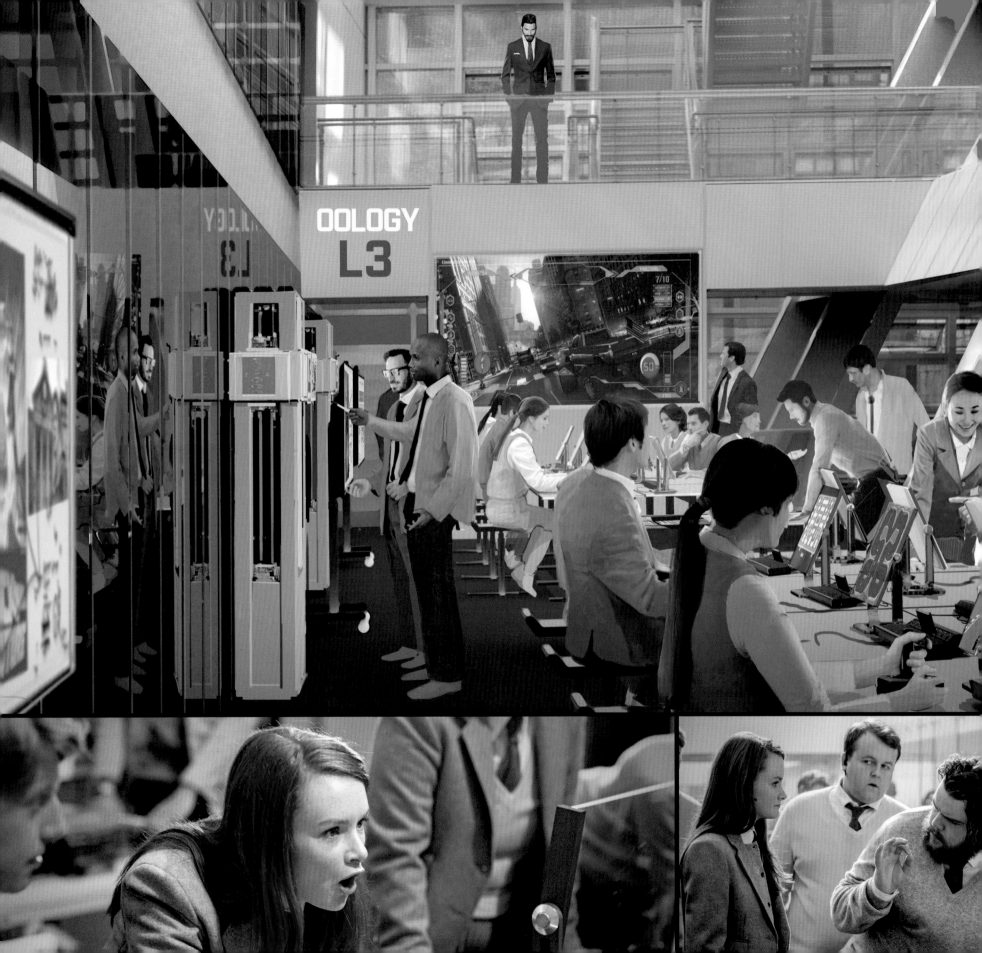

LEFT IOI Oology Division concept by Dominic Lavery.

OPPOSITE BOTTOM AND BOTTOM LEFT The Oology Division specialists debate the finer points of Halliday's challenges.

TOP RIGHT Steven Spielberg directs Ben Mendelsohn as Nolan Sorrento at the Holland Park School set.

PAGE 96 Loyalty Center helmet, Dominic Lavery (top left); Loyalty Center pod detail, Lee Oliver (center left); Loyalty Center pod overview, Paul Threadgold (bottom left).

PAGE 97 Final IOI Loyalty Center concept, Alex Jaeger.

To capture the scenes featuring the elite Oology Division, the production filmed on location at Holland Park School in central London. "The basic shape of the architecture is very stark and very modern, so we didn't touch that for the basic shell of the space, but we fully dressed it out," Stockhausen says. "The idea is that it's a central bullpen where the IOI scholars are working. Everything that Wade knows by personal interest about '80s pop-culture lore, IOI has people studying and trying to ferret out clues. So, we have libraries full of comic books under glass and Atari video games being played to learn every last secret that can be taken from them."

Far less glamorous is IOI's Loyalty Center, where anyone who owes too much money to IOI can agree to perform menial tasks—such as manning the corporation's IT and customer service call centers—until their account is paid in full. (With the low wages the company pays, it's almost impossible to climb out of debt.) Stockhausen envisioned the area as a futuristic fulfillment center for an online distribution company, or a "debtor's prison full of taupe-colored cubicle cells."

"We're trying to get it to have a mechanical kind of assembly-line quality to it," he says. "The idea is that there are floors and floors and floors of these worker bees kind of serving the IOI corporate beast. You're doing grunt work in this place at these not very enjoyable workstations, these pods that you're locked into. This was kind of inspired by my own experience working in the corporate environment in a sea of cubicles stretching to the horizon. This would be the terrible future version of that."

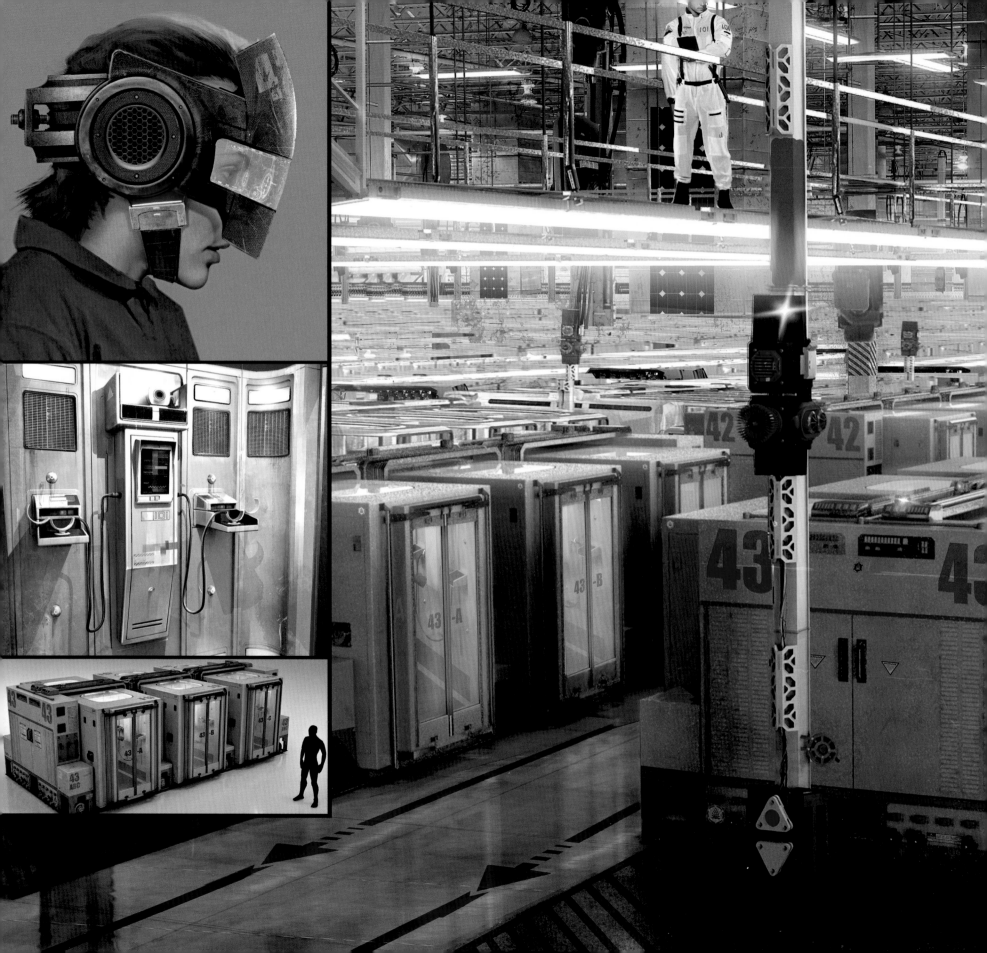

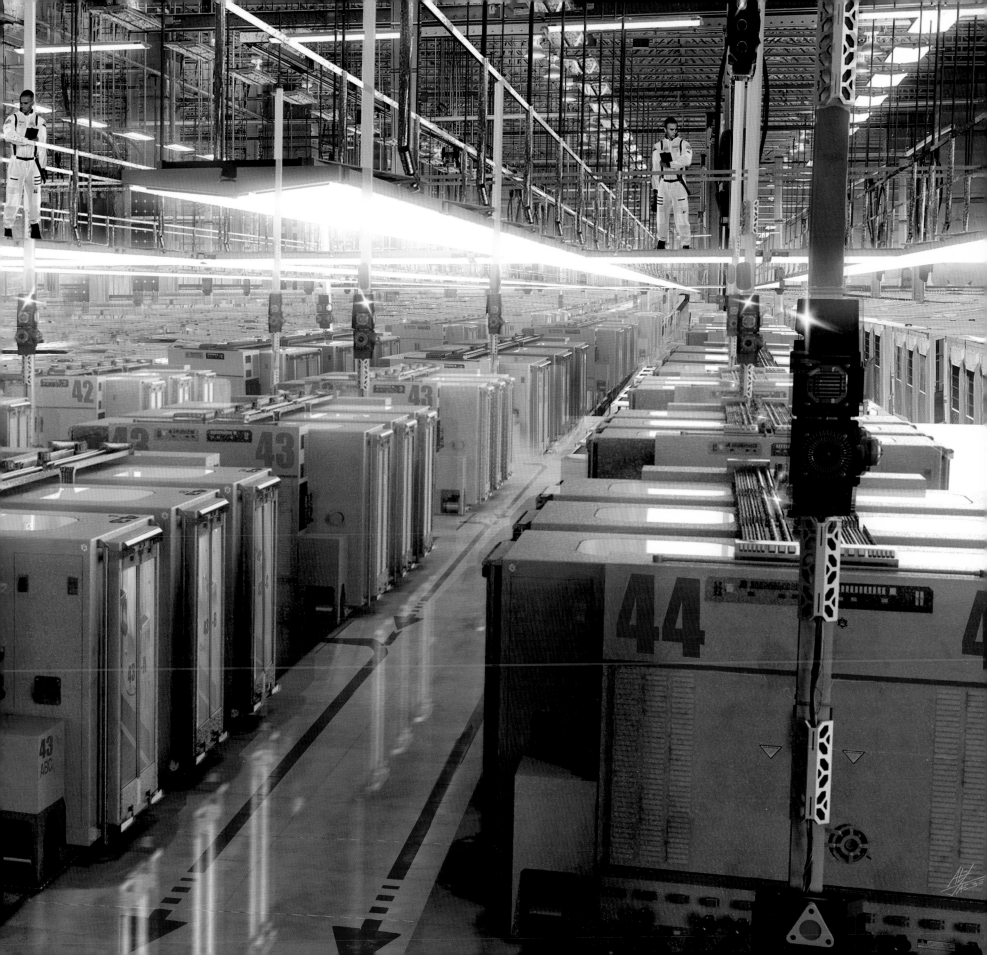

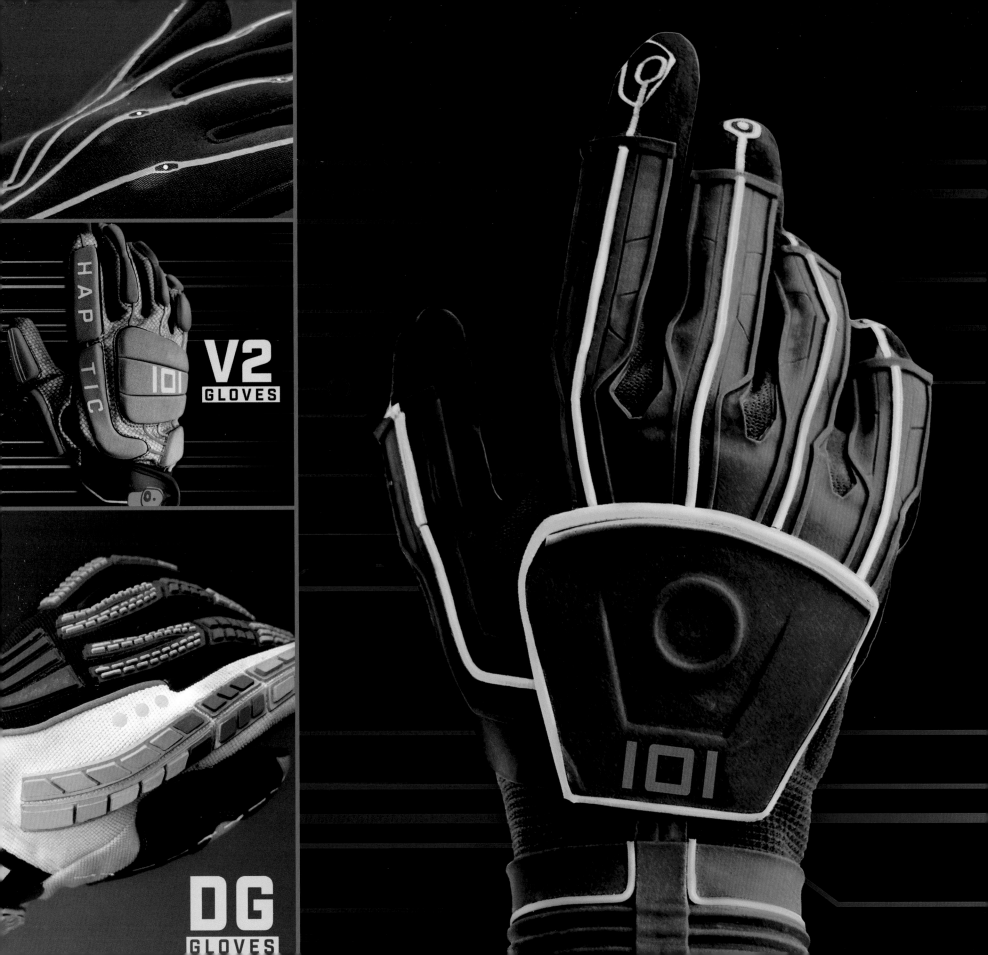

SUITING UP

DESPITE SORRENTO'S ADVANTAGES, it's Parzival who finally wins the race through New York—a conversation with Art3mis prompts him to drive through the racing circuit backward, and the unlikely maneuver sends him over the finish line. To celebrate his victory, he buys himself IOI's top-of-the-line X1 haptic boot suit, a considerable upgrade from his outdated gear.

It fell to costume designer Kasia Walicka-Maimone to determine how to physically produce the boot suit for the film. Her process began with copious amounts of research into the latest in wearable technology. When she arrived at Leavesden, she met with a team of special fabricators and armorers well versed in alternative materials and 3D printing and described the material she would need to execute her vision for the suit. The garment she had in mind was clear and skintight and housed the wiring necessary for the wearer—in this case, Wade—to connect to the OASIS and to physically experience what his avatar would feel.

"We had to figure out how on earth we were going to create this boot suit, because materials like this have not existed," Walicka-Maimone says. "I was like, they sell baking sheets made from silicone in every variety, shape, or form—we need something like this but see-through. On the other hand, it had to be worn on the body. It had to have enough flexibility and enough stretch. You don't walk around in a silicone baking sheet for a few hours, let alone a few days of shooting."

The final suit was made from a version of silicone that was produced in transparent sheets. It was worn over a base suit made from a very fine, stretchable netting typically used in dancewear onto which a pixelated pattern based on human musculature was printed. The pieces of the silicone suit were glued together over that mesh material—with seams strategically placed to cover the glue lines. Walicka-Maimone added tiny perforations along the back and sides for comfort and breathability. "It was quite an engineering project of making it look effortlessly like a skin, but with some substance and structure and color added to it," Walicka-Maimone says.

For that hint of color, the costume designer selected a pale aquatic green. "I was very much interested in the gray of the future," she said. "These days, gray represents this industrial functional color. Gray is such a color of steel, and I feel that we will move away from that. A lot of trends of the futuristic technologies go toward golds and metallics and sea green, which is very much a color of weeds and organic matter."

OPPOSITE Concepts for IOI haptic glove marketing materials by Neil Floyd.

TOP LEFT Wade sports his top-of-the-line X1 haptic boot suit.

CENTER LEFT Haptic gear design by Dominic Lavery.

BOTTOM LEFT Haptic gear design by Neil Floyd.

ABOVE LEFT Wade is ready to log in to the OASIS in this final frame from *Ready Player One*.

ABOVE RIGHT Concept for Sorrento's haptic gear.

For Sorrento, Walicka-Maimone developed a different high-end boot suit that would accommodate the demands of his professional life at IOI. "His version is a suit that can function over regular clothing," the costume designer says. "He's basically a businessman, so the idea that he would be in a skintight suit that he has to take on and off constantly to work [was not practical]."

Inspired by fencing uniforms, Walicka-Maimone crafted something akin to digital armor that was molded out of flexible tinted plastic and built specifically to fit Mendelsohn's frame. "It got adjusted for wearability because hard molded plastic has to be perfectly fit to the dimensions of the person we are making it for.

Otherwise, it would be like a bad cartoon. This had to be perfectly proportioned."

Rather than boot suits, which would have been too difficult and costly to produce en masse, the Sixers were dressed in a more streamlined costume. "The army had almost like an industrial coverall that is wired for digital connectivity," Walicka-Maimone says. "They had the wiring printed on the surface of their suits."

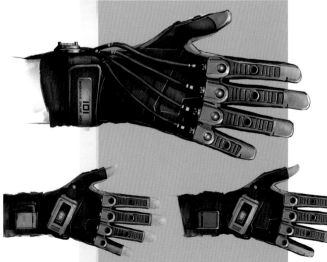

TOP An early concept for Wade's haptic gear by Dominic Lavery.

RIGHT Haptic streetwear glove design by Lee Oliver.

OPPOSITE RIGHT Visor design by Paul Threadgold.

OPPOSITE LEFT IOI visor marketing materials by Neil Floyd.

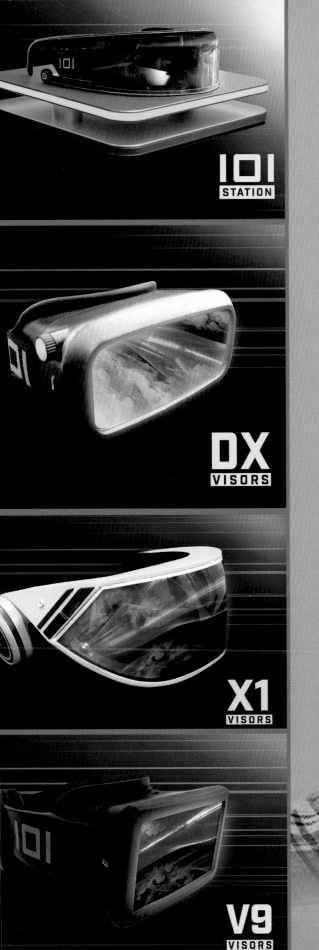

101
STATION

DX
VISORS

X1
VISORS

V9
VISORS

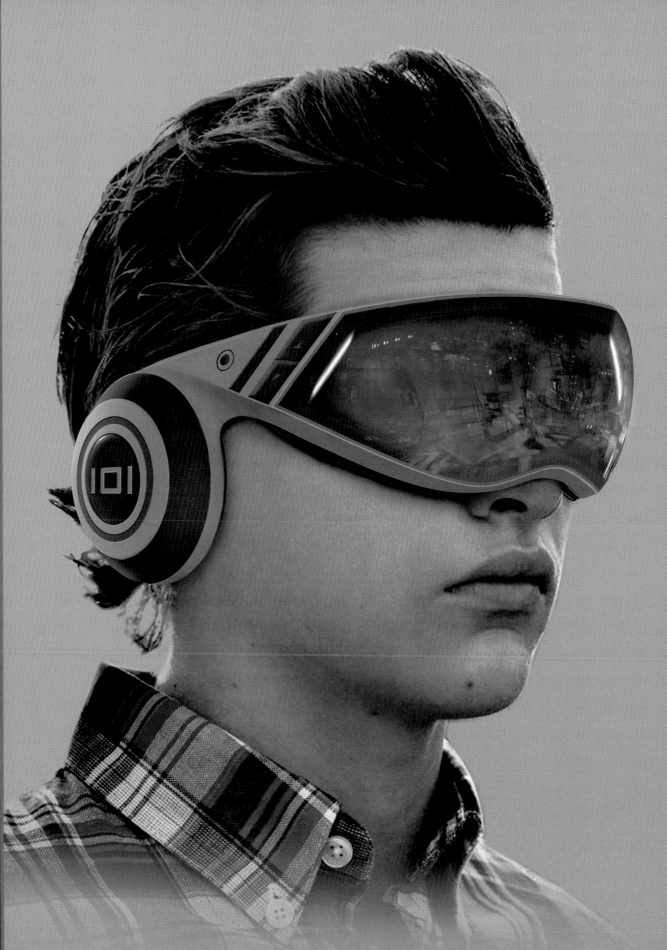

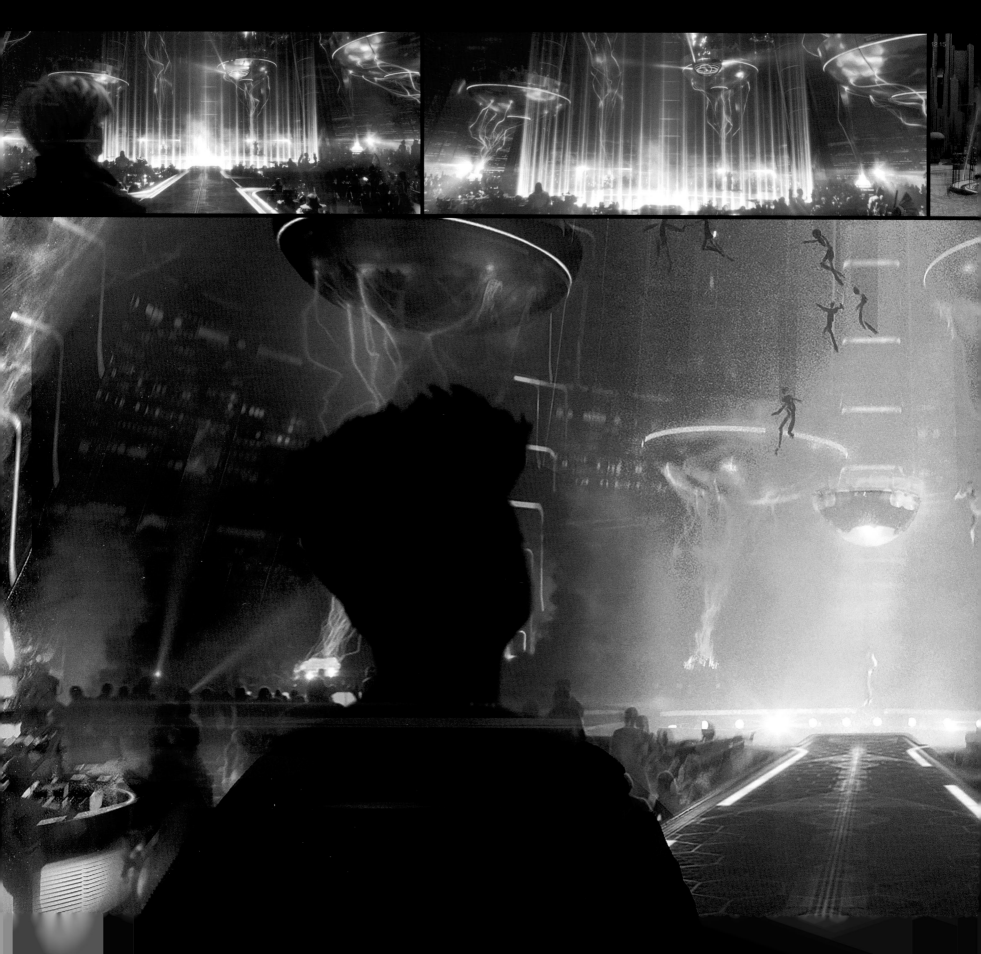

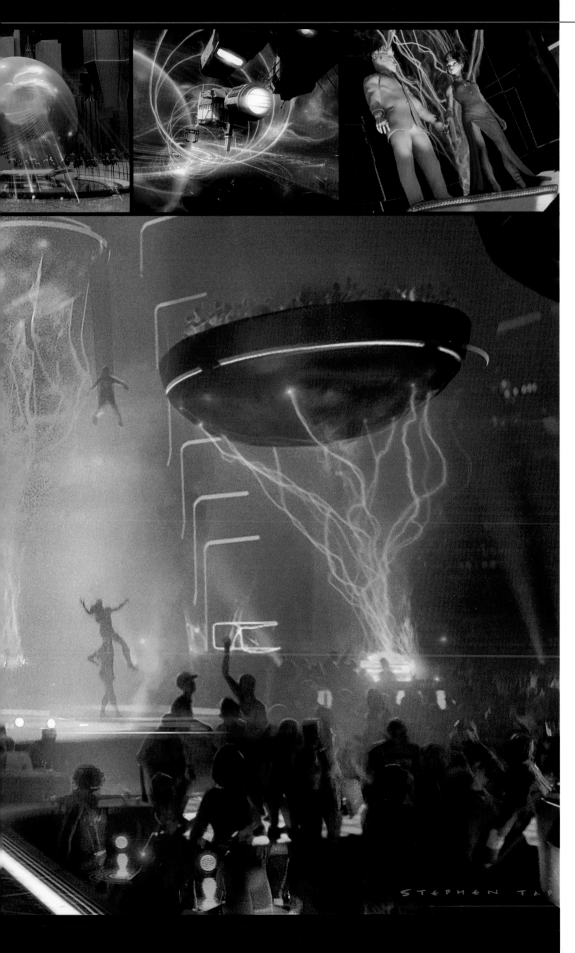

AFTER CLEARING THE FIRST GATE, Parzival and Art3mis make plans to celebrate at the hippest dance club in the OASIS, the Distracted Globe, where it's '80s Night every night—and there's no gravity to hold the dancers down to earth. (Watch carefully and you might notice one or two familiar clubgoers, such as Harley Quinn and Deadshot from DC Comics' *Suicide Squad*.)

The sequence is one of the signature set pieces in Ernest Cline's novel, but bringing it to life, even in the virtual world, required some ingenuity on the part of production designer Adam Stockhausen and the rest of the creative team. "That was a really hard one to design," he says. "We just couldn't find the geography for it. We kept doing these spherical designs for it, but then every shot looked the same. If you think about shooting inside of a ball, any way you turn it, it looks the same as any other way you turn it."

Adding an entry point that was subject to the laws of gravity turned out to be the ideal solution. "When you walk in, you get to see where you are and what's going on, and then you take a leap off sort of a diving board and enter the zero-gravity portion of the club," Stockhausen says.

Still, the sequence was among the most challenging for the visual effects team, according to ILM's David Shirk. "Dancing is one of the hardest things to animate well, and dancing in space is compounded," he says. Thus, "zero gravity" became "modified zero gravity," or, as Shirk says, "zero gravity kind of crossed with under-water. Characters are able to exert a certain amount of control over their movements where it became expedient to the story. We could increase or decrease the amount of control they could exert just slightly—not enough to take the audience out of the story, but just enough so that we were able to stage the shots in the way that Steven wanted to stage them."

OPPOSITE TOP Two final frames of the Distracted Globe interior from *Ready Player One*.

LEFT Parzival takes in the view at the Distracted Globe in this interior concept by Stephen Tappin that bears a remarkable resemblance to the final look of the sequence.

TOP LEFT Color concept art of the club's exterior by Alex Jaeger.

TOP CENTER Early concept art of the nightclub world that would become known as the Distracted Globe. Illustration by Alex Jaeger.

TOP RIGHT Club dive plank concept by Alex Jaeger.

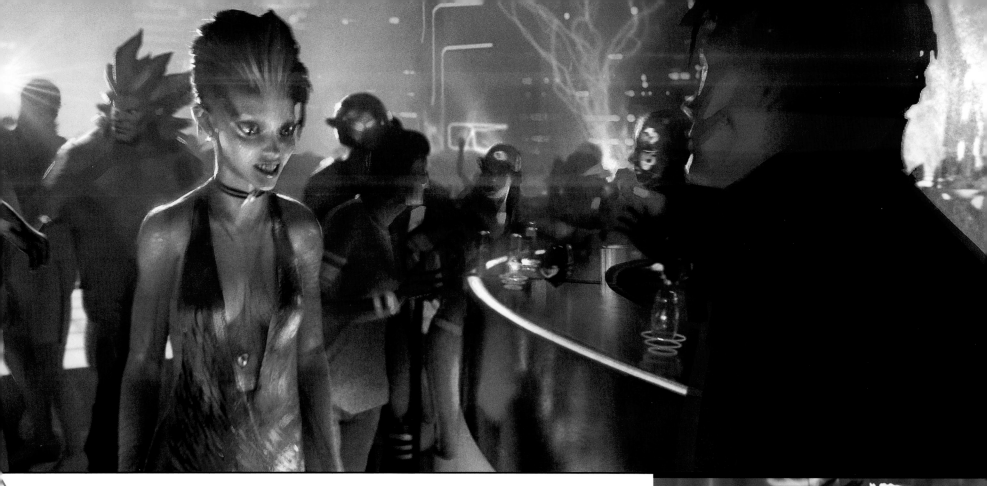

To populate the club, the production brought aerialists onto the mo-cap stage and used their movements as the model for the Distracted Globe's background dancers. "They were working in wire harnesses," Shirk says. "The work that they did was kind of invaluable to help pad out what we [were required] to put together for that scene. The aerialists were actually able to re-create a decent percentage of the zero-gravity dancing that's at the core of the scene."

Surrounded by dancers and bathed in the deep blues and purples of the club's decor, Parzival feels compelled to profess his love to Art3mis, even going so far as to reveal his real identity. But the romance between the star

TOP Art3mis and Parzival celebrate at the Distracted Globe in this lighting concept by Stephen Tappin.

RIGHT A final frame from *Ready Player One* of the same scene depicted in the concept art.

OPPOSITE Hugh Sicotte illustrations of the Distracted Globe interior.

gunters is interrupted by invading battalions of IOI soldiers sent by Sorrento to eliminate Parzival and Art3mis—if an avatar dies inside the OASIS, they "zero out," or, as the gunters say, "lose their shit." In an instant, all the experience, artifacts, and money the avatar might have collected suddenly vanishes from their inventory and is up for grabs by other avatars. That extends even to coveted items such as the Zemeckis Cube—a gizmo dreamed up for the movie and named for *Back to the Future* director Robert Zemeckis—which can transport avatars back in time thirty seconds, or the Cataclyst, which can instantaneously zero out every player.

For the scene, the film's stunt team served as the IOI army, giving the visual effects team a wealth of motion-capture performance footage to work from. "Taking all of that, we combed through the performances, and we found what material was useful for us that could feed into that zero-gravity motion," Shirk says. "The animators would fill in the gaps. We would remove evidence of gravity. It's almost impossible to lose it altogether—we went in and reworked quite a lot of things—but we always had the template of the original performance."

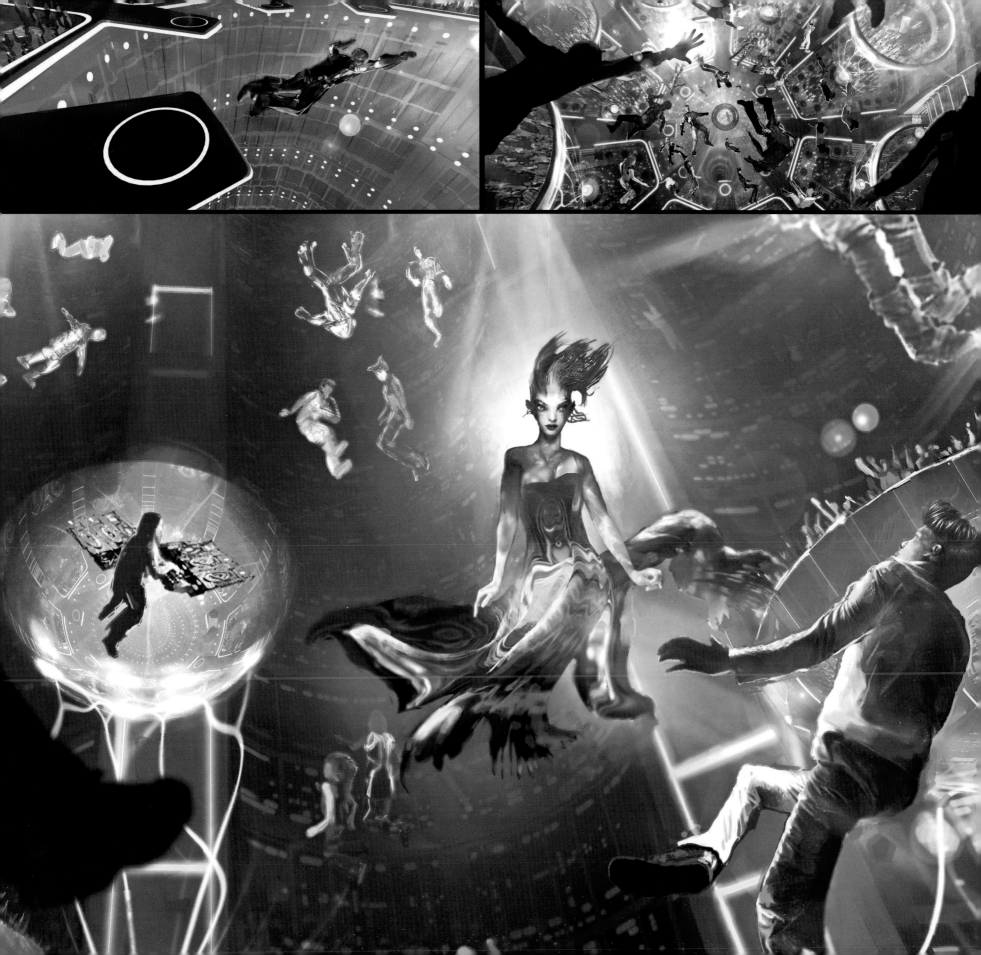

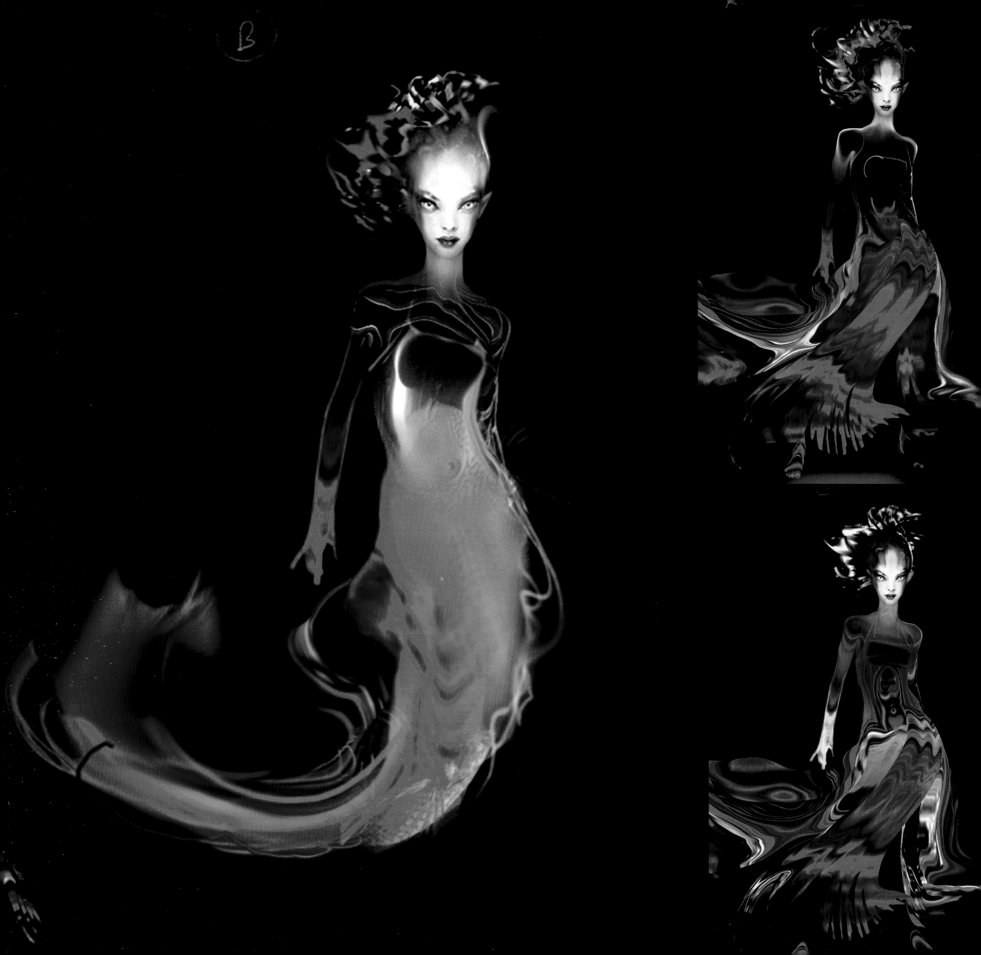

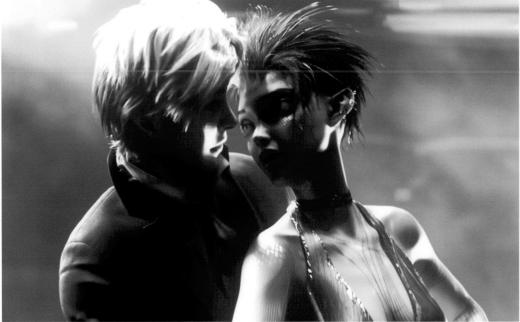

OPPOSITE Concepts by Dan Baker for Art3mis's Distracted Globe dress.

ABOVE Parzival and Art3mis dance at the Distracted Globe in this concept piece by Dan Baker.

LEFT A final frame from *Ready Player One* shows Parzival and Art3mis at the Distracted Globe.

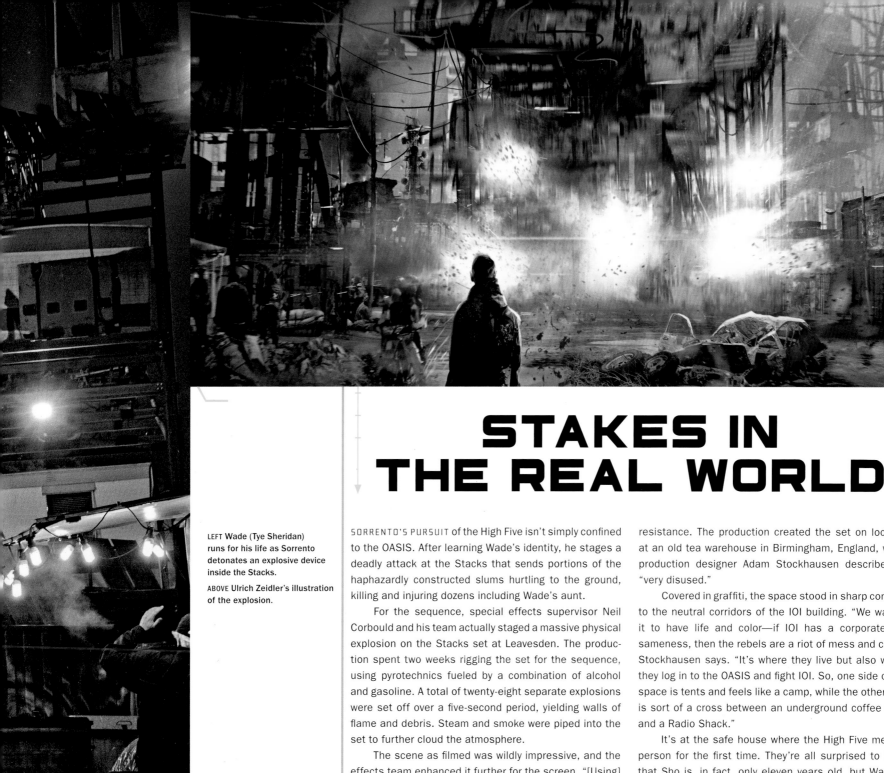

STAKES IN THE REAL WORLD

LEFT **Wade** (Tye Sheridan) runs for his life as Sorrento detonates an explosive device inside the Stacks.

ABOVE Ulrich Zeidler's illustration of the explosion.

SORRENTO'S PURSUIT of the High Five isn't simply confined to the OASIS. After learning Wade's identity, he stages a deadly attack at the Stacks that sends portions of the haphazardly constructed slums hurtling to the ground, killing and injuring dozens including Wade's aunt.

For the sequence, special effects supervisor Neil Corbould and his team actually staged a massive physical explosion on the Stacks set at Leavesden. The production spent two weeks rigging the set for the sequence, using pyrotechnics fueled by a combination of alcohol and gasoline. A total of twenty-eight separate explosions were set off over a five-second period, yielding walls of flame and debris. Steam and smoke were piped into the set to further cloud the atmosphere.

The scene as filmed was wildly impressive, and the effects team enhanced it further for the screen. "[Using] CGI, they take over and make it a lot bigger," Corbould says. "This whole structure comes crashing down and narrowly misses [Wade]."

After the attack, Samantha helps Wade and the other members of the High Five escape to the Rebs' safe house, which serves as the real-world home to the IOI resistance. The production created the set on location at an old tea warehouse in Birmingham, England, which production designer Adam Stockhausen describes as "very disused."

Covered in graffiti, the space stood in sharp contrast to the neutral corridors of the IOI building. "We wanted it to have life and color—if IOI has a corporate-cool sameness, then the rebels are a riot of mess and color," Stockhausen says. "It's where they live but also where they log in to the OASIS and fight IOI. So, one side of the space is tents and feels like a camp, while the other side is sort of a cross between an underground coffee shop and a Radio Shack."

It's at the safe house where the High Five meet in person for the first time. They're all surprised to learn that Sho is, in fact, only eleven years old, but Wade is especially shocked to learn best bro Aech's real identity. "There's a wonderful moment where Wade realizes, 'Oh, you're still the same person—even though you're a woman, and you're a lesbian, you're still the person I've trusted, and I've loved, and I've cared about all these years,'" says Lena Waithe.

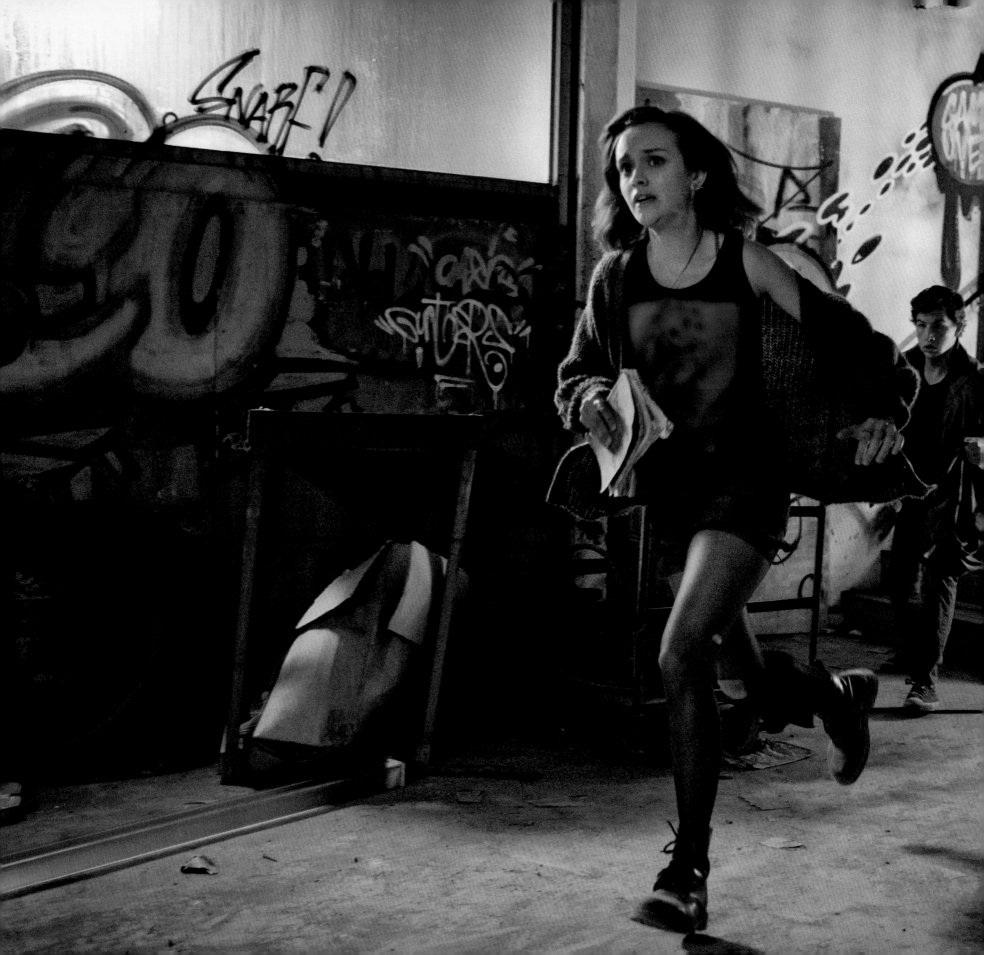

LEFT Samantha (Olivia Cooke) and Wade (Tye Sheridan) make their escape when IOI attack the Rebs safehouse.

BELOW Win Morisaki, left, with Olivia Cooke and Steven Spielberg on the safe house exterior location; Spielberg on location in Manchester, England; Wade with best friend Helen (Lena Waithe) in the real world.

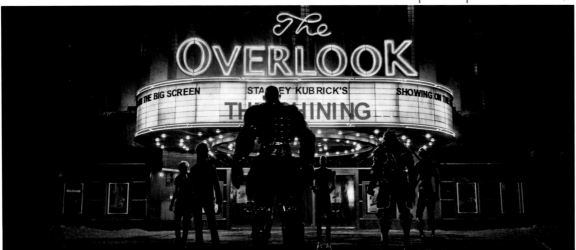

TO COMPLETE THE SECOND CHALLENGE and win the Jade Key, the High Five must survive a night inside the Overlook Hotel, a chilling Halliday-built simulation of the haunted, claustrophobic location from Stanley Kubrick's landmark 1980 horror film, *The Shining*. "*The Shining* has been completely re-created inside the OASIS, which is easily the craziest and most fascinating and awesome thing I've ever been involved with in a movie," says *Ready Player One* co-screenwriter Zak Penn.

In Ernest Cline's novel, Halliday's Flicksync program dropped Wade into a simulation of the 1983 Matthew Broderick movie *WarGames*. But for Spielberg's film, *The Shining* was selected instead to once again surprise fans with a truly terrifying twist. It's also a nod to the special relationship between Steven Spielberg and the late Kubrick, whose friendship dated back decades. (*A.I. Artificial Intelligence* had initially been developed by Kubrick in the years prior to his death in 1999, and Spielberg brought it to fruition as an Amblin/Kubrick production in 2001.)

Production designer Adam Stockhausen says that, initially, there was some discussion of building perfect reproductions of the original sets from *The Shining*. But given that it's Parzival, Art3mis, and the other High Five avatars who find themselves inside the Overlook Hotel, as opposed to their real-world counterparts, it made more sense to find a digital solution.

Senior visual effects supervisor Roger Guyett, of ILM, admits that when he was first presented with the concept of incorporating Kubrick's film into *Ready Player One*, he wasn't entirely certain of the best way to proceed. "I'll be honest . . . it was a real challenge to see how this whole thing could get incorporated into the story and work in a way that made sense," Guyett says. "Clearly Steven had this great vision in his head, but it just took a bunch of us—and I wasn't on my own—a little while to figure out how to make it work."

At first, Guyett says, the ILM team considered building *The Shining* simulation as though it were just that, a simulation. "The idea was kind of like, if you imagine that *The Shining* was a hologram—a very complicated hologram—you could actually have seams, and there might be some kind of weird fritzing or breakdown so that you could see some of the way it was put together," says Guyett. "The biggest problem we had with that approach was it then made the whole thing feel fake. I think Steven was very worried that the audience would not be emotionally invested [unless] you truly were inside *The Shining*. So, we just turned it into, you're really in the Overlook Hotel . . . and you're experiencing all these events firsthand."

Eventually, Guyett and his ILM collaborators hit upon the idea of carrying out a scan of the original film that could be used to build a digital version of the various Overlook Hotel rooms and hallways in ILM's computers that the avatar characters could then be placed into. Working from a high-quality telecine transfer of Kubrick's original feature, the ILM visual effects artists began to re-create some of the most immediately recognizable locations from the film—the hotel's ornate grand hall, the winding corridors haunted by cinema's best-known set of ghastly twin girls, and, of course, Room 237, the chamber where *Shining* star Jack Nicholson famously encounters an alluring woman who turns into a ghoul after she emerges nude from the bath.

Guyett says he and ILM's head of environment, Barry Williams, collaborated on various previsualization animations to give Steven Spielberg a sense of what might be possible to retain from *The Shining* and what new material would need to be created to help incorporate the High

TOP A final frame from *Ready Player One* shows the High Five approaching the Overlook Theater.

RIGHT Art3mis and Parzival prepare to enter the Overlook Theater in the hopes of winning the second challenge in this concept by Alex Jaeger.

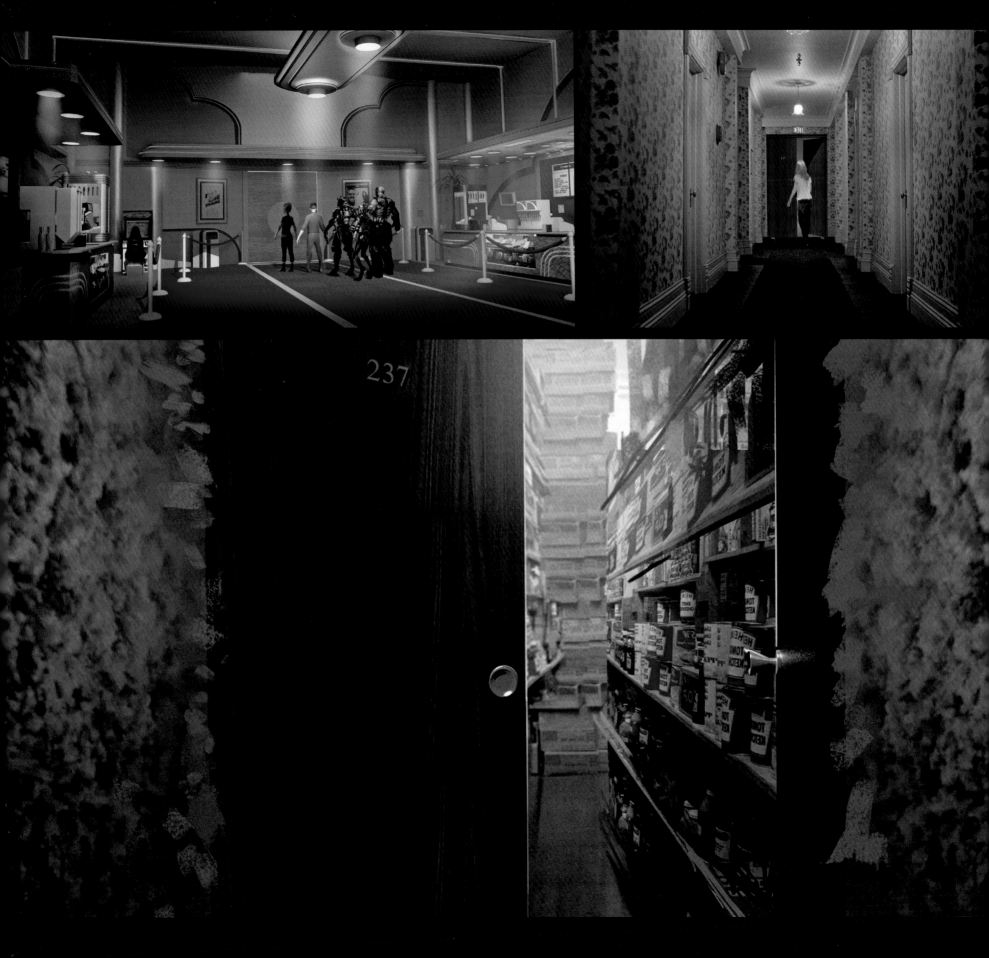

Five into the film. "The bar that I wanted to reach was for anyone to watch it and go, that's a shot from *The Shining*," Guyett says. "It just happens to have our characters in it. Of course, if you're inventing new scenes within *The Shining* or new moments or new characters, then the camerawork has to [change]. We didn't have enough coverage of the different scenes."

Ready Player One does also contain some actual footage from *The Shining*. "It generally has been augmented in some way or another for practical reasons, but there are shots that are lifted from the movie," Guyett says.

After the telecine copy of the movie was scanned, the scenes involving the High Five were shot using motion capture. Then, separately, additional live-action elements were photographed with a very high-resolution HD camera. The more "agnostic" format, as Guyett describes the HD camera, gave the ILM artists more flexibility in postproduction to manipulate the individual elements and the overall look of the sequence.

"Our goal was to precisely match the characteristics of the original film, all the way down to the grain structure," says ILM's Grady Cofer. "The benefit of HD acquisition is that the footage is very 'clean.' By starting with

pristine—or 'agnostic'—imagery, we can more closely mimic the imperfections of the original film."

The HD camera was used for shots involving the woman in the bathtub—a body double was hired to help augment some of the original footage—and the two young girls who were recruited as new incarnations of the famously ill-fated daughters of former Overlook caretaker Charles Grady. "We did find our own version of the twins, lovingly created, of course, in terms of their wardrobe and everything else," Guyett says. "We felt that at the end of the day, the twins were the most key component. We don't really show them in close-up."

Still, costume designer Kasia Walicka-Maimone made it a point to re-create the girls' dresses as closely as possible. "There was no artistic license taken whatsoever," she says. "They're made from cotton, and we overdyed the fabric to match the tone of the blue perfectly."

The same mandate applied to the few physical props that were fabricated for the scenes—everything was built as an exact replica of an element from the original production. "That was the idea, to get the exact bathtub from Room 237 or to try to figure out what exactly all the carving details were on the surround

OPPOSITE TOP LEFT The High Five stand together in the lobby of the Overlook Theater. Concept by Alex Jaeger.

OPPOSITE TOP RIGHT, OPPOSITE BOTTOM, AND ABOVE The hotel's design was intended to match the look of *The Shining* down to every last detail, as seen in these concepts that show the infamous Room 237 opening into other iconic parts of the location, including the well-stocked pantry. Illustrations by Stephen Tappin.

BELOW A final frame from *Ready Player One* shows the High Five in the lobby of a perfectly re-created Overlook Hotel.

PAGES 116–117 The "Gold Room" from *The Shining* gets a ghastly makeover in this concept by Stephen Tappin.

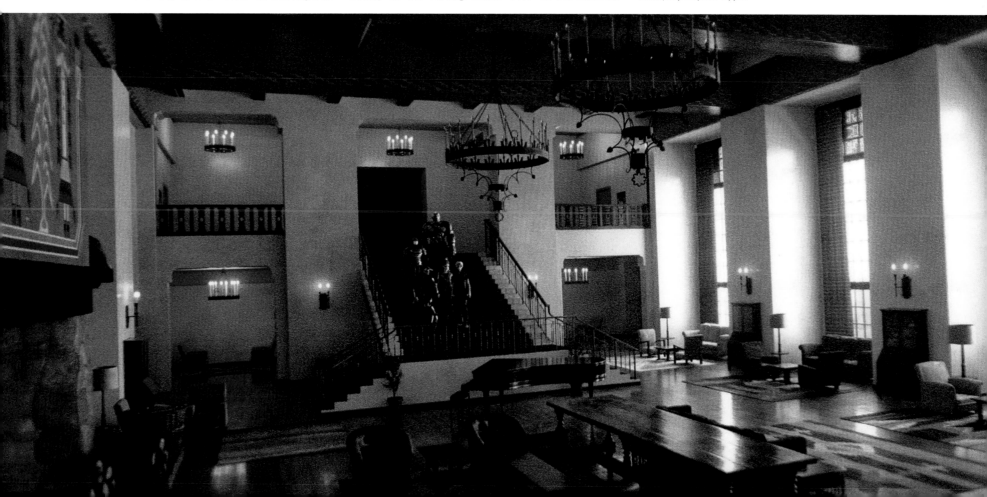

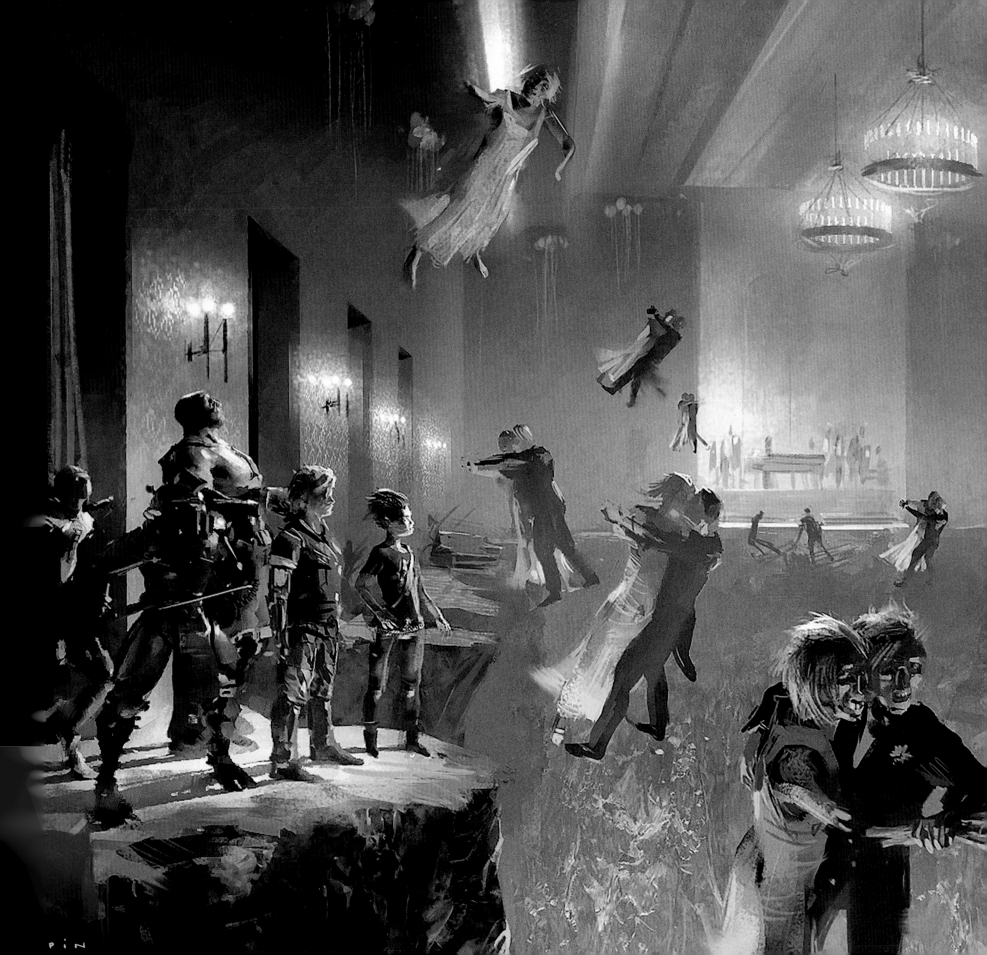

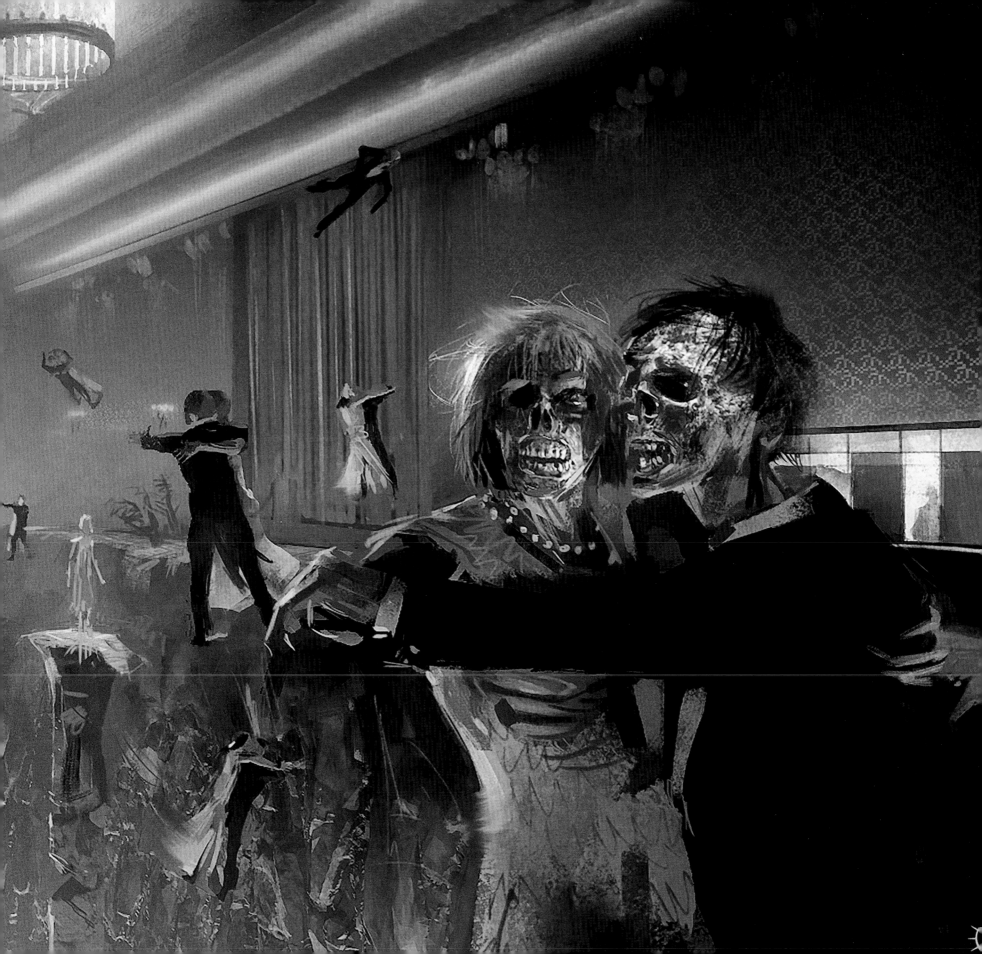

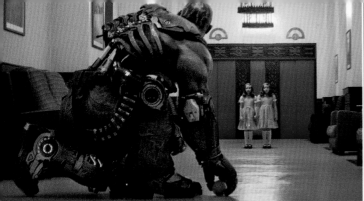

for the elevator doors—really being as exacting as we could," Stockhausen says. "We had the original film, and there's a wonderful book with tons of photographs in it. But we didn't have original blueprints, unfortunately. It would have been great if we did."

Again, every decision was in service of creating the most authentic reproduction of *The Shining* possible. "The way I thought of it, anyway, you had the feeling that you're in a dimensional re-creation of the movie, every aspect of it," Guyett says. "All the lighting would be the same, the characters would all be the same, the way that the film behaved would also be the same. The idea is that when you enter *The Shining*, you actually physically run into the Overlook Hotel. . . . As you walk into the main room where Jack would type away, that is a completely digital re-creation of that space. But as you do that, the look of the movie itself changes. It becomes grainy. It has a look of film that was shot in the 1980s."

While they are competing in the second challenge, even the avatars themselves are rendered through that grainier lens. "My heart was set on the fact that they're in that space and therefore they have all the attributes of that space," Guyett says. "Otherwise they would feel too stuck-on. I showed [Steven Spielberg] a test of them with that [grittier] look and he was like, 'Oh man. That's the way to go.'"

TOP A final frame from *Ready Player One* shows Aech coming face to face with the sinister Grady twins from *The Shining*.

RIGHT Concept art by Stephen Tappin shows Parzival and Art3mis running from *The Shining*'s iconic blood flood.

BELOW Early, unused concepts by Stephen Tappin show Aech lost in a maze of Overlook Hotel corridors.

STEPHEN TAPPIN

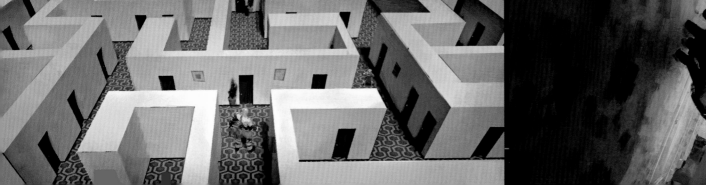

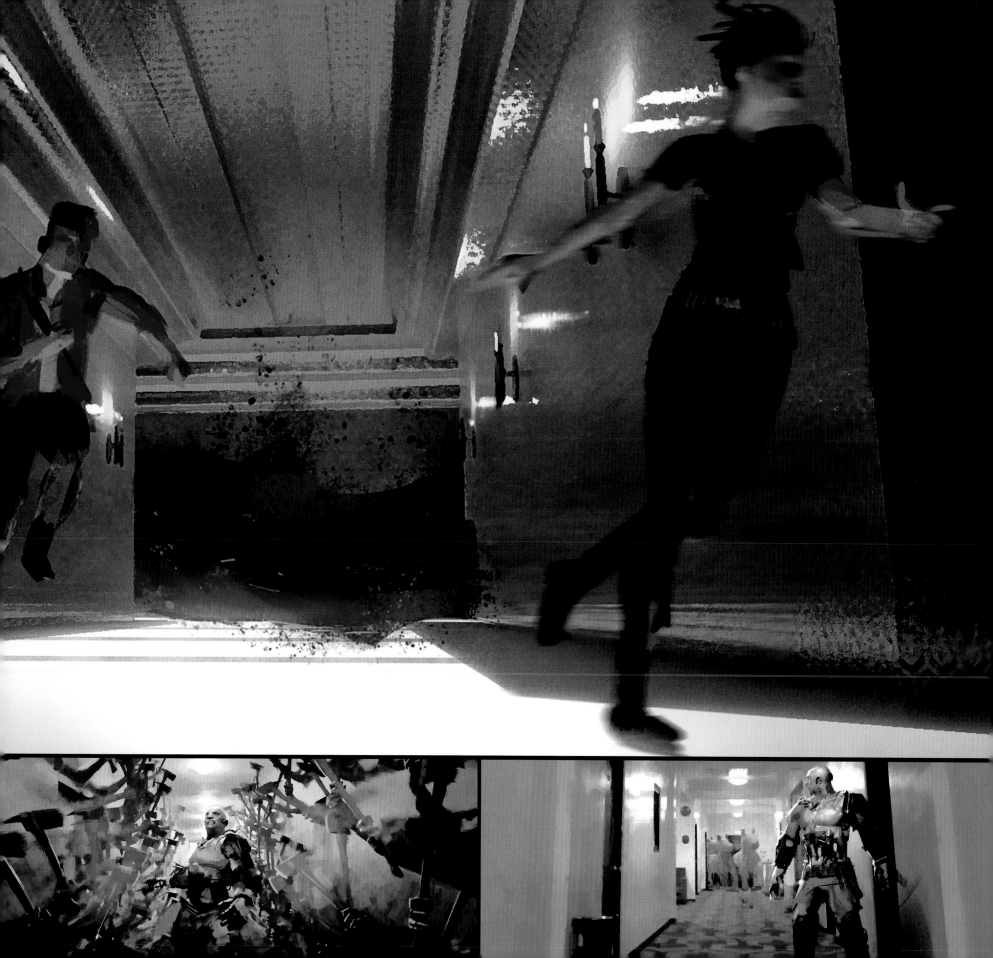

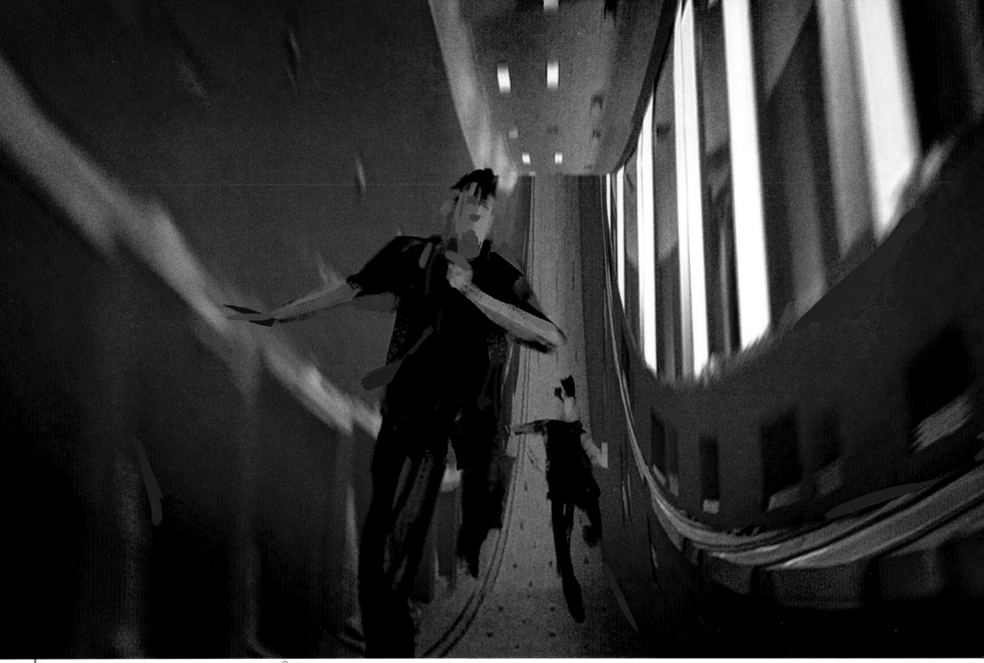

I don't understand, these weren't in the film!.. wait a minute!...

TOP AND OPPOSITE TOP LEFT An early Stephen Tappin concept shows the familiar bathroom from *The Shining* turning into a centrifuge-like structure in an homage to another Kubrick classic, *2001: A Space Odyssey*.

LEFT A storyboard by Stephen Tappin shows Art3mis and Parzival being pursued by sinister denizens of the Overlook Hotel.

OPPOSITE Further concepts by Stephen Tappin make creative use of iconic elements from *The Shining*, including the Big Wheel bike ridden by young Danny Torrance and Jack Torrance's deadly axe.

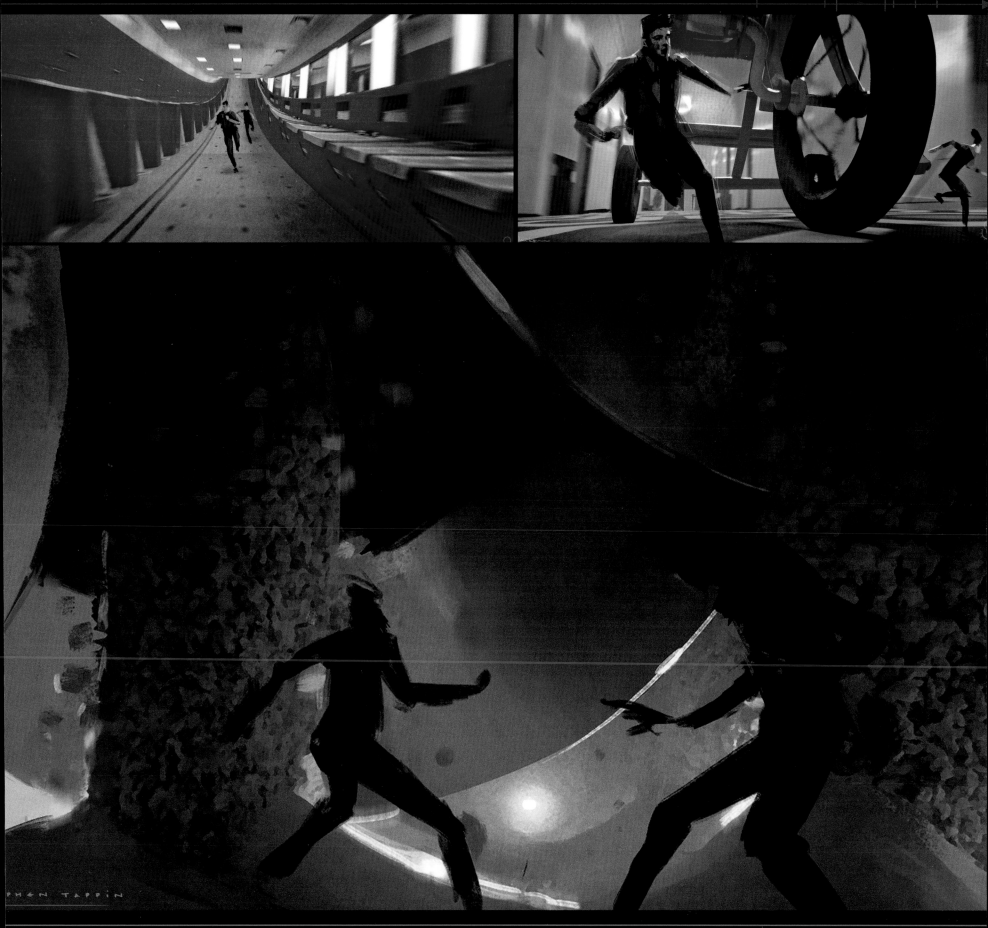

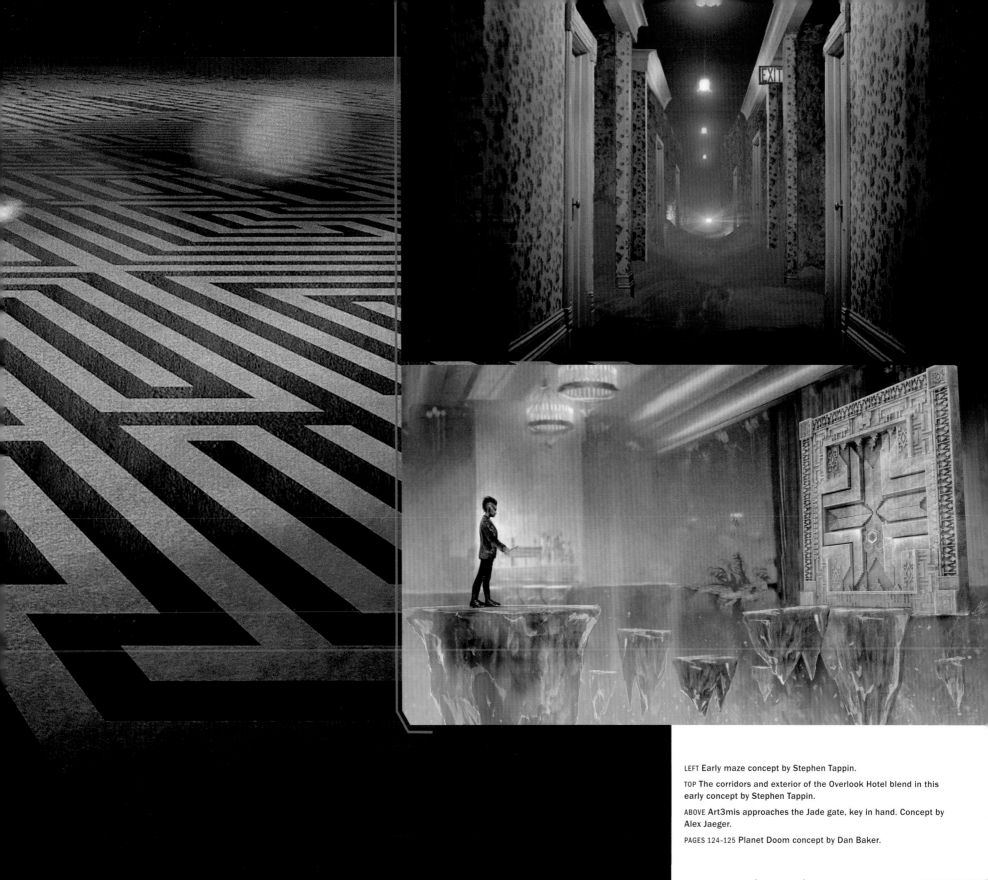

LEFT Early maze concept by Stephen Tappin.

TOP The corridors and exterior of the Overlook Hotel blend in this early concept by Stephen Tappin.

ABOVE Art3mis approaches the Jade gate, key in hand. Concept by Alex Jaeger.

PAGES 124-125 Planet Doom concept by Dan Baker.

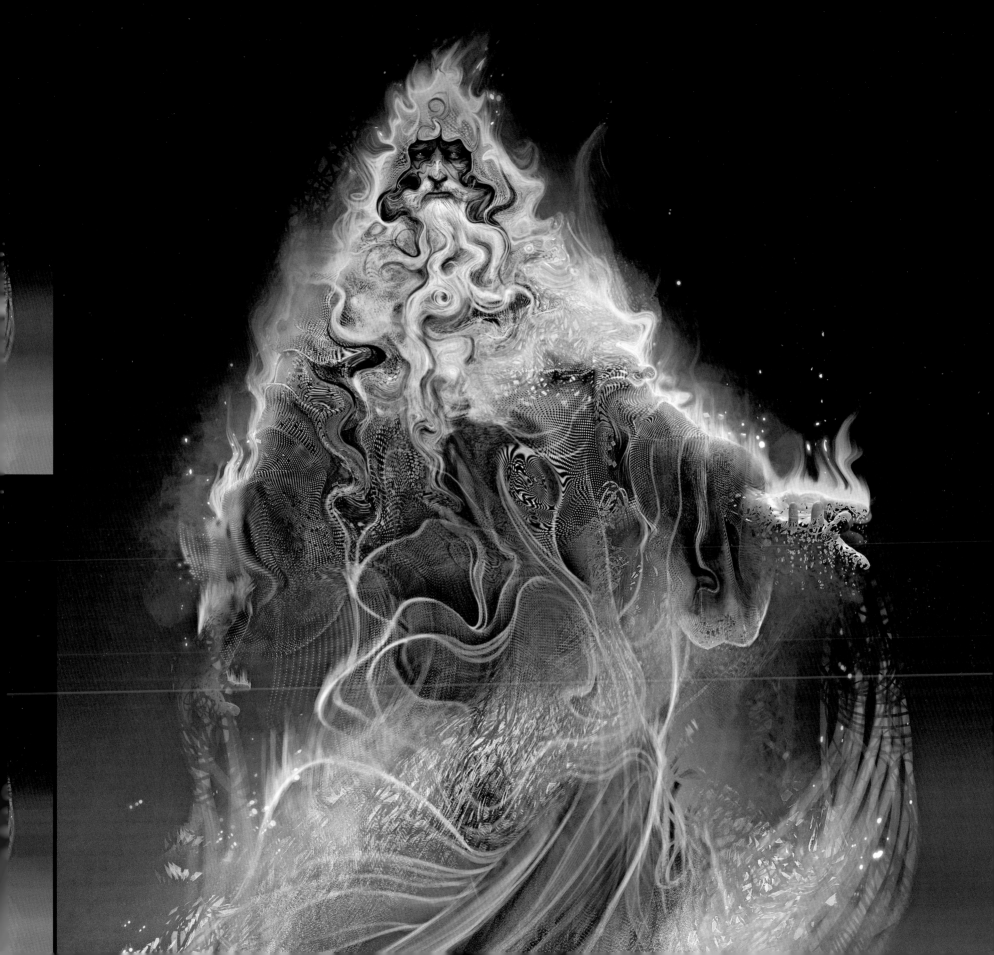

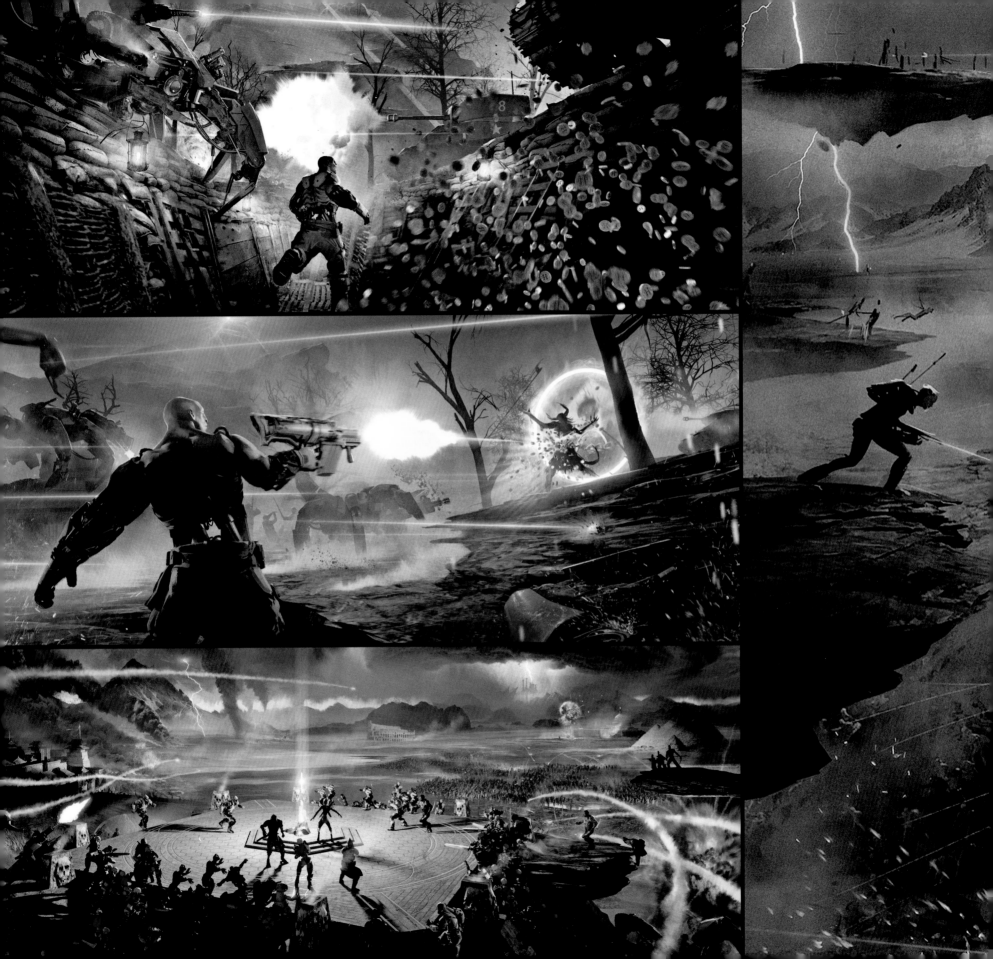

ABOVE AND TOP LEFT Planet Doom scavenger concepts by Aaron Sims Creative.

LEFT Planet Doom tank concepts by Alex Jaeger.

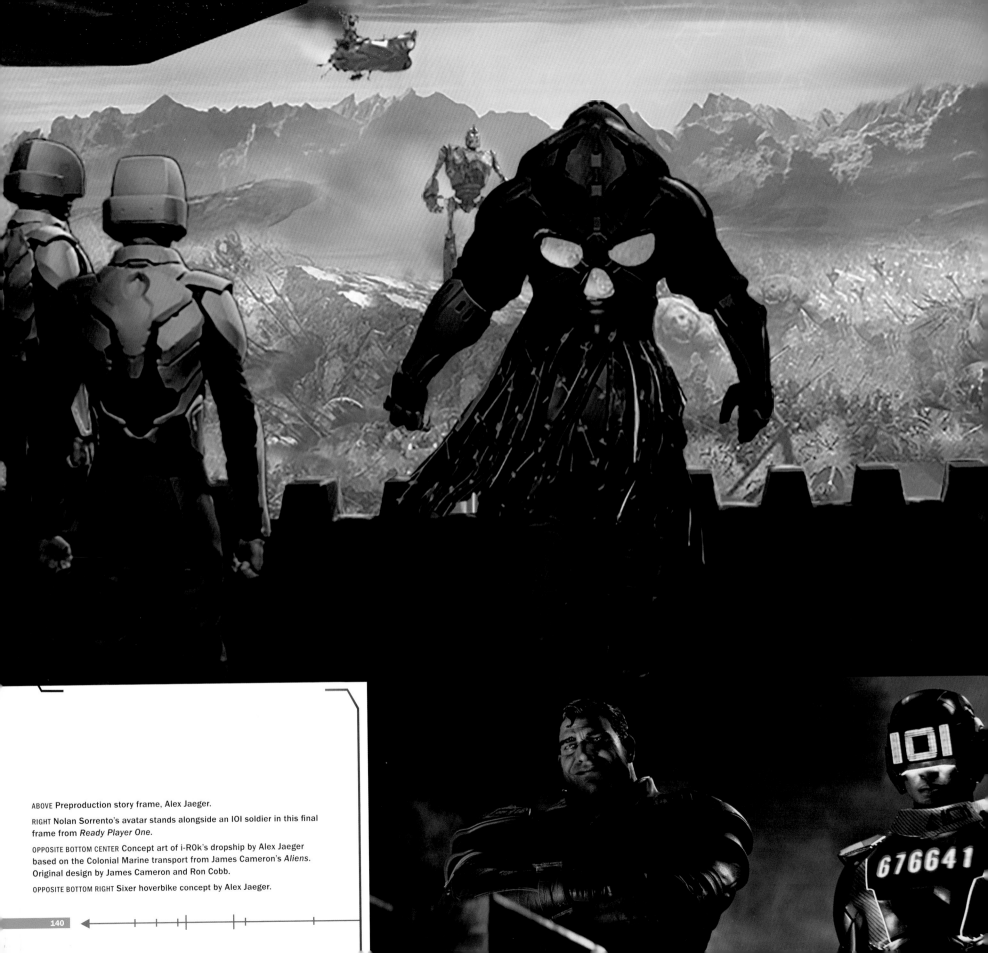

ABOVE Preproduction story frame, Alex Jaeger.

RIGHT Nolan Sorrento's avatar stands alongside an IOI soldier in this final frame from *Ready Player One*.

OPPOSITE BOTTOM CENTER Concept art of i-R0k's dropship by Alex Jaeger based on the Colonial Marine transport from James Cameron's *Aliens*. Original design by James Cameron and Ron Cobb.

OPPOSITE BOTTOM RIGHT Sixer hoverbike concept by Alex Jaeger.

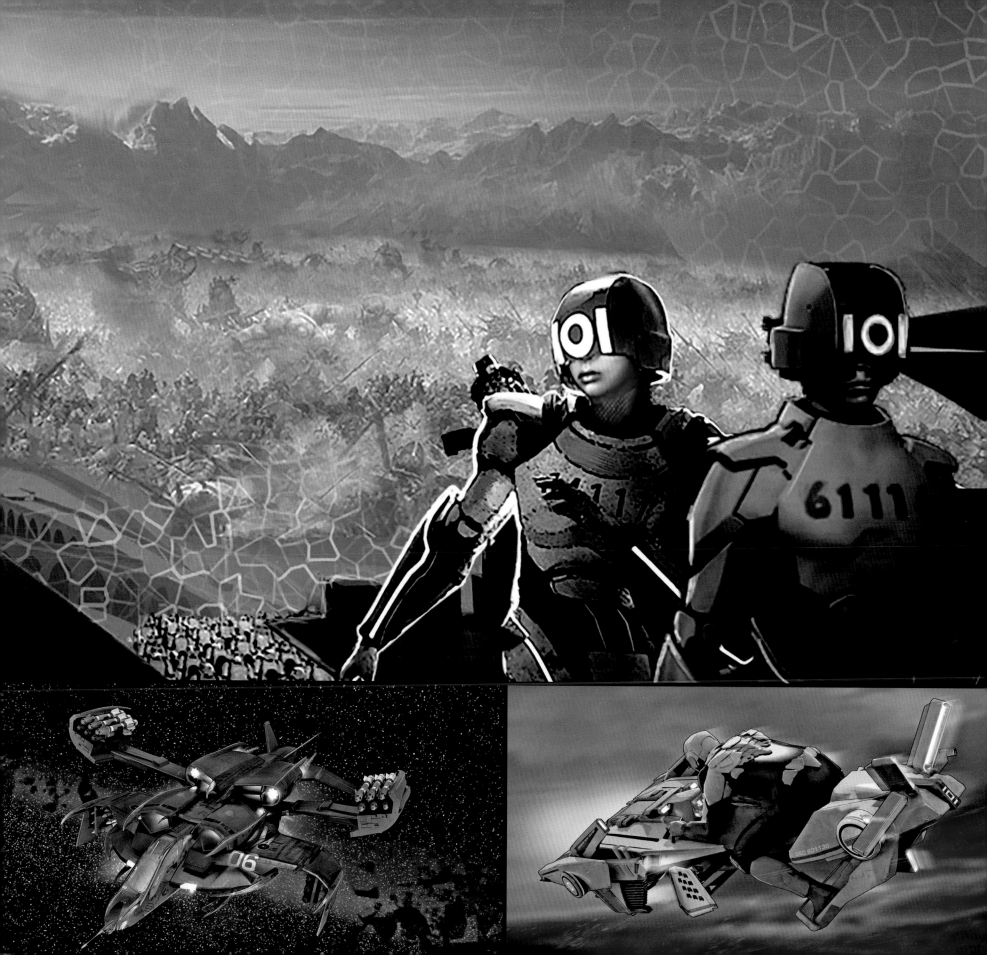

THE IRON GIANT

AMONG THE LARGER and more impressive avatars to take to the battlefield is the Iron Giant, the beloved character from Brad Bird's 1999 animated feature. In the new movie's story, master mechanic Aech has been constructing a replica of the Iron Giant in his garage. When it looks as though the towering character might help bring down Sorrento, Aech marches him into war. "The Iron Giant is a real major player in this story," Spielberg says.

"When we knew we were going to be able to bring Iron Giant back to the big screen, it made a lot of people here at ILM very happy," says Grady Cofer. But translating a character designed for an animated feature into a three-dimensional computer-generated character prompted a great deal of creative discussion about how he might need to be altered to appear inside the OASIS.

"We needed Iron Giant to really have weight and to have lots of scale and detail," Cofer says. "We did

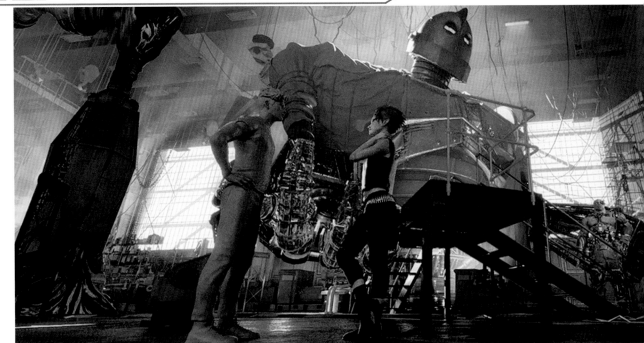

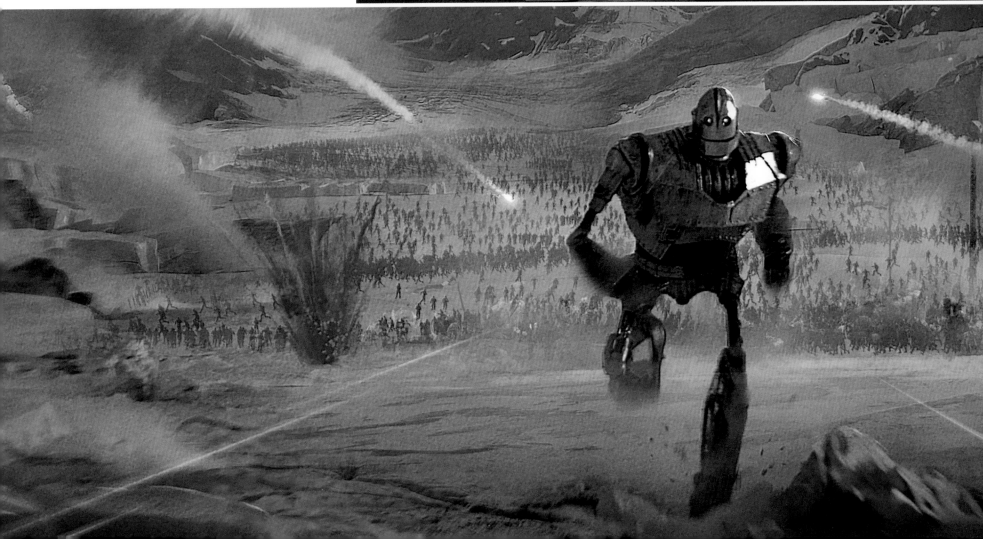

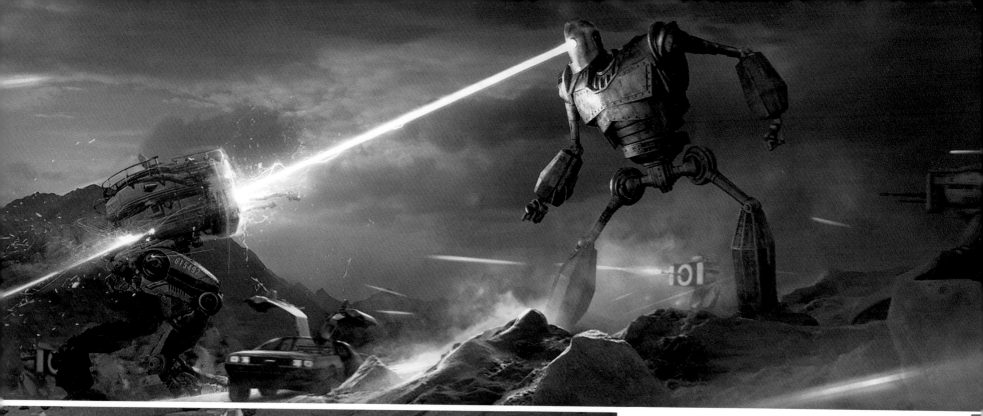

STEPHEN TAPPIN

a lot of detailed illustrations before settling on all of the close-up design details. Then we had to figure out the look and feel of that character, like what does iron look like if it were manufactured and cut into pieces and riveted together?"

For inspiration, Cofer, who was based in London during production and postproduction, visited various museums to help gain a visual understanding of classic machines. "We started looking at Victorian machinery and factory machinery . . . that have massive gears and spinning flywheels and pistons, almost like a locomotive. So we started borrowing from some of that language, kind of building from the inside-out pieces of the Iron Giant."

Adds ILM's Alex Jaeger, "We had to think of the Iron Giant as a physical thing. What would it actually be made out of? How would Aech build it? Is he welding things together or is he having 3D-printed stuff happening on it? There is one shot where we see [the avatars] standing between [the Iron Giant's] feet in the garage, and you see little chalk marks where Aech is doing his math on the foot and marking angles and things—just to give it the sense that this thing is huge, and he's been crawling all over it and doing little markings and cutting out parts. We never

OPPOSITE TOP LEFT **Aech's garage lighting concept by Alex Jaeger.**

TOP **Final battle lighting concept by Gaelle Seguillon.**

LEFT **Final battle lighting concept by Stephen Tappin.**

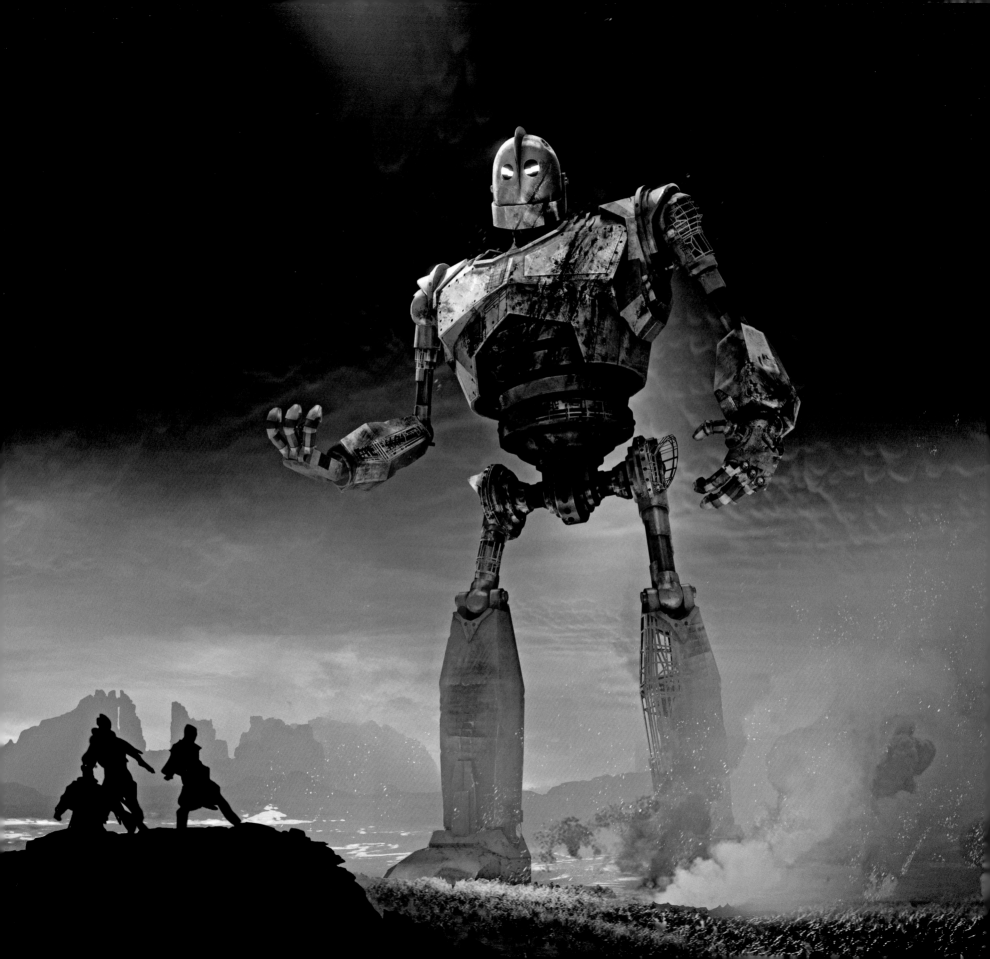

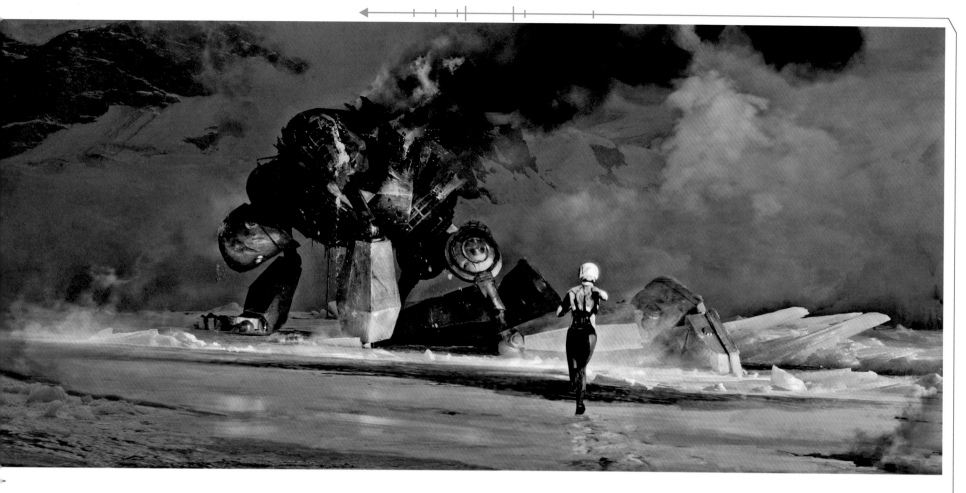

OPPOSITE The Iron Giant concept by Alex Jaeger. The character was designed to look as though he had been fashioned from raw metal ore or raw iron to contrast with the gleaming chrome of Mechagodzilla.

TOP The Iron Giant takes a punishing blow in this lighting concept by Gaelle Seguillon.

ABOVE A preproduction storyboard image by Alex Jaeger shows the heroes resting beside their fallen champion.

PAGES 146-147 A damaged Iron Giant creates a bridge over a perilous gap in this concept by Valentin Petrov.

see him 100 percent complete because Aech never got to fully finish him."

When it comes to the weapons at the Iron Giant's disposal, the visual effects artists sought to ensure they remained faithful to the original character. "We weren't making up new weapons for him," Jaeger says. "We were basically sort of saying, Well, he's got eye lasers, and he's got this gun that comes out his hand, so we'll make sure to copy those and update those and detail those and make them look realistic."

As it happens, Aech isn't the only one with a giant secret weapon at his disposal: In the middle of the battle, Sorrento's avatar transforms into Mechagodzilla, the metallic incarnation of the King of the Monsters, who makes an imposing foe for the Iron Giant. Because the two characters would be seen battling each other in a major scene, the designs were developed in tandem.

"As we started working on animation for the fight, we did try to develop those two characters side by side—we've worked to differentiate the two," says ILM's Cofer. "As much as we wanted Iron Giant to be a formidable robot, we knew Mechagodzilla had to be a massive and imposing foe. And Mechagodzilla is a massive creature. We've given him

a lot of weight by breaking him into tons of little pieces that all kind of move and work together whenever he walks."

Although both are metallic, Iron Giant appears to be fashioned from raw metal ore, or raw iron, while Mechagodzilla seems built from a shiny metal closer to chrome. "You have this kind of gleaming character, and in kind of David and Goliath fashion, you have a grungier Iron Giant facing off against him," Cofer says.

When it came to securing the rights to prominently feature such iconic characters on-screen, producer Donald De Line says that more than anything else, it was the presence of Steven Spielberg in the director's chair that ultimately paved the way for the production to weave together a tapestry of references from various fan-favorite films.

"It's always easier if Steven Spielberg is directing your movie, because if people are going to grant their rights to a movie, of course they're going to want to grant it to the best director that there is, and that's Steven," De Line says. "Honestly, almost all the studios were cooperative with us. I think that's largely because of Steven's relationships—he's worked with every studio. Everybody wants to be in business with him and will bend over backward to make something work."

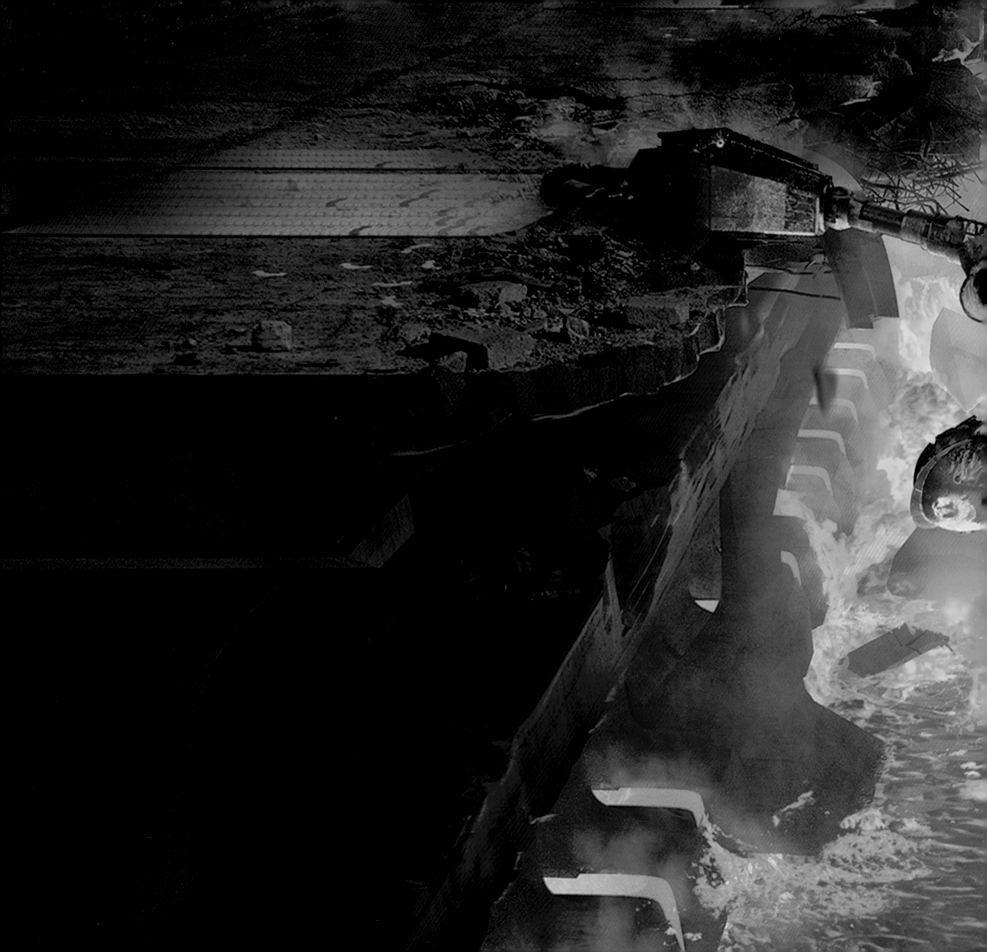

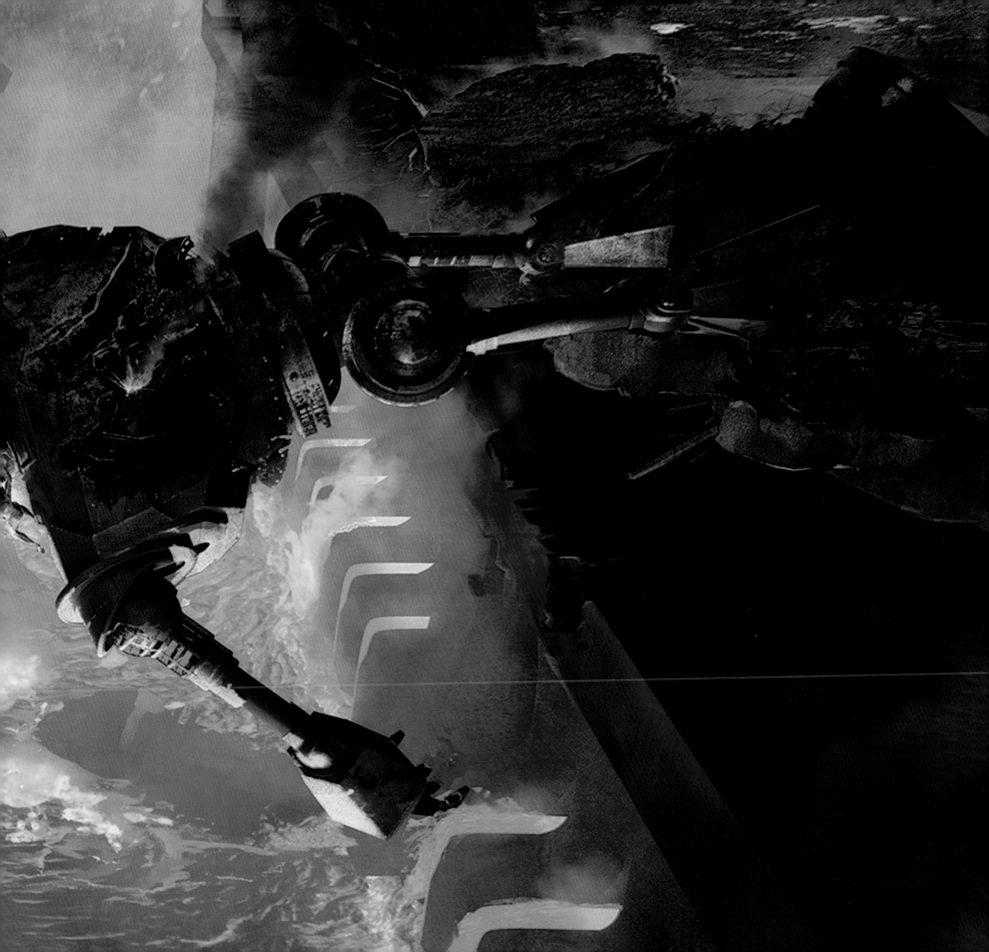

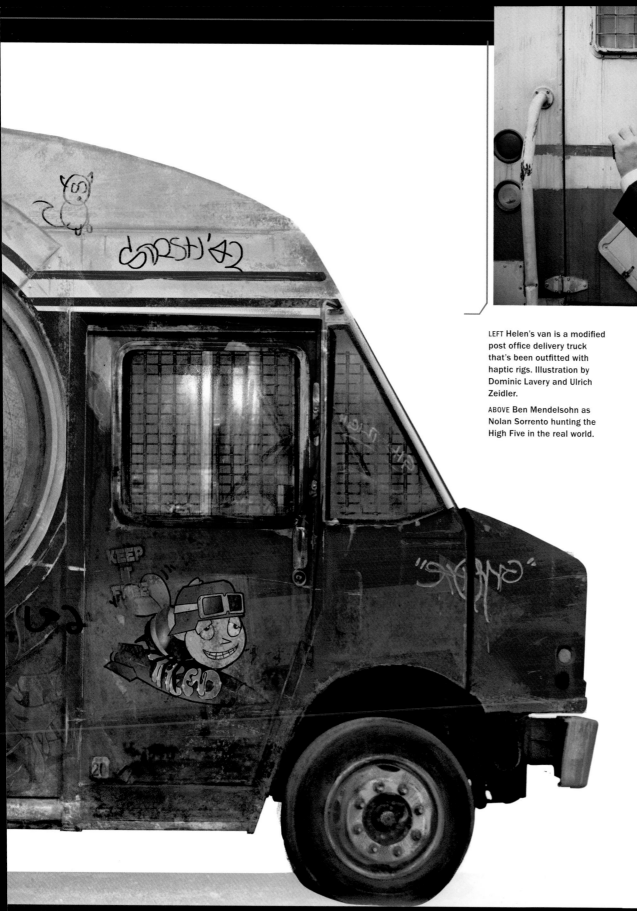

LEFT Helen's van is a modified post office delivery truck that's been outfitted with haptic rigs. Illustration by Dominic Lavery and Ulrich Zeidler.

ABOVE Ben Mendelsohn as Nolan Sorrento hunting the High Five in the real world.

BY THE TIME war has erupted between the gunters and Sorrento's forces outside the walls of Castle Anorak, in the real world the High Five have few places to safely plug into the OASIS—Samantha is secretly working from the inside of IOI's corporate headquarters, but her compatriots are logged in from rigs in the back of H's van.

"H's van was an RV in the novel, but we wanted something more open in the back so we could have the characters moving in their rigs throughout the battle at Anorak's castle," explains production designer Adam Stockhausen. "We settled on the idea of using an old post office mail truck—one that had been modified with an iris on the side for drone delivery. Our thought was that these trucks would be common on the streets as mobile platforms for drones as they made deliveries in the Stacks. Aech bought an old one and tricked it out with immersion rigs in the back—all while blending into the streets on the outside."

Ultimately, the van becomes a getaway vehicle, as the four members of the High Five are furiously pursued through the streets of Columbus by Sorrento's lieutenant F'Nale Zandor. Spielberg believed it was important in the climax of the film to cut between the action on Planet Doom and events in real-world Columbus. "He wanted all these parts to be moving at the same time," says co-screenwriter Zak Penn. "The contrast is really important—we go from this dilapidated van they're driving around in and then cut to this crazy battle sequence."

Stunt coordinator Gary Powell orchestrated much of the action, which was filmed on location in Birmingham, England. The sequence featured stunt performers leaping from one car to another, various IOI vehicles spinning out of control, and Zandor ramming into H's van and eventually jumping onto the back doors of the van as they swing open. "We did our best to destroy it," Powell says of the vehicle.

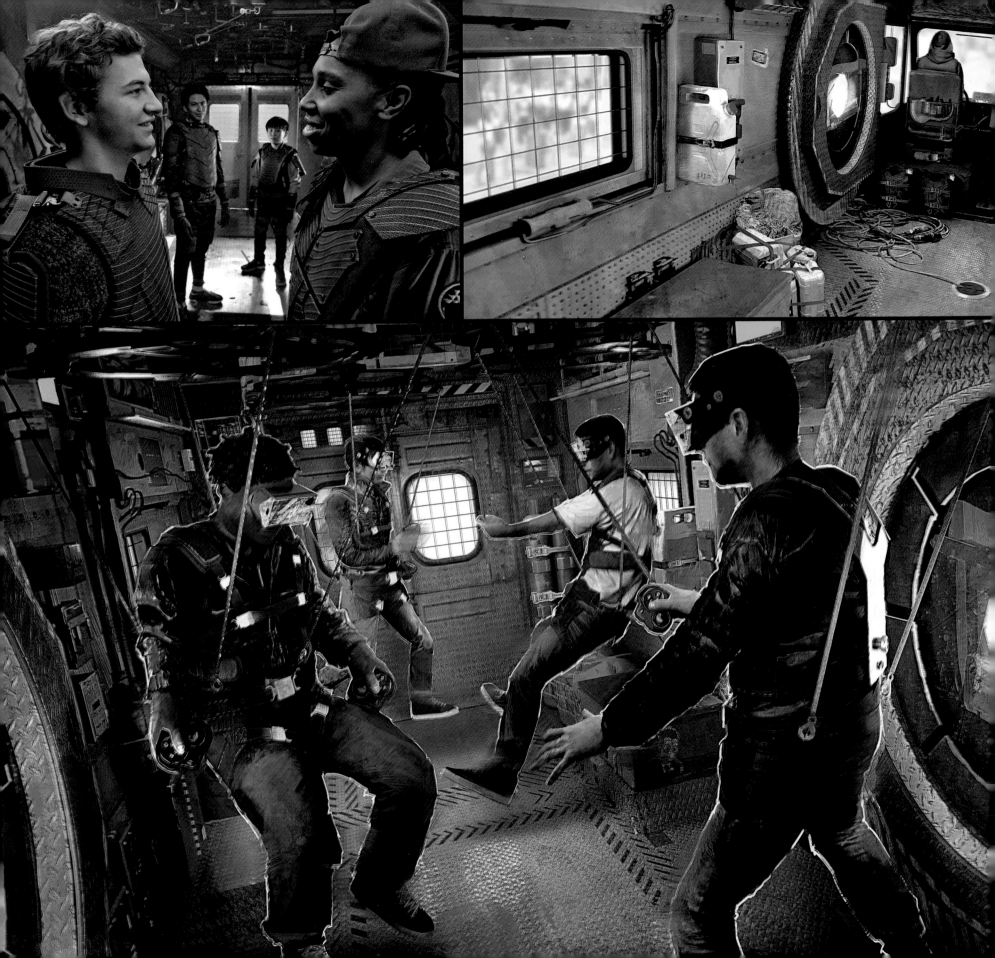

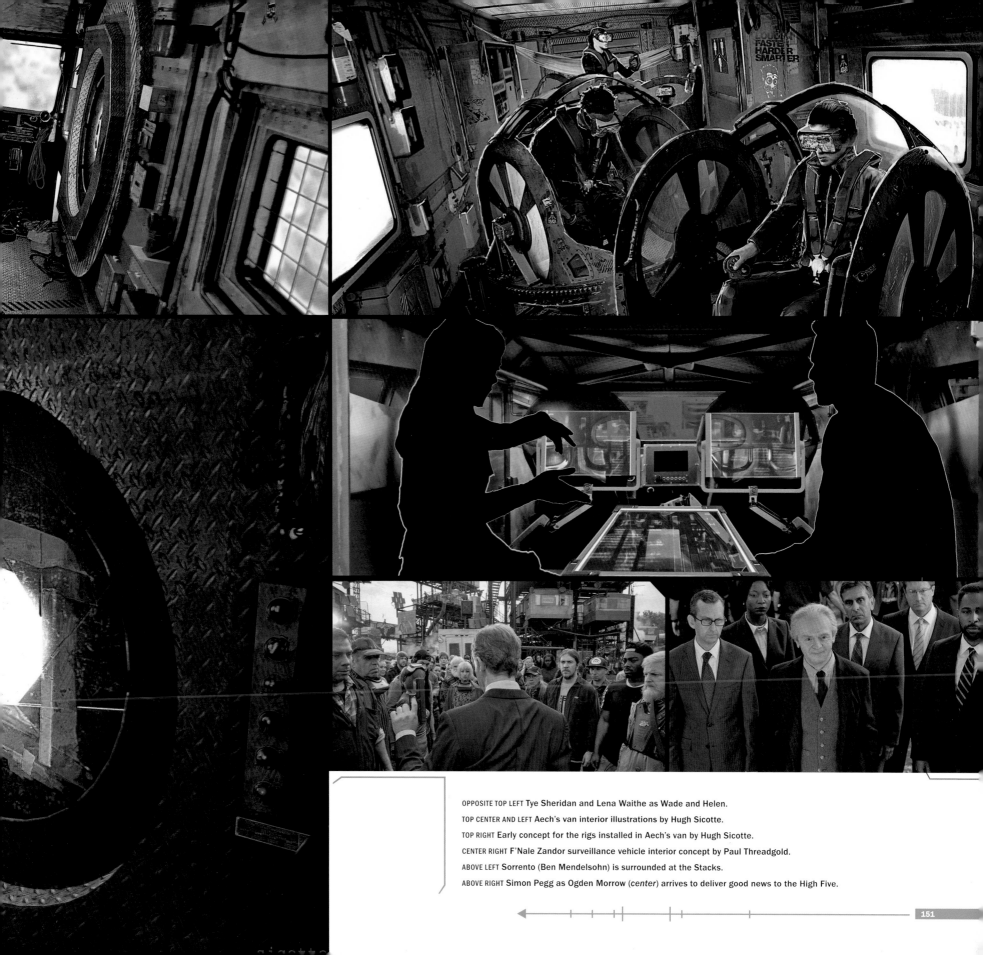

OPPOSITE TOP LEFT Tye Sheridan and Lena Waithe as Wade and Helen.

TOP CENTER AND LEFT Aech's van interior illustrations by Hugh Sicotte.

TOP RIGHT Early concept for the rigs installed in Aech's van by Hugh Sicotte.

CENTER RIGHT F'Nale Zandor surveillance vehicle interior concept by Paul Threadgold.

ABOVE LEFT Sorrento (Ben Mendelsohn) is surrounded at the Stacks.

ABOVE RIGHT Simon Pegg as Ogden Morrow (*center*) arrives to deliver good news to the High Five.

AN EXCELLENT ADVENTURE

IN THE 1979 ATARI 2600 video game *Adventure*, players had to retrieve three special keys in order to obtain an enchanted object; it was also the first game to feature an Easter egg (creator Warren Robinett hid his own name in a secret chamber within the game). Audiences won't have to look too carefully to spot the homages to *Adventure* in *Ready Player One*, but finding all of the dozens of such nods to vintage pop-culture landmarks that are peppered throughout might be a taller order.

Seeding the film with loving tributes to nostalgic favorites seemed like the ultimate act of fan service and an appropriate way to honor Ernest Cline's remarkable novel, says ILM's Grady Cofer: "[Production designer] Adam [Stockhausen] started peppering the movie with hidden pop-culture references, little Easter eggs for the audience to find. There really is something for everyone—the video gamers, the movie buffs, the anime fans. It's just like the book. Those references become a part of the movie's texture and add this extra dimension for fans out there who really will appreciate them. We worked really hard to keep it fun and add a lot of hidden gems."

Adds ILM's David Shirk, "I think one of the great payoffs for the movie is that it's going to be very watchable, but it's also going to be very re-watchable because there's so much going on in the frame. While it's not competing with the main action, there's a ton of extra stuff to find once you have the opportunity to go back and take a [casual look] around the frame."

While the references capture the fun popcorn energy of the original novel, at its heart, *Ready Player One* squarely falls into the best traditions of Spielberg's work—visually dazzling, forward-looking, character-driven adventures full of passion and imagination.

"One of the things that I always loved about Spielberg's movies is they're not filled with fear for technology," says co-screenwriter Zak Penn. "Steven's movies are not cynical at all. Part of the point of the book is to see some hope in this technology, to see some hope in the future. It is a cautionary tale, but it's a celebration of culture, of our collective memories. This is our language."

Adds novelist and co-screenwriter Cline: "*Ready Player One* is, for me, a celebration of video games and cinema and television and everything about pop culture that I love, and the experience of making the movie is getting to see people like Zak and Steven do the same thing, pay homage to certain films or video games that they love."

Offers Spielberg himself: "It's really wonderful to be able to make a movie from a book that has been such a cult hit, and also kind of a crossover hit as well. Ernest Cline is a visionary who really has a grand imagination and I think has seen the future before any of us possibly could even imagine it."

RIGHT A final frame from *Ready Player One* shows Anorak's throne room complete with golden Easter egg.

BELOW Samantha (Olivia Cooke) and Wade (Tye Sheridan) relax following the conclusion of their quest.

OPPOSITE Anorak's throne concept by Luis Carrasco.

PAGES 154-155 A concept by Dominic Lavery shows Parzival standing amid Halliday's vast treasure in the Castle Anorak throne room.

PAGE 156 Halliday's stop button concept by Alex Jaeger.

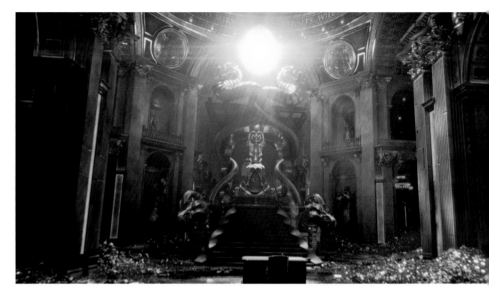

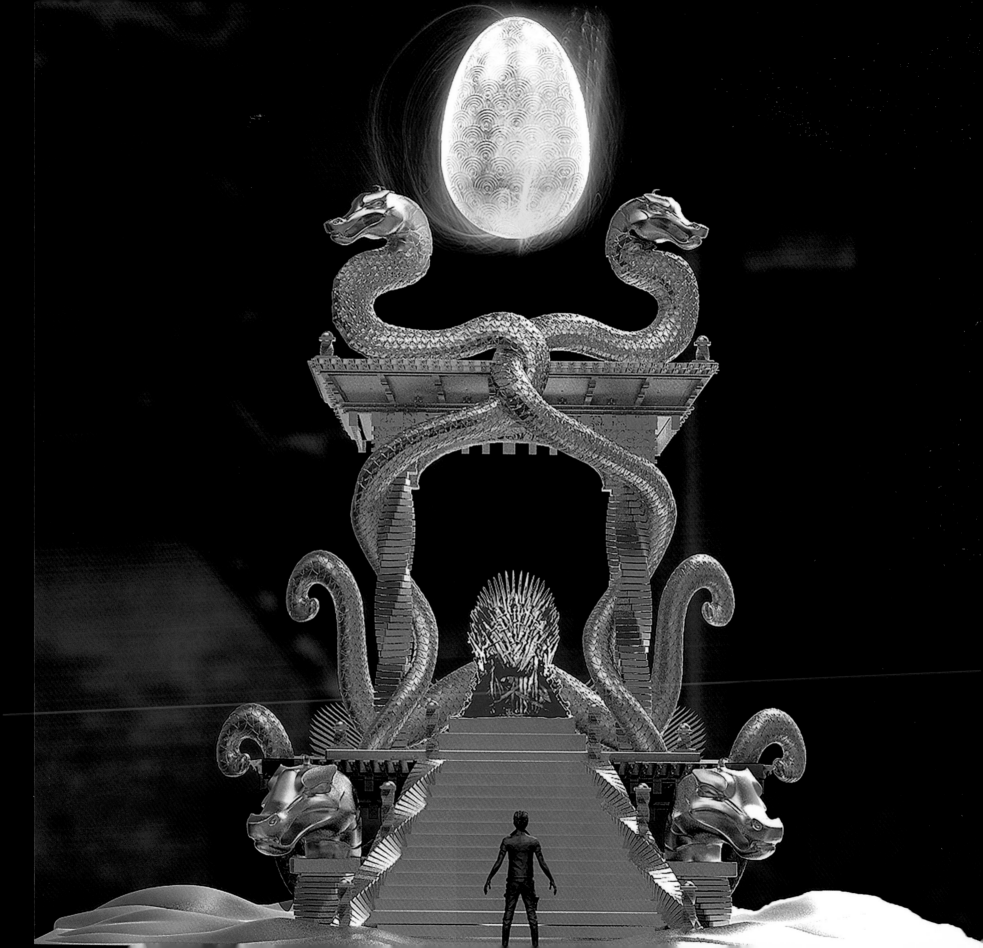

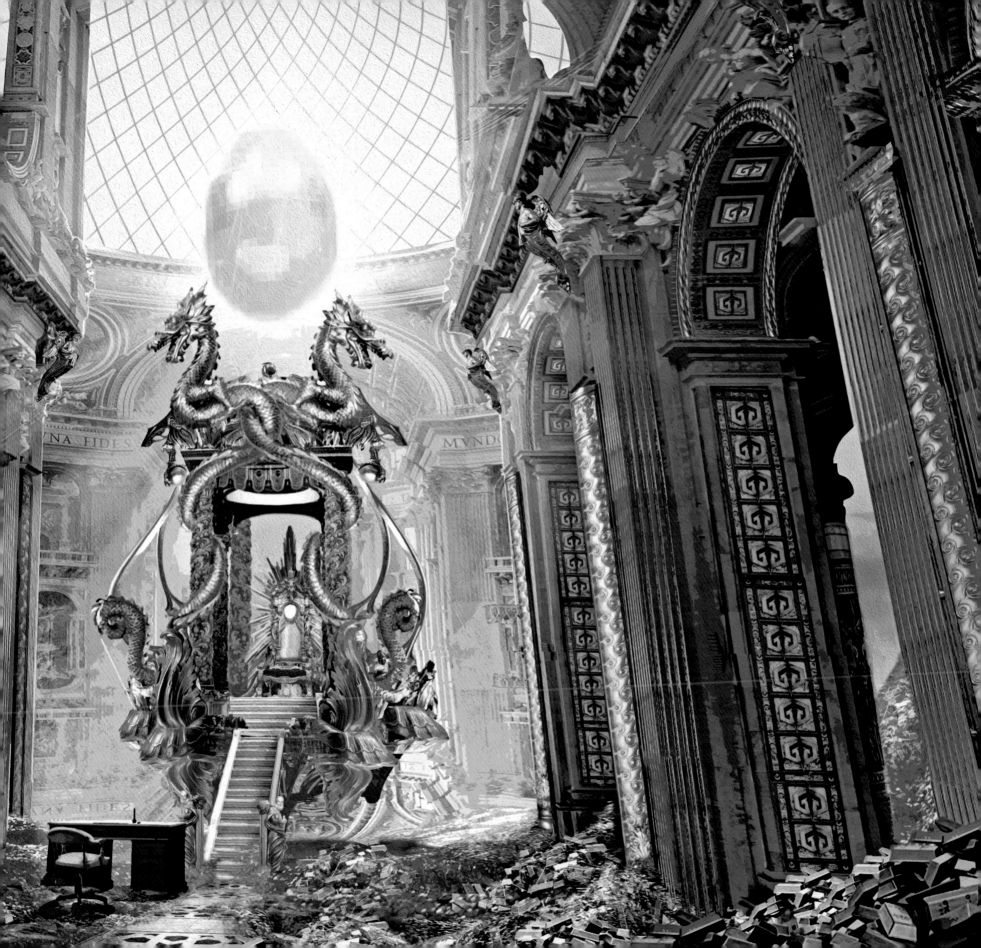

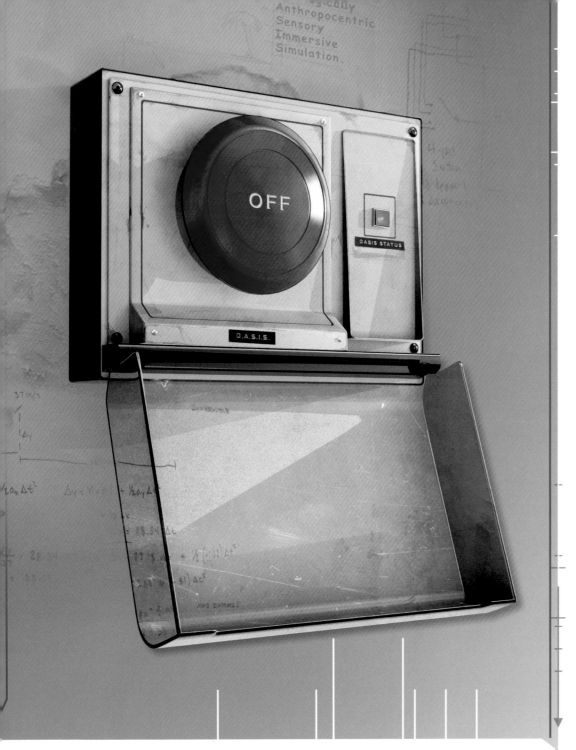

AUTHOR ACKNOWLEDGMENTS

For their help and support in making this book, I would like to thank Steven Spielberg, Kristie Macosko Krieger, Donald De Line, Dan Farah, Ernest Cline, and Zak Penn. A special thanks to the cast: Tye Sheridan, Olivia Cooke, Lena Waithe, Ben Mendelsohn, Mark Rylance, Simon Pegg, Win Morisaki, and Philip Zhao.

To those who helped make this book possible, thank you to Laurent Bouzereau, Grady Cofer, Neil Corbould, Greg Grusby, Roger Guyett, Chris Hawkinson, Graham Kelly, Viet Luu, Kasia Walicka-Maimone, Jennifer Meislohn, Gary Powell, Patrick Perkins, George Ricker, Violet Ricker, David Shirk, Clint Spillers, Adam Stockhausen, and Greg Weiler. Thanks also to Josh Anderson, Daniele Dohring, Shari Gary, Nick Gligor, Bruce Hughes, Melissa Jolley, Isabel Lemon, Nik Primack, Megan Korns Russell, Amy Weingartner, Stephanie Wheeler, and Emma Whittard at Warner Bros.

Many thanks to artists Dan Baker, Alex Jaeger, Jama Jurabaev, Dominic Lavery, Hugh Sicotte, and everyone at Aaron Sims Creative, including Chase Friedman, Michael Pecchia, Steffan Reichstadt, Aaron Sims, and Cooper Surrett.

The Dark Crystal imagery on page 152 courtesy of The Jim Henson Company, Inc.

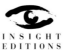

INSIGHT EDITIONS
PO Box 3088
San Rafael, CA 94912
www.insighteditions.com

Find us on Facebook: www.facebook.com/InsightEditions

Follow us on Twitter: @insighteditions

Copyright © 2018 Warner Bros. Entertainment.
READY PLAYER ONE and all related characters and elements
© & ™ Warner Bros. Entertainment Inc. (s18)
WB SHIELD: ™ & © WBEI. (s18)

INED40856

Published by Insight Editions, San Rafael, California, in 2018.
No part of this book may be reproduced in any form without written permission from the publisher.

Library of Congress Cataloging-in-Publication Data available.

ISBN: 978-1-68383-209-6

PUBLISHER: Raoul Goff
ASSOCIATE PUBLISHER: Vanessa Lopez
ART DIRECTOR: Chrissy Kwasnik
DESIGNER: Jon Glick
SENIOR EDITOR: Chris Prince
MANAGING EDITOR: Alan Kaplan
EDITORIAL ASSISTANT: Maya Alpert
SENIOR PRODUCTION EDITOR: Elaine Ou
PRODUCTION MANAGER: Greg Steffen

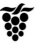

ROOTS of PEACE REPLANTED PAPER

Insight Editions, in association with Roots of Peace, will plant two trees for each tree used in the manufacturing of this book. Roots of Peace is an internationally renowned humanitarian organization dedicated to eradicating land mines worldwide and converting war-torn lands into productive farms and wildlife habitats. Roots of Peace will plant two million fruit and nut trees in Afghanistan and provide farmers there with the skills and support necessary for sustainable land use.

Manufactured in the Italy by Insight Editions

10 9 8 7 6 5 4 3 2 1

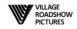